THE METROPOLITAN MUSEUM OF ART NEW YORK · THE METROPOLITAN MUSEUM OF ART NEW YORK

MUSEUM OF ART
The United States of America

INTRODUCTION

BY

Oswaldo Rodriguez Roque

ASSOCIATE CURATOR, DEPARTMENTS OF AMERICAN ART

THE METROPOLITAN MUSEUM OF ART, NEW YORK

PUBLISHED BY

THE METROPOLITAN MUSEUM OF ART
New York

PUBLISHER

Bradford D. Kelleher

EDITOR IN CHIEF

John P. O'Neill

EXECUTIVE EDITOR

Mark D. Greenberg

EDITORIAL STAFF

Sarah C. McPhee

Josephine Novak

Lucy A. O'Brien

Robert McD. Parker

Michael A. Wolohojian

DESIGNER

Mary Ann Joulwan

Commentaries written by the editorial staff.

Photography commissioned from Schecter Lee, assisted by Lesley Heathcote: Plates 2, 4, 8, 15, 19, 20, 25, 28, 29, 32, 41, 43, 49, 52, 55, 64, 71, 73, 79, 83, 84, 87, 88, 90, 99, 102, 104, 105, 107, 108, 112, 118. Photographs for Plates 47, 48, 75, 76, 80, and 81 by Jerry L. Thompson. Photograph for Plate 1 by Richard Cheek, and for Plate 33 by Paul Warchol. All other photographs by The Photograph Studio, The Metropolitan Museum of Art.

Maps and time chart designed by Wilhelmina Reyinga-Amrhein.

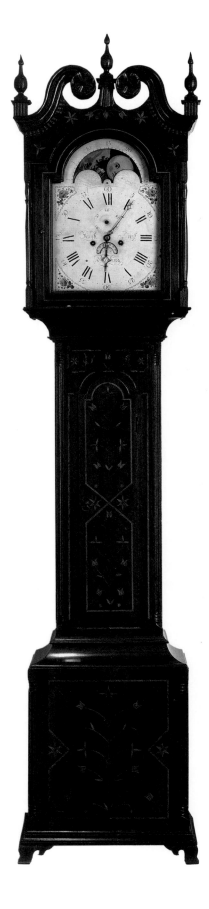

TITLE PAGE

At the Seaside
William Merritt Chase, 1849–1916
Oil on canvas; 20 x 34 in. (50.8 x 86.4 cm.)
Bequest of Miss Adelaide Milton de Groot
(1876–1967), 1967 (67.187.123)

THIS PAGE

Tall Clock
Reading, Pennsylvania, ca. 1800
Jacob Diehl, 1776–1858
Walnut; H. 96½ in. (2.45 m.)
Purchase, Douglas and Priscilla de Forest
Williams, Mr. and Mrs. Eric M. Wunsch, and
The Sack Foundation Gifts, 1976 (1976.279)

Library of Congress Cataloging-in-Publication Data

The Metropolitan Museum of Art (New York, N.Y.)
 The United States of America.

 Includes index.
 1. Metropolitan Museum of Art (New York, N.Y.). American Wing. 2. Art, American. 3. Decorative arts—United States. 4. Art—New York (N.Y.) I. Metropolitan Museum of Art (New York, N.Y.)
N611.U55 1987 709'.73'07401471 85-13900
ISBN 0-87099-416-6 ISBN 0-87099-417-4 (pbk.)

Printed and bound by Dai Nippon Printing Co., Ltd., Tokyo. Composition by U.S. Lithograph, typographers, New York.

This series was conceived and originated jointly by The Metropolitan Museum of Art and Fukutake Publishing Co., Ltd. DNP (America) assisted in coordinating this project.

This volume, devoted to the arts of the United States of America, is the ninth publication in a series of twelve volumes that, collectively, represent the scope of the Metropolitan Museum's holdings while selectively presenting the very finest objects from each of its curatorial departments.

This ambitious publication program was conceived as a way of presenting the collections of The Metropolitan Museum of Art to the widest possible audience. More detailed than a museum guide and broader in scope than the Museum's scholarly publications, this series presents paintings, drawings, prints, and photographs; sculpture, furniture, and the decorative arts; costumes, arms, and armor —all integrated in such a way as to offer a unified and coherent view of the periods and cultures represented by the Museum's collections. The objects that have been selected for inclusion in the series constitute a small portion of the Metropolitan's holdings, but they admirably represent the range and excellence of the various curatorial departments. The texts relate each of the objects to the cultural milieu and period from which it derives, and incorporate the fruits of recent scholarship. The accompanying photographs, in many instances specially commissioned for this series, offer a splendid and detailed tour of the Museum.

We are particularly grateful to the late Mr. Tetsuhiko Fukutake, who, while president of Fukutake Publishing Company, Ltd., Japan, encouraged and supported this project. His dedication to the publication of this series contributed immeasurably to its success.

In order to present the most comprehensive picture of American art, the editors of this volume have drawn on the collections of several of the Museum's curatorial departments: the Department of Prints and Photographs, the Department of Musical Instruments, the Costume Institute, and most notably, the departments of American and Twentieth Century Art.

Since it was established over a century ago, the Metropolitan Museum has been acquiring American art, and its collections are now the most comprehensive and representative to be found anywhere. To accommodate its ever-increasing wealth of American painting, sculpture, and decorative arts, the Museum opened The American Wing in 1924, where, for the first time, American antiques were presented in an orderly, chronological way. The great enthusiasm that greeted this opening was reflected in a renewed interest in American antiques and early houses throughout the 1920s, which has continued unabated ever since. In 1980 an expanded American Wing opened, in order to give an integrated and coherent representation of America's artistic past.

American art of this century is collected by the Department of Twentieth Century Art, which was established in 1970. The Museum's involvement in contemporary art, however, goes back almost to its very beginning, with several artists among its founding members. In 1906 George A. Hearn, a trustee of the Museum, established a fund in his name for the purchase of art by living American artists; five years later a second fund in the name of his son, Arthur Hoppock Hearn, was established for the same purpose. These funds as well as the Kathryn E. Hurd Fund and the Edith Blum Fund for the acquisition of American art continue to be the main sources of departmental purchases. Gifts and bequests have also contributed to the department's growth. Among the most important was the bequest of Alfred Stieglitz in 1949, which included over four hundred paintings, sculptures, and works on paper. Although the department collects works from all areas of twentieth-century art, its strengths are decidedly American—particularly paintings by The Eight, the modernist works of the Stieglitz circle, and postwar Abstract Expressionist and Color Field painting. In February 1987, the new twentieth-century galleries will open to the public in the Lila Acheson Wallace Wing, reflecting the Museum's commitment to the art of this century as well as to that of centuries past.

We are grateful to the Museum's curatorial staff for their help in preparing this volume, and especially to Oswaldo Rodriguez Roque of the Department of American Art for his invaluable assistance. In addition to composing the introduction, he spent much time reviewing the photographs and text.

Philippe de Montebello
Director

THE UNITED STATES
OF AMERICA

The chief preoccupation of the first European settlers to arrive in the New World, whether in North or South America, was the re-creation of the material world they had left behind. In North America, and especially in New England, this happened extraordinarily quickly, despite the enormous natural obstacles that had to be overcome. The Puritan settlers of New England were largely members of a literate middle class who had left the motherland primarily for religious reasons, but also because of poor economic and public health conditions. They were a highly organized, enterprising, and varied people. They came from rural regions of England—East Anglia, Somerset and Dorset, Yorkshire and Hampshire, among others—with strongly developed local customs and traditions, and frequently emigrated in a large group from one of those communities. In the new land they tended to remain cohesive—different groups settling different towns—so that by about 1660, New England was already a mosaic of small villages, reflecting to a remarkable extent the regional diversity of rural England.

An object such as the blanket chest attributed to Thomas Dennis (Plate 2), therefore, is part of a cabinetmaking tradition peculiar to a region of England, in this case an area in Dorset and in Devon where the craftsman served his apprenticeship in the late 1640s. This style of furniture making, with its strong reliance on curved decorative motifs, originated in continental Europe during the late Renaissance, or Mannerist period. It, in turn, became the local style of Ipswich, Massachusetts, where Dennis and other settlers from Dorset and Devon lived. The locality-to-locality pattern in transmission of style from Europe to America is evident in nearly all known seventeenth-century American-made objects.

Usually, objects made in the American colonies in the seventeenth century tend to have a heavy, substantial look, and somewhat irregular surfaces (Plate 2). For a long time the term "Pilgrim"—referring to the Puritan settlers of Plymouth Plantation who had arrived in 1620—was generally and indiscriminately applied to these objects. The result, wholly intended, was to turn the objects into early statements of an American tradition. There was no single dominant style at this time, and none of the craftsmen would have thought of them as all that different from what they would have made had they remained in Europe.

In painting, such works as have survived are mostly portraits of New England origin. The Puritans shunned religious imagery and placed a strong emphasis on usefulness —thus virtually ensuring that any painting tradition that developed in New England in the following century would be in portraiture, which preserved the likenesses of relatives and reinforced all-important family ties.

A more up-to-date sense of elegance, judging by the standards of the European capitals, began to penetrate the art of the Colonies in the late seventeenth century. There were many reasons for this: increased wealth, the arrival of court-appointed Colonial governors with their retinues, the loosening up of the old Puritan oligarchy in New England, and last but not least, the steady development of art-related crafts and industries in England, especially in London, during the last half of the century. This new stylishness was first articulated in America in the formal language of the European Baroque style. In furniture, the old technique of joining, in which the use of mortise-and-tenon joints permitted heavy wooden members, usually made of oak, to frame thinner panels of the same wood, was replaced by thin-board construction employing dovetails. Chests and cabinets thus became lighter and could be elevated on shapely turned legs. Chairs, too, became thinner and more vertical, with elaborately carved crests and curving arms. The use of shimmering burl veneers on case pieces resulted in visually activated surfaces that echoed in wood the breakup of reflected light achieved in silver through chasing, gadrooning, and repoussé work (Plates 4, 5, 6). Lighter methods of construction also began to be used in domestic architecture, with sash windows, higher ceilings, and interior wainscoting becoming much more commonplace (Plate 1). Still, the impact of the Baroque style was not felt equally by all regions or all people. Even in major urban areas such as Boston, the forms associated with the mid-seventeenth century continued to be produced long after the introduction of the Baroque.

The first quarter of the eighteenth century saw many changes in the life of the Colonies that set the stage for the development of a provincial but highly individual society. Trade between the Colonies, the West Indies, and the motherland increased tremendously, as did trade between the Colonies themselves. Significant numbers of new immigrants, particularly Scotch-Irish Presbyterians, Germans from the Rhineland, and Huguenots, arrived in the middle and southern Colonies. William Penn's experiment in tolerance, Pennsylvania, with its thriving capital city of Philadelphia, rose to challenge the primacy of Massachusetts, as did Rhode Island in a lesser way. Much progress was made in education and learning with the founding of several colleges and many newspapers. By about 1730, the Colonies were already emerging as a loosely knit group of political entities, each

one with a distinct social and cultural stamp and its own commercial capital. Real power increasingly came to be wielded by a merchant elite eager to consume luxury goods but never so far removed from the realities of life as to attempt to do so on the scale of a hereditary nobility, even when they had the means. In terms of art, American colonials became more aware of, and willing to pay for, objects in the latest fashions. The sequence of styles that characterize English fine and decorative arts of the eighteenth century was mirrored in the American colonies no less than in Ireland, Scotland, or India.

The native influence was least operative in silver, which closely followed English developments and which, were it not for the marks, could not be readily distinguished from English examples (Plate 5). Silver objects were easily imported and many silversmiths sold English wares along with the pieces they produced on order. Furniture was without a doubt the most distinctively Colonial, with regional schools of cabinetmaking taking shape in Boston, Newport, New York, Philadelphia, Williamsburg, and Charleston.

If one had to single out the most original design achievements of the American colonies, the list would inevitably include the shell-block style furniture produced in Newport, Rhode Island, by the Goddard-Townsend family of cabinet-makers, the interpretations of the English Chippendale (or Rococo) style accomplished by Philadelphia's leading furniture makers, and the mature portraiture of John Singleton Copley. All are triumphs of a highly conservative artistic outlook reluctant to discard the old and familiar; all are sober and carefully crafted designs of pronounced clarity.

The character of the American people of the mid-eighteenth century is probably most immediately revealed in the portraits of John Singleton Copley, all painted in Boston with the exception of a number produced in New York during a visit in 1771 (Plate 11). Largely self-trained, but clearly influenced by a number of artists working in Boston, Copley was able to elevate the always desired strong likeness to the level of art, through careful observation, painstaking working methods, and a clever manipulation of light and shadow. His works were of unquestionable quality, even by English norms, and they set the standard for Colonial America. Only after the return from Europe in 1793 of another great American portraitist, Gilbert Stuart, was the spell of Copley's crisp style broken.

For artists of ambition like Copley, the career opportunities in America were simply not enough. They yearned for the museums and galleries of Europe, for the companionship of other like-minded artists, and for the chance to paint works other than portraits. Benjamin West, born and educated in Philadelphia, was the first painter to succeed in establishing himself in London. Before that, however, beginning in 1760, West had spent three years in Italy looking at ancient Roman sculpture and architecture, as well as the well-known masterpieces of fifteenth- and sixteenth-century painting. His interest in antiquity, further spurred by the intellectual climate of Rome at the time, led him to paint some of the earliest representations of great heroic deeds, of both the ancient and recent past, that can be called Neoclassical in style. Such works made him an admired, and much sought-after, painter in England, and eventually led

to his appointment as historical painter to King George III, and to his election as president of the Royal Academy. A man of generous spirit, West made his London house and studio available to many American painters who wished to broaden their experience or obtain formal training abroad. *The American School* by Matthew Pratt (Plate 7) is one such guest-artist's testament to the kindness of his mentor. In time, Charles Willson Peale, Gilbert Stuart, and John Trumbull would also benefit from West's hospitality.

By the time of Copley's departure for Europe, it was clear that a military confrontation between the motherland and her American colonies was in the offing. Despite strong regional differences, amply attested to in her art, America was united in its dislike of recently renewed attempts by Great Britain to assert tighter commercial and political control. In 1776, in unforgettable words penned mostly by Thomas Jefferson, independence was declared and the United States of America came into being, at least on paper. But first a war had to be fought.

Ironically enough, political independence at first had the curious effect of making American art adhere more closely to English models (Plates 27 and 28). The war years had isolated the country artistically as well as commercially: When peace and prosperity returned, not only was there a pent-up desire for imported goods, there was an entirely new style, the Neoclassical, to assimilate. Still, the regional character of American art did not disappear during this period; on the contrary, its variety increased with the rise of Salem, Massachusetts, and Baltimore, Maryland, as important art centers.

Initially an affair of plain surfaces, geometric simplicity, and thinness of parts, the Neoclassical style took on a more ornate robustness when a revivalistic approach toward antiquity was generally adopted in Europe. France, in the years of the Directorate and Consulate (1795 to 1804), took the lead in this movement, which turned into the official national style during the time of the Napoleonic Empire (1804 to 1815). America, which had regarded the events of the French Revolution with horror, began to warm up to its old Revolutionary War ally during Jefferson's presidency: From the early 1800s on, the influence of France rivals that of England in American art. American artists now looked to Paris as well as London for stylistic guidance, with the result that a certain ambivalence began to characterize the art of the early Federal Period. In painting, for example, Gilbert Stuart (Plate 25) brought home the painterly approach to portraiture fashionable in London, while John Vanderlyn (Plate 31) preferred the sharp linearity practiced by Jacques-Louis David and his followers in Paris. In furniture, Duncan Phyfe interpreted the forms associated with the English Regency Period, while Charles-Honoré Lannuier introduced the vocabulary of the French Empire style. The same is true in silver and other mediums.

The years following the cessation of hostilities with Britain were ones of fairly steady growth. One result of this general increase in national wealth was the rise of the American middle class, economically, politically, and culturally. The ranks of the common man now began to supply artists and craftsmen who would satisfy the increased aesthetic needs of their own class. Thus began the considerable output of objects that are today inappropriately called folk, rural,

primitive, or naive, but which in reality are simply the arts of the American common man. Sometimes they were produced by professional artists such as Ralph Earl (Plate 18), who had worked in England and was familiar with fashionable portraiture; at other times they were the result of a less proficient, but far more creative sensibility (Plate 21). They incorporated recent styles as well as traditional ones (Plate 22) and were crafted in both rural and urban areas, frequently by women as part of their household duties (Plate 24). Only the triumph of the machine and of mass-produced commercial goods at the beginning of this century put an end to this very American type of art—and then not completely.

Although Neoclassicism held sway in architecture and the decorative arts until about 1840, it is clear that in its late phase the style was rife with artistic attitudes having little to do with classical discipline, republican virtue, or rational restraint. In the decorative arts, these attitudes, again prodded by European precedents, would soon enough seek fulfillment in a variety of revivalistic and eclectic styles that would follow each other in quick succession. These impulses, however, had earlier manifestations in painting and, before that, in literature. It would be easy enough to characterize them as a whole as the American version of European Romanticism, which in a sense is true, save that to do so overlooks the peculiarly American national conditions that so affected them. One such condition had to do with the question of American identity: Who was the new American? Another had to do with what America itself was: How big was the land and how big could it be? European Romantic ideas about the primacy of the emotions, the importance of Nature to man, or society, and of God, were pondered in this country in a rather different psychic context, and it was out of that context that the romances of James Fenimore Cooper's *Leatherstocking Saga* emerged—however much they may owe to Sir Walter Scott—as did the genre paintings of George Caleb Bingham (Plate 39) and William Sidney Mount, and the landscapes of the Hudson River School.

Besides genre and landscape painting, still life benefited greatly from the expansion of America's cultural horizons at the beginning of the nineteenth century. Ironically, history painting, the realm in which Americans had made their first notable contribution to international art, in the English works of West and Copley, continued to languish. It was probably too big in sheer physical dimensions, too pretentious, and too boringly elevated for American taste. Increasingly, its prerogative of dealing with the great philosophical, religious, and moral themes of mankind was assumed by landscape painting. The great natural features of a vast land became eloquent symbols in a type of painting that, on the surface, appeared intensely true to observed fact, but that, in reality, was highly idealistic and emotionally charged. This tradition began with Thomas Cole (Plate 38), who also painted works with overtly religious and historical content, and largely through his influence and teaching, it developed into an important school of painting based in New York City. Cole's followers, Asher B. Durand and Frederic E. Church, took the style of the Hudson River School, so called after the majestic New York river that inspired many of its painters, and pushed it decisively in the direction of greater detail and greater realism (Plate 37). With Church, especially, the style became high drama and reached beyond the national boundaries of America to grasp the whole world, something many critics have viewed as the counterpart in paint of the expansionist nationalism of the mid-nineteenth century.

As the Civil War approached, landscape painting, by now the acknowledged artistic keeper of the national soul, began to explore scenes of extreme, and sometimes ominous, quiet (Plate 46). Perhaps reflecting the Transcendentalist philosophy of Ralph Waldo Emerson, these works communicate a sense of oneness with Nature, and therefore with God, which was certainly a refreshing solace to Americans living through those turbulent times.

The first of the major pre-Civil War revival styles that so drastically changed the look of the decorative arts was the Gothic Revival (Plate 44). In furniture, it appeared as early as the 1820s because most American Neoclassical architects recognized the viability of the Gothic style for ecclesiastical buildings and picturesque houses. It was followed in the 1850s—or possibly earlier—by the more exuberant Rococo Revival and Renaissance Revival styles (Plates 43 and 55). Once introduced, each enjoyed remarkable longevity. In many homes they coexisted with one another in a happy eclecticism that continued to characterize the majority of American domestic interiors until the end of the century. Sometimes it is difficult to tell on the basis of appearance alone just when a given object in a revival style was made. When an astonishingly high degree of luxury and stylistic complexity are seen, however, it is virtually certain that the object was made after the Civil War (Plate 56). Only after the war had first marshaled the industrial capabilities of the nation did a more furiously paced industrialization make possible the vast wealth that could afford such things (Plates 54 and 57).

By comparison with the alienating world of huge factories, immigrant laborers, slums, and unbridled plutocratic power that took shape after the war, the decades of the 1830s, 40s, and 50s seemed like a time of idyllic harmony. In many ways this was the case—not because that period was free of political and social problems, but because, in spite of them, an optimistic mood and innocent outlook were so general.

The traumatic experience of the Civil War—the most horrible and costly military conflict yet seen by mankind in both financial and human terms—made the relatively simple-minded, but usually genuine, sentimentalism of so much prewar American art inappropriate. The war touched everyone, either directly or indirectly. Those very few who were fortunate enough to have no relatives or friends killed or injured, no property destroyed, no disturbance in their private lives, were still made painfully aware of its horrors through newspaper accounts, Winslow Homer's woodcut illustrations (which eventually resulted in reportorial paintings such as *Prisoners from the Front*, Plate 50), and the photographs of Mathew Brady (Plate 51).

As in the early decades of the nineteenth century, literature and painting first registered the changed attitudes of the post-Civil War period. In painting, two major directions may be observed: One explores a type of realism that was detailed and relatively blunt, the other veers in the direction of

refinement and aestheticism. At the risk of oversimplifying matters enormously, the former may be said to have been motivated by a desire to deal with the world as it was; the latter, by the realization that only a retreat into art and its blandishments made life in such coarse times bearable. What a change from the unabashed, but still emotionally shallow patriotism of Leutze's *Washington Crossing the Delaware* (Plate 40) to the psychological complexity of Homer's *Prisoners from the Front* (Plate 50), or to the unpretentious implied heroism of Eakins's *Max Schmitt in a Single Scull* (Plate 61)! What a change, also, from the redemptive landscapes of the Hudson River School to the morally neutral nocturnes of Whistler! Such changes, however, are clearly discernible only in the stratosphere of American art; at lower altitudes, the sentimentalism of the pre-Civil War years, despite its inappropriateness, continued to sell, in painting as well as in architecture and the decorative arts. The latter, especially, not only continued to exploit the possibilities of revivalism, but now did so in a manner that blatantly revealed the increased, and frequently vulgar, materialism of newly acquired wealth (Plate 54). A work like Eastman Johnson's *The Hatch Family* (Plate 57), concerned with interior decoration as much as with painting, attempts to harmonize postwar conspicuous consumption with the gentler values of domesticity ardently preached by many pre-Civil War writers. Only by 1890, under the spell of European ideas of refinement (themselves inspired by the example of oriental art), did a more restrained and thoughtful approach to the decorative arts begin to show itself in the work of talented designers such as Christian Herter (Plate 83).

Of all the major arts of this period, sculpture took the longest time, but not by many years, to adjust to the requirements of the new American Gilded Age, as Mark Twain and Charles Dudley Warner so aptly characterized the last decades of the nineteenth century. Probably the first sculptor to adapt to the new age in the years immediately following the war was John Quincy Adams Ward, who recognized the authority of classical ideals but was by temperament a close observer of nature (Plate 48). By 1880, however, his approach was eclipsed by the work of Paris-trained younger men such as Augustus Saint-Gaudens, Daniel Chester French, and Frederick William MacMonnies, who brought home the highly decorative neo-Baroque style popularized in France during the Second Empire and the reign of Napoleon III (Plates 76, 80, 81). Their works were perfectly attuned to the architecture of the great palace builders Richard Morris Hunt and the firm of McKim, Mead & White, with whom they frequently worked. Saint-Gaudens, who never lost sight of the importance of honest emotion, is surely the finest artist of the group.

To return to painting, no clearer revelation of the dilemmas posed by life in post-Civil War America exists than the decision by three of her most talented artists, James McNeill Whistler, Mary Cassatt, and John Singer Sargent (Plates 60, 78, 59), to pursue their careers abroad as voluntary expatriates. In London and Paris, they found the sophistication, tolerance, and cultural maturity that America lacked, despite its wealth. In Europe they were also able to escape the instability of American society, increasingly divided between capitalist and laborer, native-born and immigrant, rich and poor, black and white, increasingly plagued by political corruption, and yet, in spite of it all, growing uncontrollably. In the end, these dilemmas would force the art of such courageous home-based realists as Eakins and Homer into introspection and disillusionment.

Homer, in particular, became an artist obsessed by doom and death. One wonders whether he would have been so successful financially if his pessimism had not been rather skillfully masked by his sensuous technique. Certainly, uncompromisingly decorative and cheery imagery was what the typical American collector of the late nineteenth century desired. That much, at least, is made clear to the historian by the enormous popularity of the movement known as American Impressionism. Almost completely ignored until about twenty years ago, American Impressionism has now recaptured its original significance as one of the important stages in the history of American painting. Curiously enough, it did not arise from the example or teaching of Mary Cassatt, who, having been a member of the French Impressionist group, would have been the logical conduit for the transmission of the style to America. Rather, American Impressionism resulted from a number of "conversions" among young painters, most of whom had been trained in the realist manner of the conservative European academies. Most of the conversions took place about 1890, long after French Impressionism had first come to public attention in Europe, and most were the result of admiration for the paintings of Claude Monet. Perhaps because the American Impressionists were, at bottom, academic painters, not avant-garde rebels, or perhaps because the manner in which they came to know Impressionism did not disclose to them its psychological inner springs, American Impressionism from the beginning betrayed a penchant for the realistic, the decorative, and the undisturbing (Plates 65 and 74). From 1898—the year in which the ten most important American Impressionist painters banded together for exhibition purposes—until roughly the First World War, this style dominated American painting with remarkable tenacity.

The kind of tamed modernism so palpable in American Impressionism may also be seen in the few attempts to transport the Art Nouveau style across the Atlantic. Louis Comfort Tiffany, whose experiments in glass have earned him a place as one of the few truly progressive American designers, was the major figure in this movement, which, for still unknown reasons, did not have much impact on American decorative arts as a whole (Plate 73).

For a country that, by 1890, was clearly on the way to becoming the world's leading economic and military power, the United States was remarkably attached to what, in retrospect, were its rather immature cultural preferences. The frontier, with its cowboys, Indians, and gunslingers, became once more the testing ground of American manhood, its virtues advertised by the likes of Theodore Roosevelt and Buffalo Bill Cody, the most widely known Americans of the time. The Spanish–American War, virtually precipitated by the vociferous demands of an expansionist national press, made clear to all that the sleeping giant of the Western Hemisphere had healed his wounds and was on the move again. As it had done in the 1840s, when it annexed Texas

and conquered Mexico's northern provinces, the nation became absorbed in its own grand romance.

As the nation prepared to enter the twentieth century, the idealized baggage of the early nineteenth century still shaped its basic cultural and political attitudes. Despite the best efforts of its true geniuses, America still desperately wanted to recapture the lost values of the pre-Civil War era and used its wealth and power to that end. Why come to terms with the anxieties of European modernism when so many viewed them as only further evidence that the Old World was in irreversible decline? Why, indeed? America was still a great Romantic country on a great Romantic quest. Those who were able to look into the future, however, realized that in the end these attitudes would have to change.

One important episode of remarkably far-sighted vision occurred in Chicago in the 1880s. At first due to commercial pressures, but then as a result of a proto-modernist aesthetic rationale promulgated by Louis Sullivan, Chicago tall-building architecture assumed a boldly innovative character. Sullivan insisted that the modern steel-frame building echo in its exterior design the dynamics of the internal structures that shaped it. The sleek curtain wall and the slablike configuration of the modern office tower were thus anticipated, even though Sullivan remained committed to ornament, of which he was one of the great masters (Plate 84), and even though, in a number of instances, he deviated from his own doctrine for the sake of external effect. No sooner had Sullivan scored triumphs in Chicago, St. Louis, and Buffalo, however, than his approach was cast aside by the architectural profession in favor of Beaux-Arts Classicism.

Of the major American architects, only a very few, of whom Sullivan's pupil Frank Lloyd Wright was the most talented, attempted to carry on in the spirit he advocated. Since tall-building architecture had also fallen prey to the requirements of facade ornamentation and revivalistic style demanded by the Beaux-Arts tradition, Wright found that only domestic architecture gave him the opportunity to develop his approach. In this realm his achievement was enormous. His so-called Prairie style houses, designed to hug the flat landscape of the Midwest, attracted the attention of European avant-garde architects and propelled American architecture into the twentieth century. A room from one of the houses, now installed in the American Wing of The Metropolitan Museum, illustrates the continuous flow of space, the opening up of the inside to the outside, and the insistence on total design—down to the furniture, wall fixtures, and leaded-glass windows—so characteristic of Wright (Plate 82).

Wright's perception that art had to become responsive to modern needs was also shared by the painters who eventually became known as the Ash Can School, although, in the end, their solutions would not prove to be as radically original as his. In spite of the fact that many of the Ash Can School painters had received their formal training under American Impressionist teachers, they felt that Impressionism as practiced here took little account of the real life of the country. Accordingly, these artists turned their attention to the world around them and discovered in the life of the common people, especially in that of the ordinary urban dweller, an immensely appealing vitality. Because they were not afraid to deal with low-life subjects, and frequently did,

they were given the name "Ash Can School" by an unfriendly critic, and the term has been used ever since. In order to capture the energy and vitality of their subject matter, the Ash Can School artists adopted a painting technique based on quick painterly execution. Unfortunately, after all was said and done, this technique began to so resemble Old Master painting that, in purely formal terms, the Ash Can School turned out to be less progressive than American Impressionism.

Avant-garde modernism in American painting did not appear until a handful of artists—most of them associated with the photographer Alfred Stieglitz and his gallery "291"—began to emulate advanced Parisian art of the early 1900s. Most of these artists had been in France between 1904 and 1912 and had responded enthusiastically to the challenge of new painting styles, such as Fauvism, Cubism, Futurism, Orphism, and Nonobjectivism, which were then on the cutting edge of European art. In America, they encountered a good deal of resistance, but the protective and patriarchal Stieglitz enabled them to continue working and exhibiting. Interestingly, the best known of the "291" artists, Georgia O'Keeffe (Plate 98), Charles Demuth (Plate 95), Marsden Hartley (Plate 89), and John Marin (Plate 86), despite an early and precocious interest in abstraction, never gave up representational painting altogether. In their mature years, they all turned to recognizable content, although their work naturally showed the considerable influence of abstraction. Of the "291" group, only Arthur Dove (Plate 91) continued to exploit the formal language of truly abstract painting.

In 1913, an event of momentous importance shook the American art world to its foundations. The Armory Show, so called because it was held at the large National Guard 69th Regiment Armory at Twenty-sixth Street and Lexington Avenue in New York City, assembled for the first time in America an exhaustive survey of European modernism. Works by Futurists, Dadaists, and Cubists outraged the American critics, who singled out Marcel Duchamp's *Nude Descending a Staircase*—called by one of them "an explosion in a shingle factory"—for special scorn. American artists of every artistic persuasion also participated in the show, but after the controversy died down, it became clear that they had been overwhelmed. It would be convenient history to state that the Armory Show had only the salutary effect of pushing American art rather rudely into the twentieth century, but the reality is far more complex. The exhibition certainly served to recruit some admirers of avant-gardism, even as it confirmed traditionalists in their loathing of it. But perhaps far more important was the enormous indecision it brought about in the minds of so many progressive Americans who, like Theodore Roosevelt—one of the show's most influential reviewers—could not figure out how modern they wanted to be. Ambivalence toward the modern thus became a general characteristic of American art of the post-World War I period.

The issue of whither American art, already made more pressing by the Armory Show, was further complicated by the arrival here, due to the outbreak of World War I in Europe, of many of the leading figures of European

modernism, among them Duchamp, Man Ray, and Francis Picabia. Their art struck many as decadent, just as the war proved to many that Europe was finished, politically, economically, and culturally. In the 1920s, therefore, a strong American reaction to modernism began to assert itself. After 1929, when the stock market crash inaugurated the Great Depression, this reaction, dominated by realism, gained ascendancy in American painting.

American realism went in many directions in the 1920s and 30s, but a common thread in the work of its chief exponents was a concern with what seemed to them to be truly and typically American. Edward Hopper's scenes of big-city life and big-city sights (Plate 93); Charles Burchfield's small-town and countryside views (Plate 99); Charles Sheeler's precisely detailed close-ups of machinery, the result of his work as a photographer (Plate 101), all have this interest in common. In the work of Thomas Hart Benton and Grant Wood, however, an important transformation took place (Plates 100 and 96). Their paintings, rife with references to great styles of the past and frequently concerned with themes relating to America's heartland, made a deliberate attempt to romanticize and heroicize the country. They presented the work-filled, but relatively dull and isolated life of hinterland Americans as the present-day moral equivalent of biblical scenes painted in sixteenth-century Italy and seventeenth-century France. Little wonder that their paintings enjoyed enormous popularity at a time when most Americans wished to be reassured about the enduring greatness of their society.

Although in the 1930s and early 40s it appeared that American native realism would continue to dominate painting indefinitely, events did not turn out that way. Interest in modernism had not died out at all, it had only, so to speak, gone underground. Since 1929, when Stuart Davis (Plate 92) returned from Paris and began a series of paintings on the eggbeater theme, interest in abstraction had been building up among artists who saw only banality and sentimentalism in the work of realists. In 1936, a number of them formed an organization called the American Abstract Artists, which, in retrospect, can be seen as having laid the groundwork for the emergence of Abstract Expressionism in the 1940s. Also of major importance in the history of abstraction in this country was the arrival, beginning in the mid-1930s, of yet another wave of European masters, seeking to escape the consequences of yet another international upheaval.

A number of abstract styles coexisted in this artistic penumbra, variously influenced by Cubism, Biomorphism, Constructivism, Neoplasticism, and so forth. But it was the attempt to merge the Surrealist interest in the unconscious with the spatial and pictorial concerns of Synthetic Cubism —probably first achieved by Arshile Gorky (Plate 103)— that was to prove particularly fruitful. In Gorky's paintings, the biologically derived forms cherished by Jean Arp and Joan Miró take on a psychological as well as visual resonance not unlike that achieved by Alexander Calder in his sculptural mobiles (Plate 111). The world of the unconscious, of totemic symbols, mythology, automatism—all part of the effort to excavate abiding human truths buried deep in the psyche—thus became the world of the advanced American abstract artist of the 1940s. Jackson Pollock's drip technique (Plate 104) turned the act of painting into a shamanistic performance in which the artist and his work become one. It thereby achieved a correspondence of ends and means that has earned him the place of honor in the pantheon of artists who soon became known as the Abstract Expressionists. Other equally bold achievements, however, were registered by Willem de Kooning (Plate 109) and Franz Kline in the development of a pictorial language based on gesture, and Clyfford Still (Plate 106), Barnett Newman (Plate 107), and Mark Rothko (Plate 105) in the use of color to capture a sublime grandeur. Both of these approaches are in a sense incorporated in the sculpture of David Smith, probably the most significant American sculptor of the present century, who sought to capture sublimity through the balanced juxtaposition of large steel shapes of strong geometric definition, but who also activated their surfaces through the almost painterly use of a burnishing wire brush (Plate 115).

Abstract Expressionism energized the entire American art world. Those who followed in its wake felt the enormous responsibility of living up to its greatness, even as they were keenly aware that mere imitation would not do the trick. Two important traditions to emerge from it in the late 1950s were those of Minimalism and Pop Art. Building on the color-field paintings of Mark Rothko and Barnett Newman, the Minimalists brought greater purity of form—in a way, translating into paint the formal reductionism that had already begun to affect architecture greatly through the buildings of Mies van der Rohe. The Pop artists, on the other hand, reintroduced subject matter into painting, but as a vehicle of irony and, at first, with an abstract purpose frequently in mind. In a short time, however, their works turned into an irreverent critique of mass-consumption, postwar America. It was in works of this type that legible iconography came back into avant-garde art, although it must be admitted that realism, or at least recognizable content, had never ceased to exist.

Pushed by the example of painting, in which the great ideas of American art during this century have most self-consciously been expounded, but pushed also by the needs of an increasingly individual-centered and pluralist culture, American art, whether in painting, sculpture, architecture, or the decorative arts, is now a lively mosaic of different styles, attitudes, and techniques, none of which holds either the copyright to excellence or the key to center stage. The end of the twentieth century has ushered in a plethora of art in such variety that the end of the nineteenth century naturally comes to mind. To deny that there is much confusion today in American art and design circles, just as there was in the nineteenth century, would be to deny the obvious truth. Yet distinctions are also obvious. At the end of the nineteenth century, America found itself with a great deal of wealth, but it did not know what it wanted to be, and it had to contend with the ever-present example of Europe. This is no longer the case: America today has no cultural inferiority complex and has a very good notion of the kind of society it wants to be. The variety of our present-day art is not any more incomprehensible than the variety of the nation as a whole. It is a variety that most Americans have little difficulty understanding, and that most Americans actively relish.

Oswaldo Rodriguez Roque

WENTWORTH ROOM

This second-floor room from the Samuel Wentworth House in Portsmouth, New Hampshire, is one of the largest domestic interiors surviving from the early Colonial Period. It was first built in 1671 and was remodeled in 1710. Unlike other early Colonial architecture, which was made of oak following a simple and regular plan, the Wentworth House was constructed entirely of white pine, using an asymmetrical plan. Its decoration, too, sets it apart. Unusually refined, it suggests the urban society developing in eighteenth-century America and the new standards of style and taste that accompanied its prosperity.

The design of the room follows the English palace style—high and spacious with deliberate architectural features—but it has been tempered by domestic needs. Broad panels of wainscot cover the south wall, and the fireplace and mantel are treated with an elaborately carved molding. The bricks of the hearth are laid in a decorative herringbone pattern, and unlike the wrought-iron fixtures common in most houses of the period, those in the Wentworth Room are made of brass. All of the woodwork has been repainted with its original Indian red color.

No inventory survives to describe the furniture originally used by the Wentworths, but the pieces included here—the japanned highboy, the daybed, and the easy chair—are in the William and Mary style (1640-1720) and are appropriate to a second-story chamber of this period.

Furniture of the William and Mary style—which takes much of its inspiration from the European Baroque—was just beginning to come into fashion when the Wentworth House was built. The traditional oak of Colonial furniture was replaced by walnut, maple, and similar hardwoods that were handsomely grained and easier to carve, and new furniture types such as the daybed and the highboy bespoke a greater concern with comfort and leisure. The resulting furniture was of a lighter form than the rough-hewn Pilgrim types and, characteristically, included elaborately carved crests and ambitious new decorative techniques such as caning and veneering. Examples of caning can be seen on the seats of chairs and on the daybed, and the surface of the highboy is covered with a lovely flame-patterned veneer.

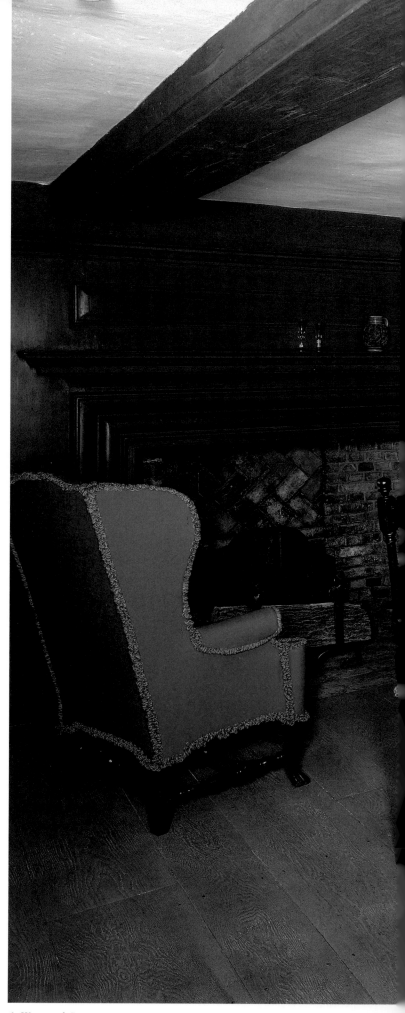

1 Wentworth Room
Portsmouth, New Hampshire, 1695–1700
Original owner: John Wentworth
Rogers Fund, 1926 (26.290)

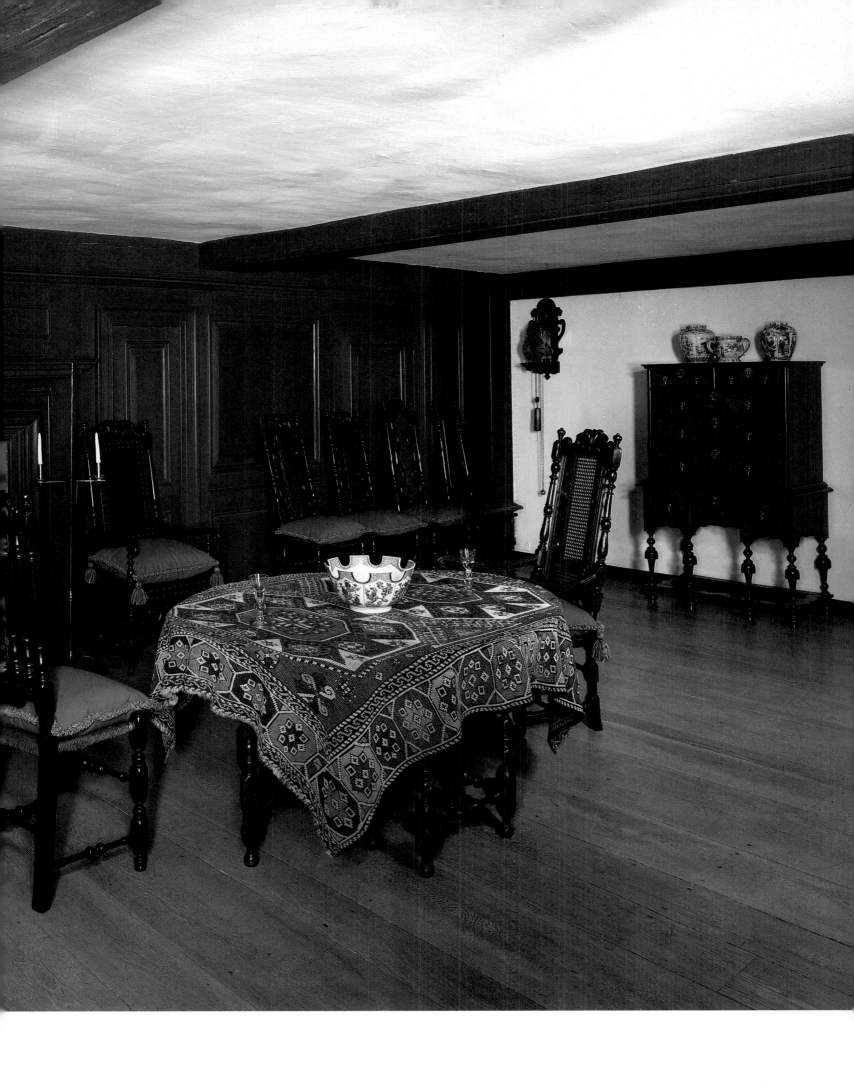

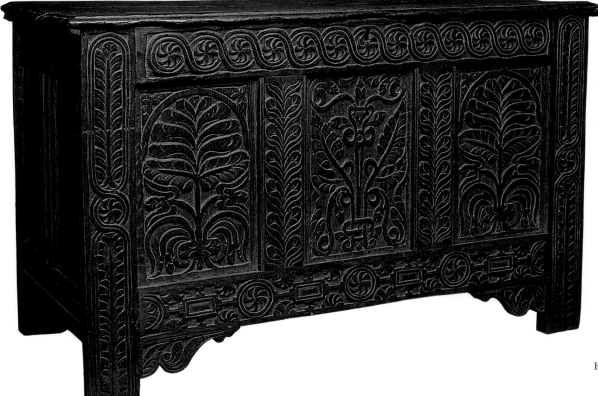

BLANKET CHEST

The simple blanket chest was found in most seventeenth-century homes. Eminently practical, the chest served as a place of storage, a seat, and a piece of luggage. This example is solidly made of red and white oak panels joined at right angles using the mortise-and-tenon technique.

Most chests of the early Colonial Period were plain, but this example is elaborately carved with a combination of Italian Mannerist motifs that were popular in Tudor and Jacobean England. The front of the chest is ornamented with three panels carved in graduated relief. The outer panel represents a stylized version of the Near Eastern tree of life, and the central panel shows a tulip emerging from an urn. The panels are framed by decorative borders of guilloche on the top, whorls and facets at the base, and a palmate pattern on the stiles. The carved embellishments have been modified for the coarse grain of American oak.

This sort of decoration is unusual on American furniture of this period, which makes it possible to trace the chest to the region of Ipswich, Massachusetts. It is thought to be the work of the craftsman Thomas Dennis (1638–1706) who was born in Devonshire, England, an area with a tradition of florid carving that includes motifs such as those depicted on this chest. He emigrated to Boston along with his friend and fellow craftsman, William Searle (d. 1706), where he set up business as a joiner, carpenter, and carver.

TURNED GREAT CHAIR

The so-called Brewster chair is one of a small number of seventeenth-century turned chairs made in Plymouth or Suffolk county of the Massachusetts Bay Colony. It is known as a Brewster chair because a chair of this type is thought to have belonged to the elder William Brewster of Plymouth Colony.

The turned great chair was the handiwork of the lathe craftsman or "turner." The seventeenth-century turner was called on to make chair legs, arms, stretchers, and stair railings. This particular example is considered among the rarest and grandest of early turned chairs because it has tiers of spindles both above and below the seat. The many tiers were produced by placing square lengths of wood on a spinning lathe and, with a variety of chisels, manipulating their surface contour into ring, ball, and urn shapes. Carefully measured, the spindles were then joined to form a sturdy armchair.

The design for this sort of chair can be traced back as far as the eleventh century, when it served as a throne in several depictions of the Virgin Mary. In the Middle Ages, chairs were a symbol of authority for the head of a household, and inventories from the early Colonial Period suggest that their prestige endured. Most well-to-do households of Colonial America record one great chair among their other important possessions.

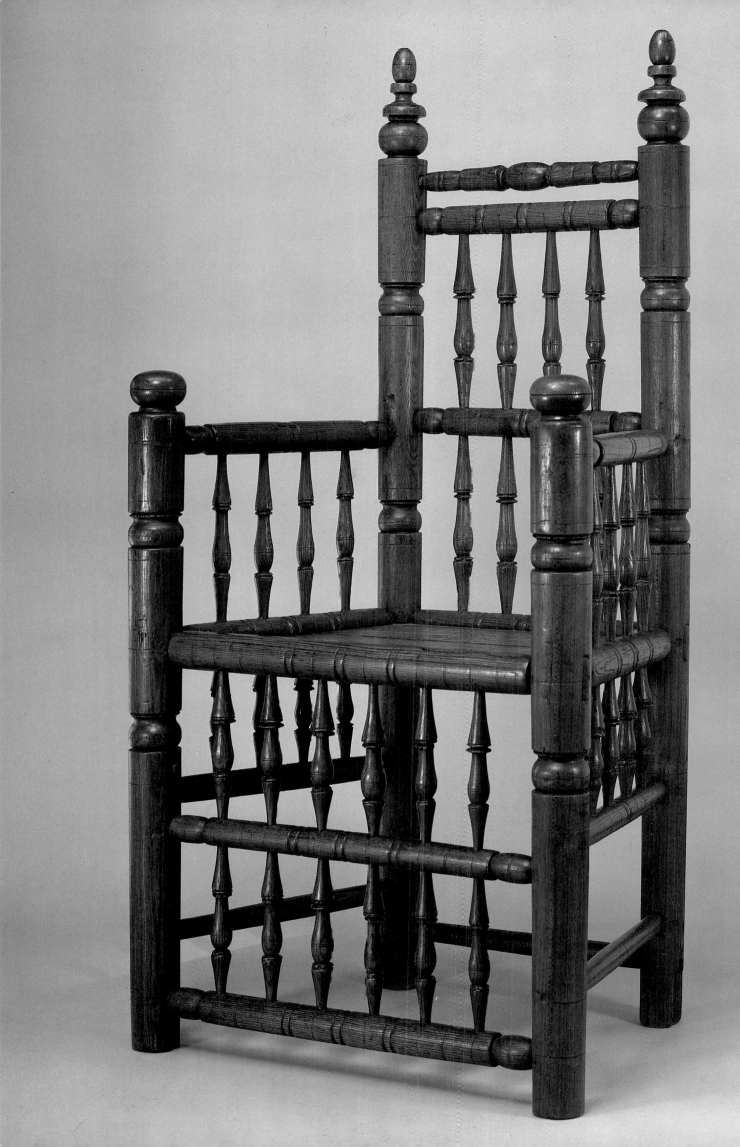

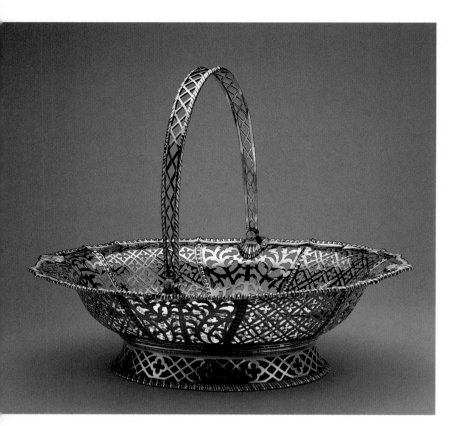

SILVER CAKE BASKET

The pierced and patterned surfaces of this silver cake basket are characteristic of the Rococo style, which became popular in America during the middle of the eighteenth century. The term "Rococo" derives from the French word *rocaille*, meaning "rockwork," and naturalistic decoration is the keynote of the style. The Rococo spirit of this basket is captured in the undulating rhythm of its outlines, the alternating fretwork and acanthus of its pierced panels, the fanciful shells that anchor the handles to the basket and decorate its rim, and the alternating quatrefoils and arabesques that pattern or diaper the base. Made in 1765 by Myer Myers of New York, this silver cake basket is one of the few Colonial examples of the form.

4 Cake Basket
New York, 1760–70
Myer Myers, 1723–95
Silver; L. 14½ in. (36.8 cm.)
Morris K. Jesup Fund, 1954
(54.167)

TWO-HANDLED BOWL

In the Colonial American community, the silversmith served as a banker of sorts. Prosperous merchants with accumulated wealth took their coin to the silversmith who would convert it to plate for safekeeping.

This six-lobed bowl—one of a group of about eighteen lobed bowls of New York manufacture—was made by Cornelius Kierstede, one of the most original of early American craftsmen. Kierstede's Dutch descent is reflected in the design of the two-handled horizontal bowl and in the Italian Mannerist influence of its decoration. The bowl was fashioned from a single ingot or lump of silver, which was skillfully raised, or hammered up, into this distinctly lobed shape. The six panels are decorated in repoussé—a technique of hammering silver into low relief—with the popular Mannerist motif of acanthus leaves. The base is accented by another strip of silver, stamped with a geometric design.

5 Two-Handled Bowl
New York, 1700–10
Cornelius Kierstede, 1675–1757
Silver; H. 5⅜ in. (13.7 cm.),
Diam. 10 in. (25.4 cm.)
Samuel D. Lee Fund, 1938 (38.63)

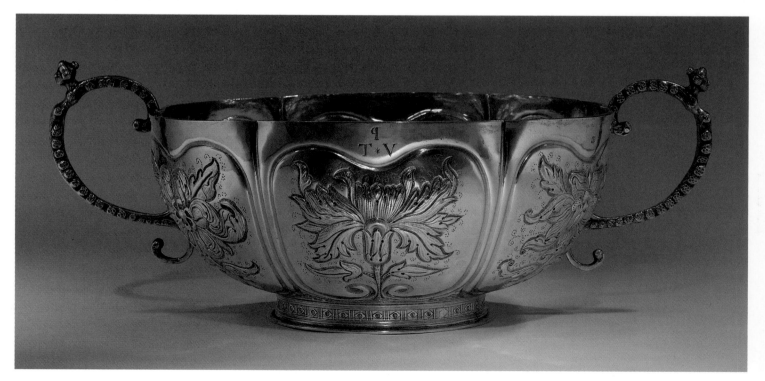

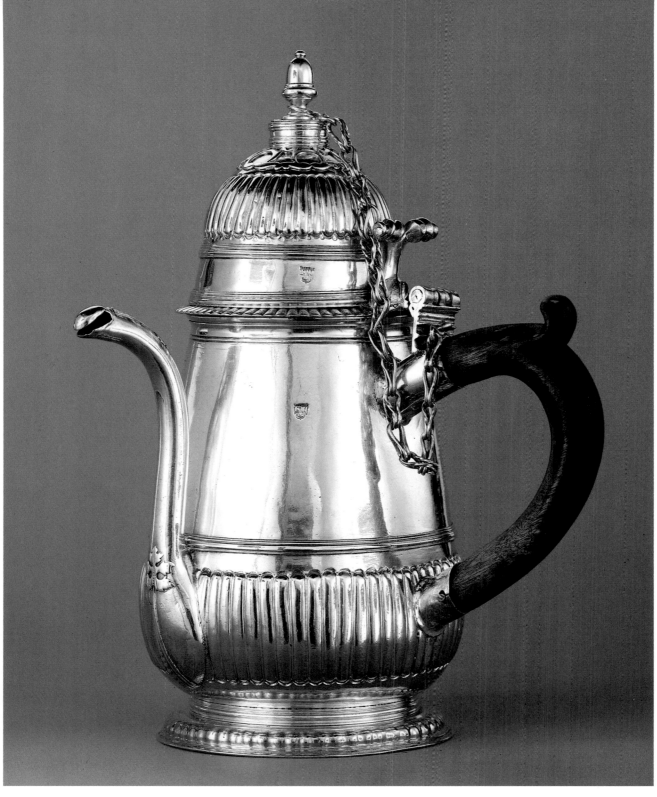

6 *Chocolate Pot*
Boston, Massachusetts, ca. 1700–10
Edward Winslow, 1669–1753
Silver; H. 9⅛ in. (23.2 cm.)
Bequest of Alphonso T. Clearwater,
1933 (33.120.221)

CHOCOLATE POT

Drinking chocolate became fashionable in England during the late seventeenth century and was soon adopted in the prosperous Colonies along with the tall, lantern-shaped pot that had evolved to serve it. This example, made in Boston by Edward Winslow, is a rare survivor from the Colonial Period. The distinctive form is decorated in the Baroque style; it combines a number of motifs in rhythmic patterns of projection and recession, contrasting light with shadow and plain with heavily ornamented surfaces. Two bands of gadrooning—parallel lozenges of relief—decorate the dome and base of the pot and are echoed by the petals of the projecting hinge. Cut-card work, in which a flat design is cut out of a separate sheet of silver and then applied, is another Baroque technique used at the base of the spout and the finial of the domed lid. The cast acorn finial is removable, secured to the handle by means of a chain, so that the chocolate can be stirred with a silver rod without affecting its temperature.

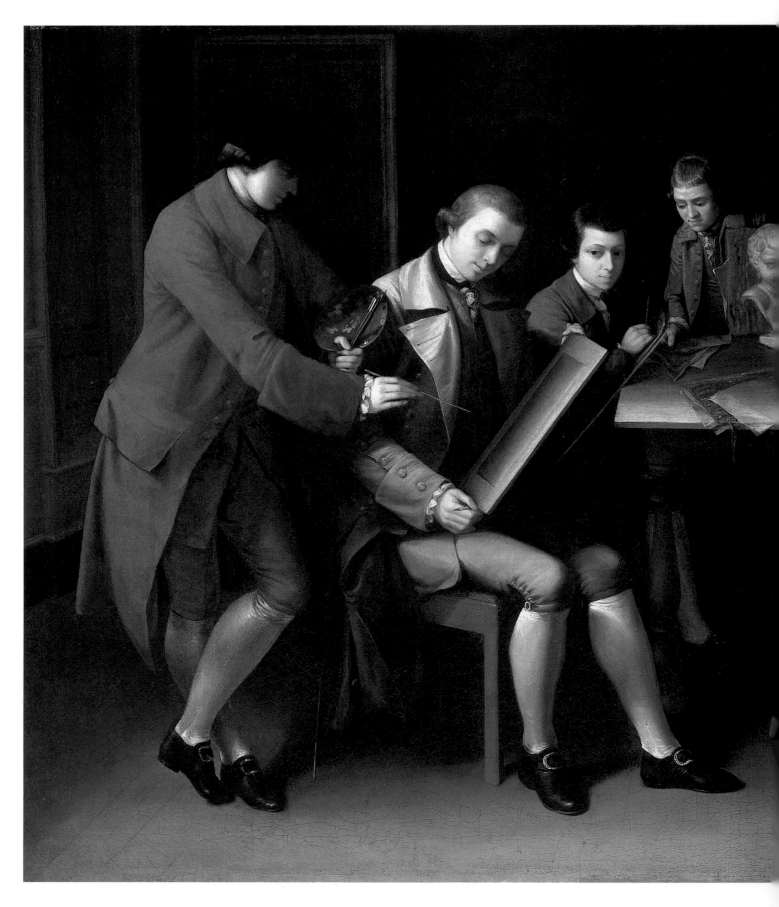

MATTHEW PRATT
The American School

Matthew Pratt began his professional life as a sign painter, but subsequently turned to portraits and worked for several years in Philadelphia and possibly New York before traveling, in 1764, to England to broaden his artistic horizons. For the next two and a half years he studied at the London school run by fellow American Benjamin West.

West (1738–1820), a self-taught Pennsylvanian artist, had traveled to Europe in 1759 to study in Italy. He was received so enthusiastically during a visit to London that he decided to stay there permanently. Under the patronage of George III, West flourished as a portrait painter, and in 1792 he succeeded Sir Joshua Reynolds as president of the Royal Academy. On his death, he was buried in St. Paul's Cathedral.

West's school, which opened in 1763, played an important part in the artistic training of three generations of American painters, including John Singleton Copley, Charles Wilson Peale, Gilbert Stuart, and John Trumbull. Thanks partly to West's London school, a national flavor developed in the American art of the period even while the young artists acquired the necessary European polish.

Pratt, who returned to America after four years in England, continued his career as an art teacher and as a steadily successful, if not first-rank, portrait painter. He appears to have had few illusions about his own greatness, for there is an endearing reference to his self-deprecation in a letter from Copley to his half-brother, in which the artist quotes Pratt as heaping praise on a portrait by Copley, whom he greatly admired, adding that he, himself, could not paint.

The American School is significant both for its documentary content and for its style—a rare attempt by an American at the informal group portrait, or "conversation piece," that was a staple of eighteenth-century English painting. The work is hard in finish, painstakingly drawn, and somewhat awkwardly composed. The stiffness of the figures suggests the possible use of jointed wooden models. But it was successful enough to be shown at the 1766 exhibition of the Society of Artists of Great Britain, and it helped to win Pratt's election to the prestigious society the following year.

7 *The American School* 1765
Matthew Pratt, 1734–1805
Oil on canvas; 36 x 50¼ in.
(91.4 x 127.6 cm.) Gift of
Samuel P. Avery, 1897 (97.29.3)

CORNER CHAIR

The preoccupation with fluid form during the Queen Anne period is easily seen in this corner or "roundabout" chair. Made in Philadelphia around 1740, it is among the most graceful achievements of Colonial craftsmanship. All four of the legs are carved in the delicate cabriole shape; the S-curve extends through the seat to inverted cabriole stiles, and the form is echoed by the vase-shaped splats and the undulating line of the seat itself. Unlike chairs from the William and Mary Period, which were rigidly upright and crowned by an ornamental crest, the Queen Anne chair is all balance and motion. The crest is replaced by a yoke or hoop back and the design assumes the curving contours of human posture. The English painter and engraver William Hogarth (1697–1764) described the style in his *Analysis of Beauty* as one that aimed to "lead the eye in a kind of chace."

The corner chair was often made with a deep skirt to conceal a commode. When the skirt is shallow, as in this example, the chair was used at a desk or dressing table.

8 Corner or Roundabout Chair
Philadelphia, Pennsylvania, 1740–60
Walnut; 30¾ x 27½ x 24½ in.
(78.2 x 69.9 x 62.2 cm.)
Rogers Fund, 1925 (25.115.15)

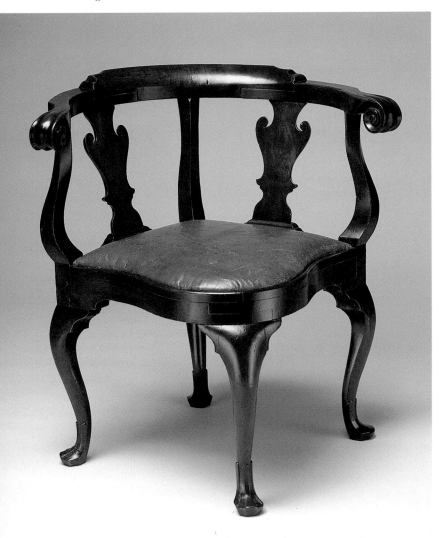

JAPANNED HIGH CHEST

The monumental size and intricate decoration of this japanned high chest reveal changes that were taking place in eighteenth-century America. During this period the Colonies were undergoing an unprecedented expansion of trade, population, and industry. The new prosperity created an increased interest in luxury items, and wealthy merchants attempted to style their lives on those of the English gentry.

The high chest, or highboy, was borrowed from England during the William and Mary Period (1640–1720), but it had a long life in the repertoire of American cabinetmakers. The form achieved a grace and elegance during the Queen Anne (1720–55) and Chippendale (1755–90) periods that surpassed its British models.

This example originally belonged to the Pickman family of Salem, Massachusetts. Standing over seven feet tall, its graceful, architectonic structure is typical of the Queen Anne style. The flat tops of William and Mary high chests (Plate 1) have here become classical pediments punctuated by decorative urns and shells, and lathe-turned supports are replaced by the revolutionary cabriole leg.

The high chest is lavishly ornamented with a Chinese landscape applied in gesso, painted, and then gilded. The imitation tortoiseshell that forms the background for the images was created by streaking vermilion with lamp black. Inspired by Oriental lacquer, the technique is called japanning.

The Queen Anne style first appeared in America in Boston, Massachusetts, around 1730 and is characterized by a delicacy of form exemplified by the cabriole leg. The curving animal form is carved from a solid board, but to achieve a graceful line, two additional pieces have been carved and affixed at the top. No longer dependent on the lathe, this leg was a structural luxury conceived with no thought for economy of time or money. With the Queen Anne style, emphasis shifted from a concentration on carving and applied ornament to an obsession with the elegance of fluid form.

9 Japanned High Chest
Boston, Massachusetts, 1730–60
Maple and birch, japanned;
85¼ x 40½ x 22 in.
(217.3 x 102.9 x 56.9 cm.)
Purchase, Joseph Pulitzer
Bequest, 1940 (40.37.1)

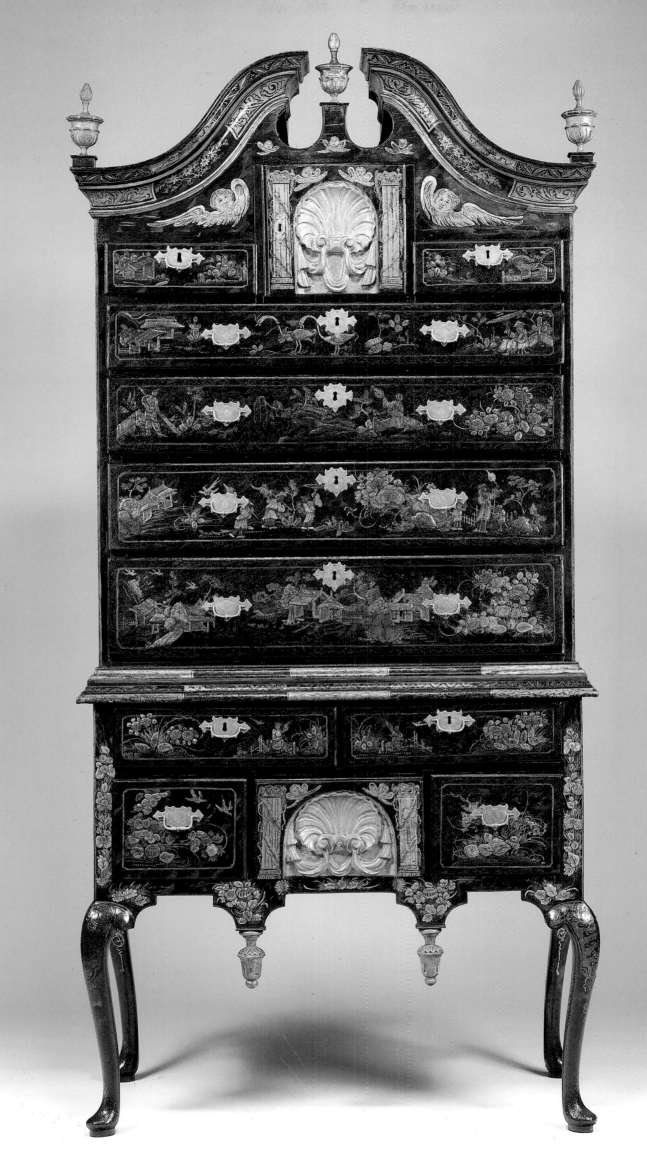

EASY CHAIR

The design for the easy chair developed during the William and Mary Period (1640–1720) and has changed less over the centuries than any other furniture type. Fully upholstered easy chairs did not exist before the eighteenth century, and their introduction bespeaks a growing prosperity and concern for comfort.

This is the most extraordinary easy chair to survive from the Queen Anne Period (1720–55). It was made in Rhode Island, and it includes features characteristic of New England: vertically tapered cones that form the scroll of the armrest and provide flat surfaces to support the sitter's arms, plain cabriole legs ending in pad feet, and the lathe-turned stretchers that join these supports.

In addition to its fine proportions, the chair is rare and remarkable because all of its upholstery is original. The front and sides are worked with a brightly colored diamond or flame stitch that was extremely popular in the eighteenth century, and as was also common, the back was reserved for another sort of fabric or decoration. In this case it is covered with a crewelwork scene. A masterpiece in its own right, this bucolic landscape shows a shepherd with his flock, as well as deer, birds, trees, and flowers, set among stylized hills. The colors of the flame stitch reappear in the landscape and serve to unify the otherwise disparate parts.

When the upholstery was removed from the chair, a signature was discovered on the crest rail: "Gardner Junr. Newport. May. 1758." The signature may be that of a Newport upholsterer, Caleb Gardner.

The easy chair is now known as the wing chair because of the projecting sides that served as headrests or gave protection against drafts or the heat of an open fire. Associated with the old or infirm, they were commonly found in bed chambers but were not unusual in the parlor or dining room. Like the corner chair (Plate 8) the easy chair could be fitted with a commode and in contemporary portraits can frequently be seen supporting aged sitters.

10 Easy Chair
New England, 1758
Walnut, maple; 46¾ x 31½ in.
(118.6 x 80 cm.) Gift of
Mrs. J. Insley Blair, 1950
(50.228.3)

Opposite: back of chair detailed

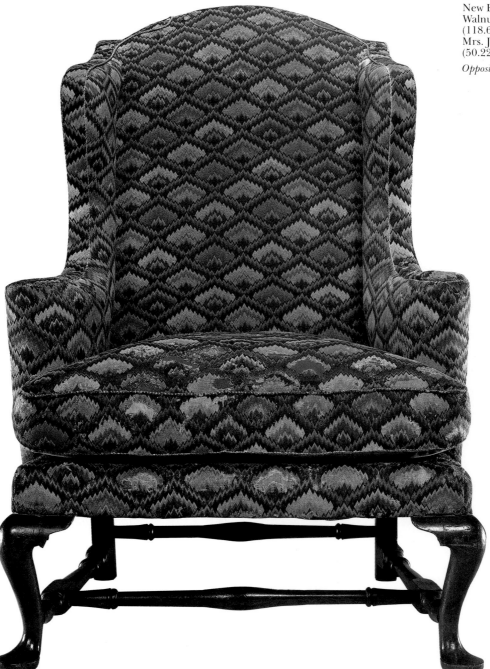

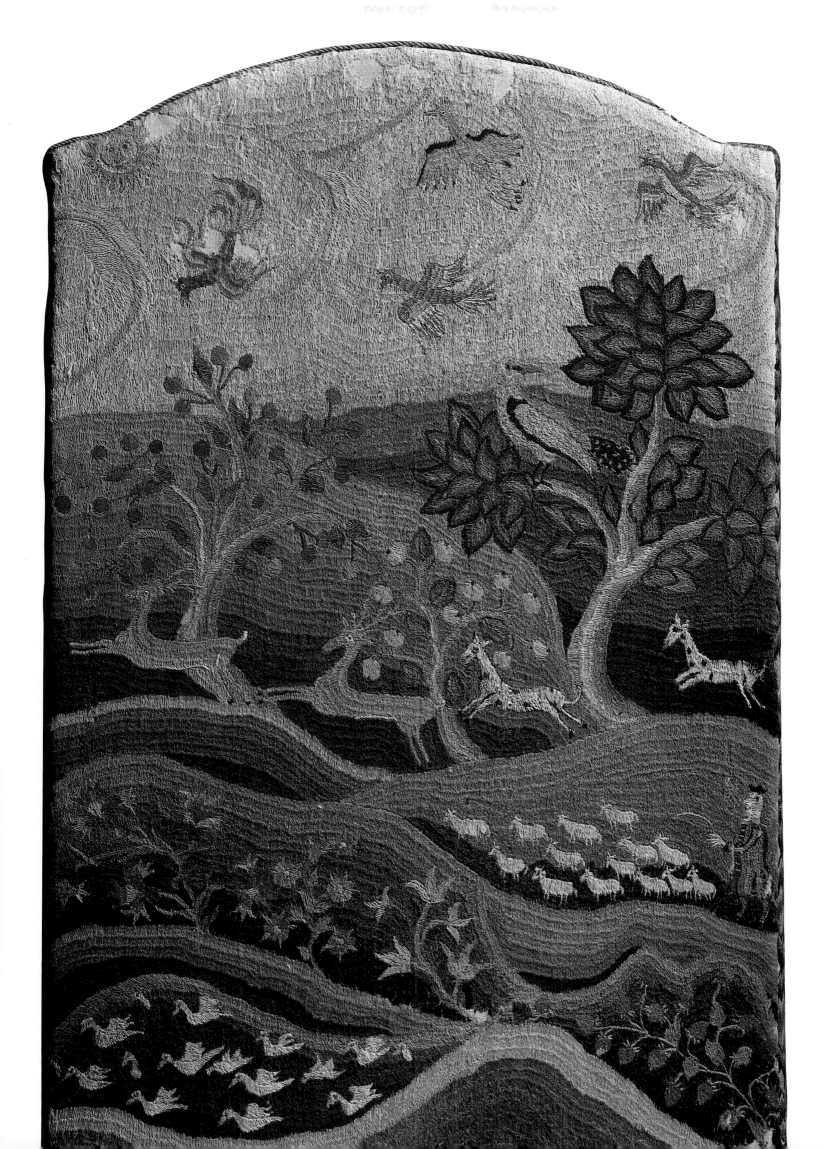

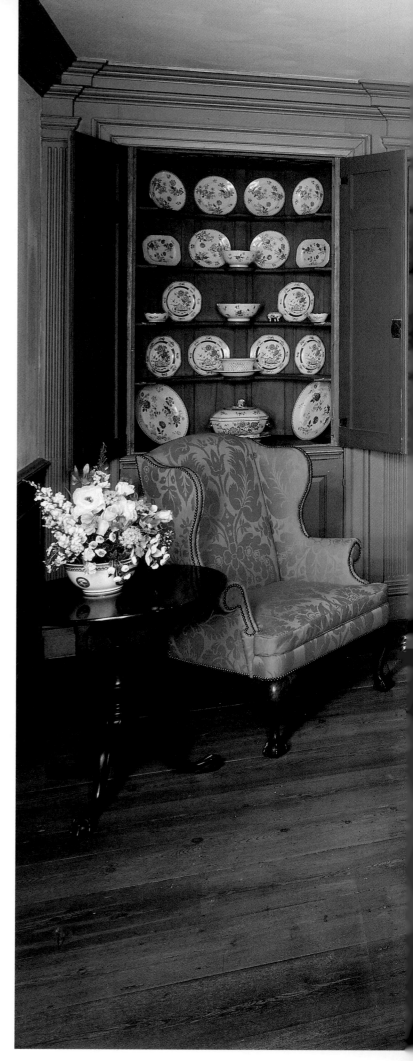

11 *Verplanck Room*
Orange County, New York, ca. 1767
Purchase, The Sylmaris Collection,
Gift of George Coe Graves,
by exchange, 1940 (40.128)

VERPLANCK ROOM

Architecture and furniture design flourished in the latter half of the eighteenth century and, despite growing resistance to British taxation and control, continued to absorb English style and innovation. Colonial cabinetmakers borrowed from England to create an American version of the Chippendale style, while architects appropriated the building traditions of the Georgian Period. The Verplanck Room displays these two styles .and demonstrates the relative affluence and luxury Colonial gentry had achieved by mid-century.

The architectural style of the room is an embodiment of English Georgian; all of its features are proportioned and balanced. The paneled fireplace wall is symmetrically divided, with a cupboard on each side of the hearth; the left one was used to store china, and the right one to store clothes. Wainscoting of the same woodwork continues along the lower portion of the other three walls.

Originally, this room was the front parlor of a Palladian-style house built by Cadwallader Colden, Jr., in Orange County, New York. Colden was the son of a celebrated naturalist and the lieutenant governor of Colonial New York. It is known as the Verplanck Room because the furnishings came from the Verplanck residence at 3 Wall Street in New York, which no longer exists. They are arranged here in the manner of an eighteenth-century parlor.

Among the furnishings is the only known set of American Chippendale parlor furniture, which includes the card table, the settee, and the set of six matching chairs. They all share a smoothly shaped cabriole leg that ends in a boxlike claw-and-ball foot and can be dated, on the basis of style, to the 1760s. The upholstered pieces in the set are covered with a pumpkin-yellow wool damask that is a reproduction of the original fabric. A japanned secretary desk of the William and Mary Period and a Rococo gilt mirror were imported from England and serve as a reminder of the quantities of English furniture that decorated Colonial interiors. The cupboard to the left of the fireplace is filled with the imported Chinese porcelain that was so prized in the Colonies. Since America had no direct contact with the Orient during this period, the porcelain was obtained from England and the Continent.

Two portraits by John Singleton Copley hang on one wall. They show Samuel Verplanck and his younger brother, Gulian; they were painted in 1771 during Copley's only visit to New York. Copley is said to have remarked of the New York gentry that they were so discerning he could "slight nothing" in taking their likenesses.

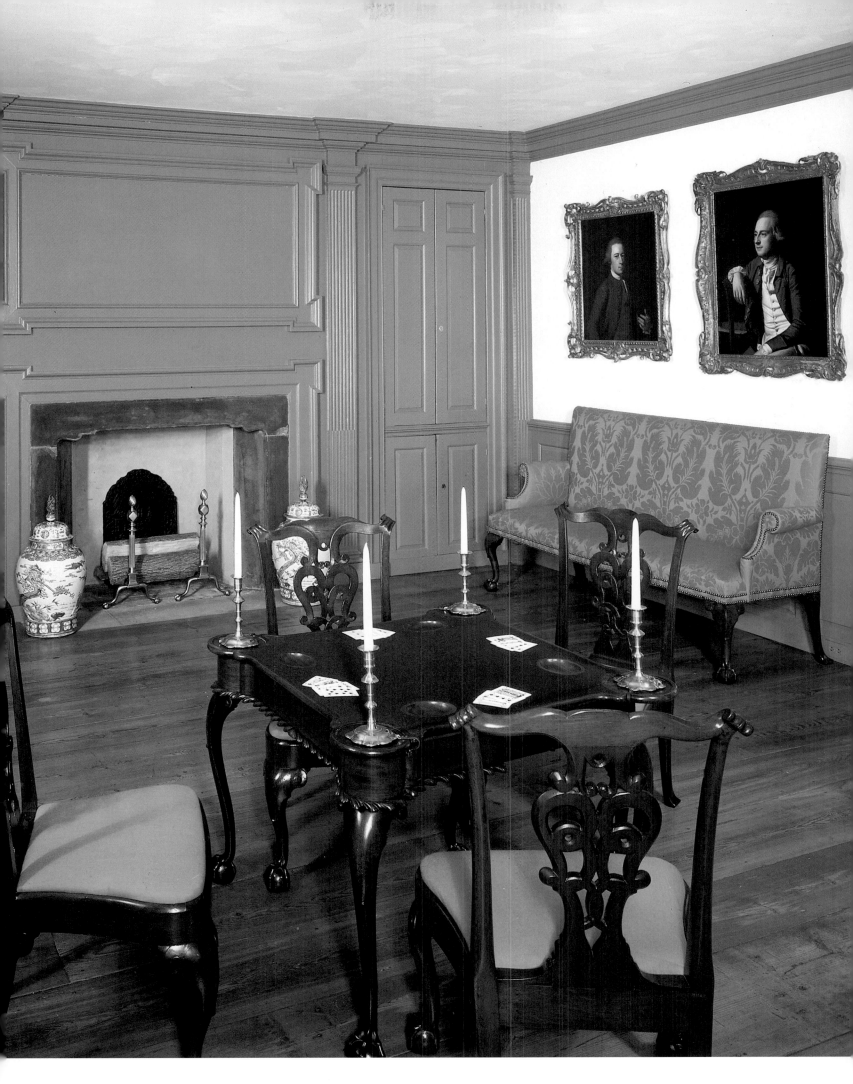

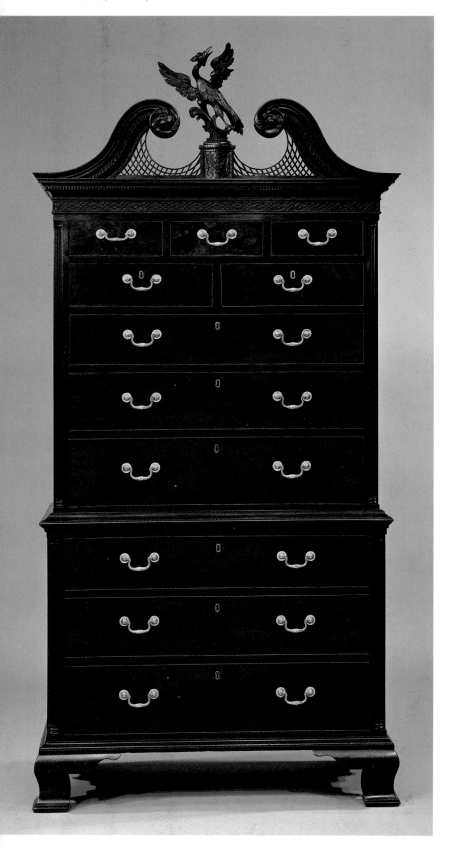

CHEST ON CHEST

The Chippendale style flourished in America from about 1755 to 1790. It was named in the nineteenth century for the English furniture designer Thomas Chippendale, who published *The Gentleman and Cabinet-Makers Director* in 1754 —the first comprehensive, illustrated catalogue of fashionable London furniture.

The style that Chippendale documented and helped to create developed in England during the first half of the eighteenth century. It sought to evoke and often combine the whimsy of French Rococo, the exotica found on oriental wallpaper and china, and the traditional arch of English Gothic. As America absorbed the Chippendale style, furniture forms remained much the same as they had been during the Queen Anne Period. The curiosities assembled in the *Director* simply provided cabinetmakers with a new vocabulary of ornament. They found their way onto furniture as cabochons of acanthus on cabriole knees, as the pierced cartouche crowning a high chest, as scrolls and Chinese fretwork on pediments, as a Rococo shell grown into the back of a chair.

During the second half of the eighteenth century, Philadelphia was the largest and richest Colonial American city. Its sophisticated society patterned its arts and entertainments on those of London, and more than any others, Philadelphia furnishings exemplify the Chippendale style, of which this chest on chest is a magnificent example.

The chest on chest is so called because, unlike the highboy —formed of a table supporting a chest—it is a literal doubling of two similar sections with small feet for supports. The style of this piece, typical of Philadelphia Chippendale, juxtaposes classical architectural form with Rococo naturalistic ornament. Fluted columns frame the traditional architectonic structure, but the scrolls of the broken pediment are now supported with Gothic fretwork and a phoenix rises from the pediment between them. The chest on chest belonged to the family of a prominent Philadelphian, William Logan, and it has been attributed to the city's most prominent craftsmen, the cabinetmaker Thomas Affleck and the carver James Reynolds.

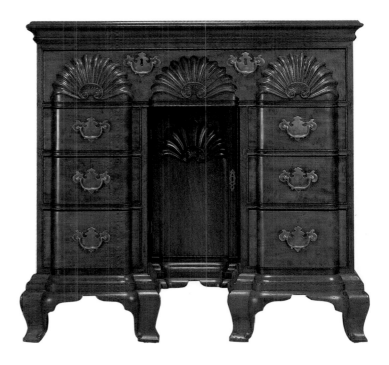

14 Kneehole Bureau Table
Newport, Rhode Island, 1760–1790
Mahogany; 34 x 36 x 20½ in.
(86.4 x 91.4 x 52 cm.)
Gift of Mrs. Russell Sage, 1909
(10.125.83)
Left: detail

CHIPPENDALE CARD TABLE

Another furniture form that reflects the growing prosperity and leisure in the Colonies is the card table, which was made in America starting in 1730. This piece, made in the American Chippendale style, is a classic example of the serpentine-fronted variety popular in New York City. The card table has a deep skirt with a boldly notched border. robust cabriole legs are carved with C-scrolls and acanthus leaves at the knees and end in the claw-and-ball foot that was introduced at the end of the Queen Anne Period (1720–55). At the end of the seventeenth century, the English adopted the claw-and-ball motif from the Chinese, who often ended furniture legs with a dragon claw clutching a pearl. In keeping with New York preferences, its treatment here is sturdy and boxlike; the rear talon of the claw is straight and the knuckles of the others jut out to form the points of a square. The finesse of this piece lies in its combination of motifs whose elegant arrangement places it among the finer examples of American furniture.

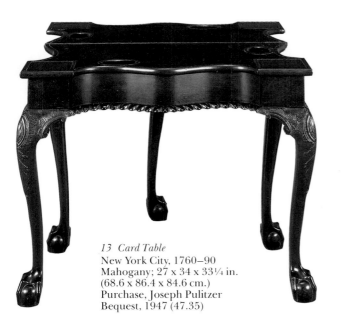

13 Card Table
New York City, 1760–90
Mahogany; 27 x 34 x 33¼ in.
(68.6 x 86.4 x 84.6 cm.)
Purchase, Joseph Pulitzer
Bequest, 1947 (47.35)

KNEEHOLE BUREAU TABLE

In the eighteenth century, Newport was one of the Colonies' busiest seaport towns. It had a large cabinetmaking business for both home and export that was dominated by two local families, the Townsends and the Goddards. Newport cabinetwork was less dependent on English design and is more finely crafted than most other American furniture. In the third quarter of the eighteenth century, Newport reached the peak of its prosperity and developed its own distinct cabinetmaking style known as "Newport Block and Shell."

This six-legged kneehole bureau table is a design that was particularly popular in Newport. In typical block-and-shell style, banks of drawers project while the central section recedes into the kneehole. The rhythm is echoed by the shell motif, which is convex on the outer sections and intaglio in the center; its repeating lobes attract the play of light. The feet continue the baroque undulation of the cabinet front, but this movement is capped and controlled by the hard edge of the rectangular cornice.

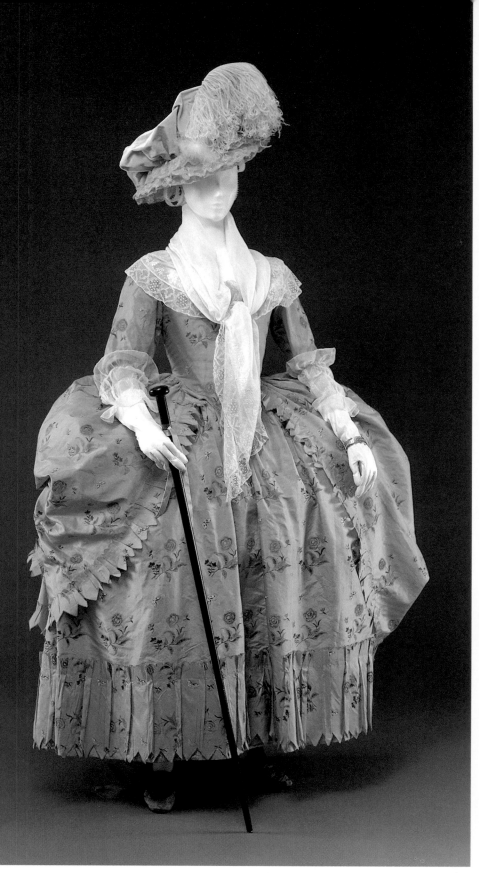

15 Walking Dress
(robe à la polonaise), ca. 1778
Hand-painted China silk
Gift of the Heirs of Emily Kearny
Rodgers Cowenhoven, 1970
(1970.87ab)

Right: detail

28

WALKING DRESS

Eighteenth-century American Colonial women of means were very interested in fashion. Although they generally followed the styles worn in England, by the time of the American Revolution the French styles of Marie Antoinette were also influencing American taste.

This *robe à la polonaise* attests to the fashion consciousness of Colonial women. It is made from a fine golden-yellow silk, hand-painted in China from Western pattern books in a design of carnations and butterflies. Merchant seamen of New England traded extensively with the Orient, bringing back silks and gauzes for sale in England and in the Colonies. The English, however, had to pay a tax on imported fabrics from which the American Colonists were exempt, thus making the same elegant materials less expensive on this side of the ocean. Abigail Adams confirms this in a letter she wrote from London to a friend in Boston: "As to India handkerchiefs, I give two guineas a-piece for them so they, as well as all other Indian goods are lower with you."

Family history relates that this dress was worn by Mrs. Jonathan Belcher, whose husband was the governor of Massachusetts and New Hampshire from 1730 to 1741 and governor of New Jersey from 1746 until his death in 1757. The *robe à la polonaise*, however, did not come into style during the lifetime of the first Mrs. Belcher, and if the second Mrs. Belcher, Mary Louisa Emilia Teal, did wear this dress, she would have been at least fifty years old at the time. Considering the style of the dress, it seems most likely that it was worn by a younger member of the Belcher family.

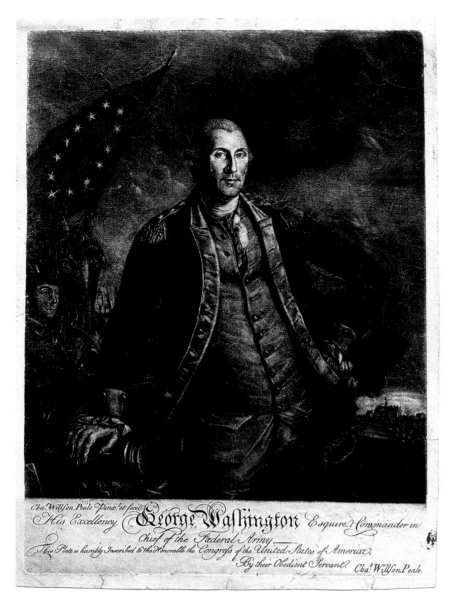

16 *George Washington*, 1780
Charles Willson Peale, 1741–1827
Mezzotint; 11⅞ x 9¾ in.
(30.2 x 24.8 cm.) Bequest of
Charles Allen Munn, 1924 (24.90.5)

CHARLES WILLSON PEALE

George Washington

During the Revolutionary War, Charles Willson Peale served with the army and also painted some excellent miniatures of fellow soldiers. It is known that he painted more than one thousand pictures, and it was at this point that he began to paint his many portraits of George Washington.

Whereas today the dissemination of popular and news-worthy images is a matter of photographic reproduction, in the eighteenth century it often meant that an artist had to copy and recopy a work that was in demand. A more practical method of painterly duplication involved engraving mezzotints, of which this is an example, though it was not until later in the nineteenth century that this medium became more commonplace in America. Engravings were frequently used to spread the news of the momentous events leading up to and during the Revolutionary War. They had a significant impact as social tools and as propaganda.

Peale is believed to have produced more likenesses of George Washington than any other artist. In the mezzotint shown here, Washington is shown in front of Nassau Hall in Princeton, New Jersey, the site of a successful engagement with the British.

PAUL REVERE

The Bloody Massacre, 1770

Paul Revere, forever associated in the American mind with his famous midnight ride (see Plate 96), was in fact a Boston silversmith, coppersmith, and engraver. As a businessman, he was quick to see the salable value of prints illustrating news events. Thus, at the time of the infamous Boston Massacre, on March 5, 1770, he did not hesitate to plagiarize the finished plate of John Singleton Copley's step-brother, Henry Pelham, and rush his own version onto the market a full week ahead of Pelham's.

The Bloody Massacre, 1770, depicts soldiers in the act of firing on a defenseless crowd. The events started when a group of youths mischievously pelted a British sentry with snowballs. A crowd gathered, and one small boy who rushed too close to the sentry was pushed back with the butt of the soldier's musket. This started the riot, which resulted in several American deaths. Revere's version of the scene is somewhat awkward and stiff, and he appears to be still uncomfortable with the engraving technique. But this print is full of spirit, and it served its propaganda purpose admirably.

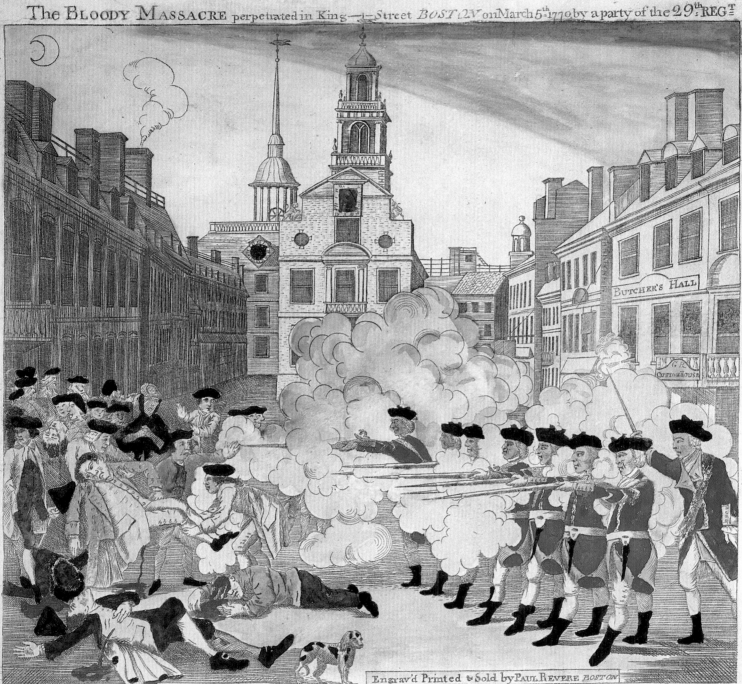

The BLOODY MASSACRE perpetrated in King——Street BOSTON on March 5th 1770 by a party of the 29th REGt

Engrav'd Printed & Sold by PAUL REVERE BOSTON

Unhappy Boston! see thy Sons deplore,
Thy hallow'd Walks besmear'd with guiltless Gore:
While faithless P——n and his savage Bands,
With murd'rous Rancour stretch their bloody Hands;
Like fierce Barbarians grinning o'er their Prey,
Approve the Carnage, and enjoy the Day.

If scalding drops from Rage from Anguish Wrung,
If speechless Sorrows lab'ring for a Tongue,
Or if a weeping World can ought appease
The plaintive Ghosts of Victims such as these;
The Patriot's copious Tears for each are shed,
A glorious Tribute which embalms the Dead.

But know, Fate summons to that awful Goal,
Where JUSTICE strips the Murd'rer of his Soul:
Should venal C——ts the scandal of the Land,
Snatch the relentless Villain from her Hand.
Keen Execrations on this Plate inscrib'd,
Shall reach a JUDGE who never can be brib'd.

The unhappy Sufferers were Messrs SAML GRAY, SAML MAVERICK, JAMS CALDWELL, CRISPUS ATTUCKS & PATK CARR
Killed. Six wounded; two of them (CHRISTR MONK & JOHN CLARK) Mortally

17 The Bloody Massacre, 1770
Paul Revere, 1735–1818
Hand-colored engraving;
10⅛ x 9 in. (25.7 x 22.9 cm.)
Gift of Mrs. Russell Sage, 1909
(10.125.103)

31

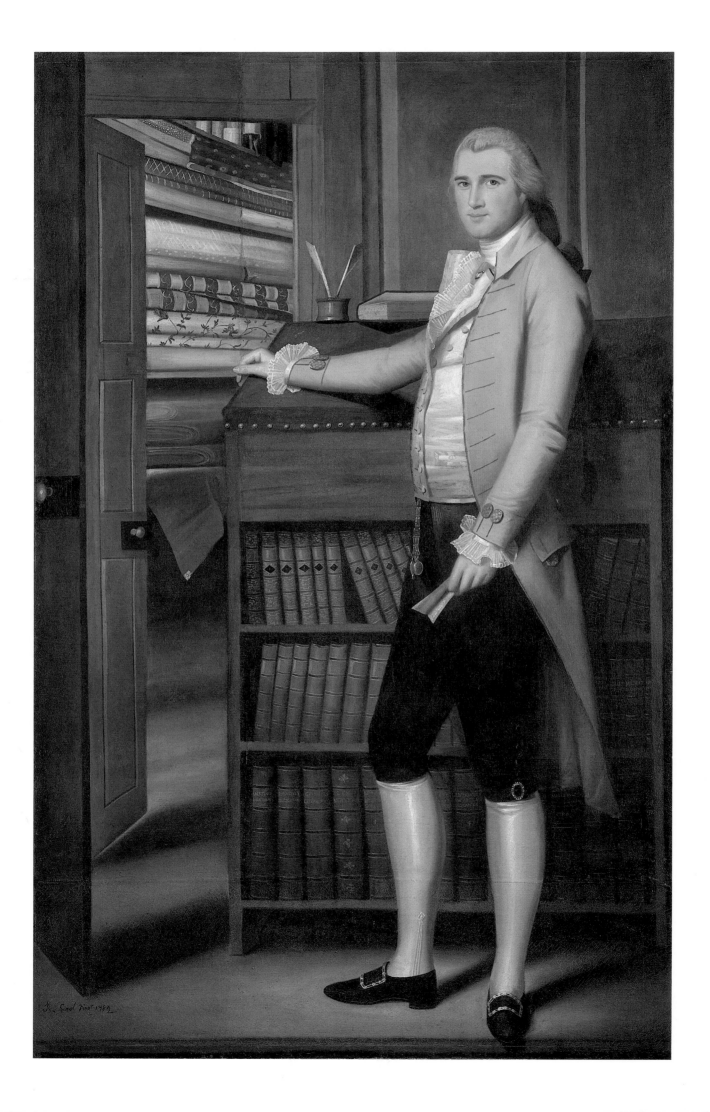

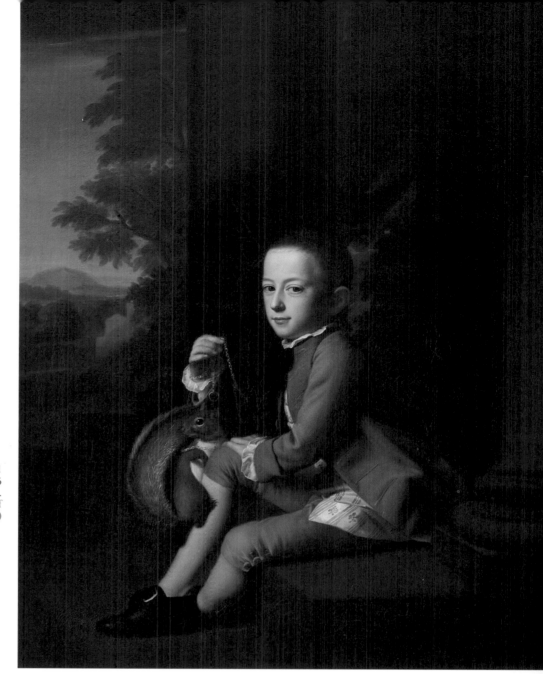

18 *Elijah Boardman*, 1789
Ralph Earl, 1751–1801
Oil on canvas; 83 x 51 in.
(210.9 x 129.6 cm.)
Bequest of Susan W. Tyler,
1979 (1979.395)

19 *Daniel Crommelin Verplanck*, 1771
John Singleton Copley, 1738–1815
Oil on canvas; 49½ x 40 in.
(125.7 x 101.6 cm.) Gift of
Bayard Verplanck, 1949 (49.12)

RALPH EARL
Elijah Boardman

Ralph Earl led an extravagant life and died from the effects of drink at the age of fifty, but he nevertheless became one of the foremost American painters of the late eighteenth century.

Elijah Boardman, the subject of this painting, was a prosperous textile merchant who fought in the Revolutionary War and involved himself in the politics of the new nation, rising eventually to the position of United States senator. As was his custom, Earl has provided clues to the background and personality of the sitter in the painting. The merchant is shown in a room of his dry-goods store; through the open doorway on the left can be seen the bolts of cloth stacked on shelves, and Boardman's arm rests on a desk filled with earnest-looking books. The horizontal and vertical patterns created by the bolts of cloth and the books enliven the picture. This and other Connecticut portraits represent the finest period of Earl's work, blending a straightforward realism with the polished grace that the artist acquired during his years abroad.

JOHN SINGLETON COPLEY
Daniel Crommelin Verplanck

John Singleton Copley was one of the first Colonial painters to earn his living with his brush. By the age of eighteen he was already established in Boston as a professional painter.

Daniel Crommelin Verplanck, painted in 1771, is an excellent example of the style that led to Copley's early success in America. He had two purposes as a portraitist: to provide a real, accurate representation of his sitter and, at the same time, to use his artistic capabilities—his understanding of color, light, and composition—to make a beautiful picture. Young Daniel Verplanck is portrayed as the child that he was, seated casually on the steps of his house with his pet squirrel (a motif evidently selected by Copley as particularly suited to portraits of children, since he used it several times). But there is a seriousness of expression in the boy's face that seems to indicate an awareness of his elevated social position and its accompanying responsibilities.

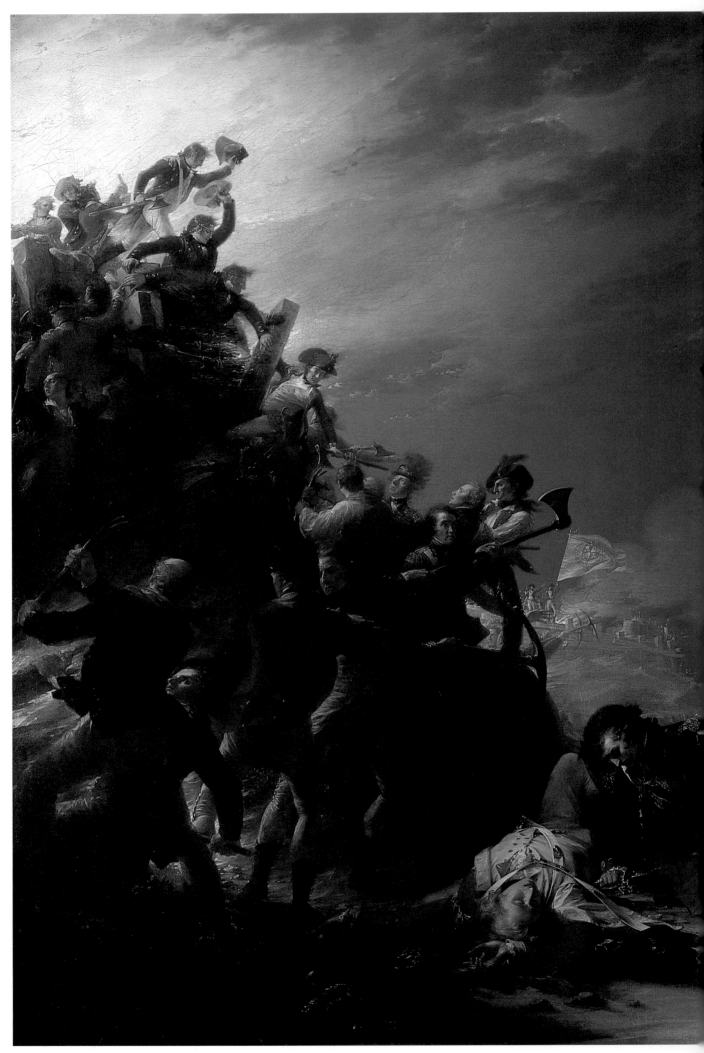

34 John Trumbull, *Sortie Made by the Garrison of Gibraltar*; text on page 36

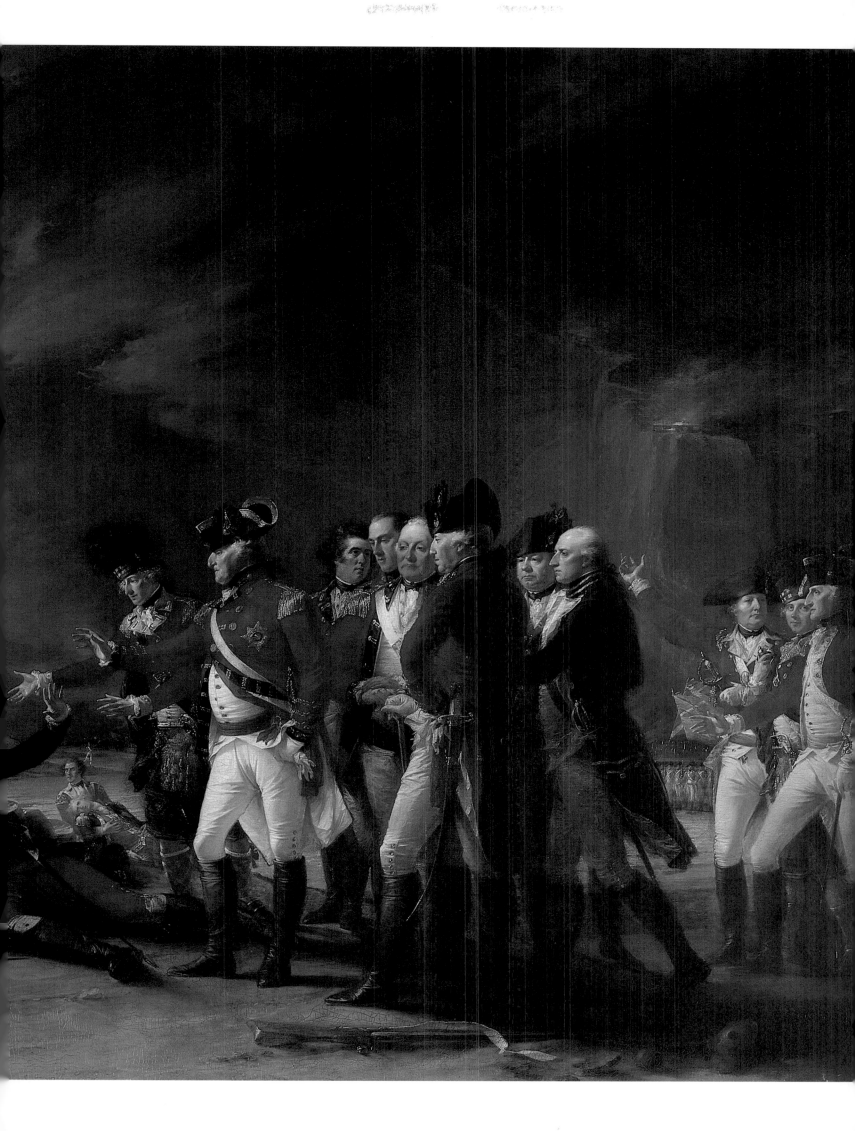

(Pages 34–35)

20 *The Sortie Made by the Garrison of
Gibraltar,* 1789
John Trumbull, 1756–1843
Oil on canvas; 70½ x 106 in.
(179.1 x 269.2 cm.)
Purchase, Pauline V. Fullerton Bequest,
Mr. and Mrs. James Walter Carter Gift,
Mr. and Mrs. Raymond J. Horowitz Gift,
Erving Wolf Foundation Gift, Vain and
Harry Fish Foundation, Inc. Gift,
Gift of Hanson K. Corning, by exchange,
and Maria DeWitt Jesup and
Morris K. Jesup Funds, 1976 (1976.332)

JOHN TRUMBULL *(Pages 34–35)*
The Sortie Made by the Garrison of Gibraltar

A New Englander who grew up in Connecticut and attended Harvard College, John Trumbull became an important man of affairs, taking an active part in the organization of the emerging American nation as well as a leading role in its artistic community. Encouraged by Benjamin West and Thomas Jefferson, he determined to make a pictorial record of the Revolution, and the series of portrait heads that he made for this project (which he also used as models for his large historical scenes) are among his finest works. Trumbull maintained his political connections carefully; they were an excellent source of commissions. Four of his works are displayed in the rotunda of the Capitol in Washington, D.C.

The Sortie Made by the Garrison of Gibraltar, painted in the early years of his career, is one of Trumbull's best heroic paintings. It depicts an episode during the three-year siege of Gibraltar by French and Spanish troops. The artist chose to make the death of a Spanish officer, Don José Barboza, the central event in this picture of a victorious assault. Barboza rejected offers of aid from the British because this would have implied an admission of defeat, and as he lay dying, the British officers stood helplessly nearby, majestic in their frozen attitudes of compassion.

RUFUS HATHAWAY
Lady with Her Pets.

Itinerant portrait painters were a common sight in New England and the eastern part of New York during the eighteenth century. These men traveled from farm to farm, often stopping for a while in small towns if the demand for their work was great enough. When business was slow or the weather prevented travel, they might use the time to stock their packs with paintings of national heroes, especially George Washington and Andrew Jackson, or with pleasing landscapes that they sold on their journeys. These artists were largely unschooled and their work was rarely of a high quality, but it provides historians with invaluable glimpses into the past.

Little is known about the life of Rufus Hathaway. His first known portrait was made in 1790, and shortly thereafter, following his marriage in 1795 to the daughter of a prominent merchant in Duxbury, Massachusetts, he gave up painting for the more secure profession of medicine. He continued to paint the occasional portrait of family members or friends, but only as a sideline. Hathaway did well with his new profession, and in 1822 was made an Honorary Fellow of the Massachusetts Medical Society.

Lady with Her Pets is an excellent example of the way in which an untutored but talented artist could rise above his limitations. It combines the simple narrative technique of an unsophisticated painter with the almost abstract use of line, color, and pattern resulting from an instinctively good sense of composition. The folds of the lady's gown, for example, are suggested by a rhythmic linear design. The sitter's face has character, which was by no means always the case in primitive portraits, in which external objects were necessary to identify the sitter since the artist lacked the skill to create a close likeness. The crackled effect all over the work is unintentional, resulting from a poor combination of materials.

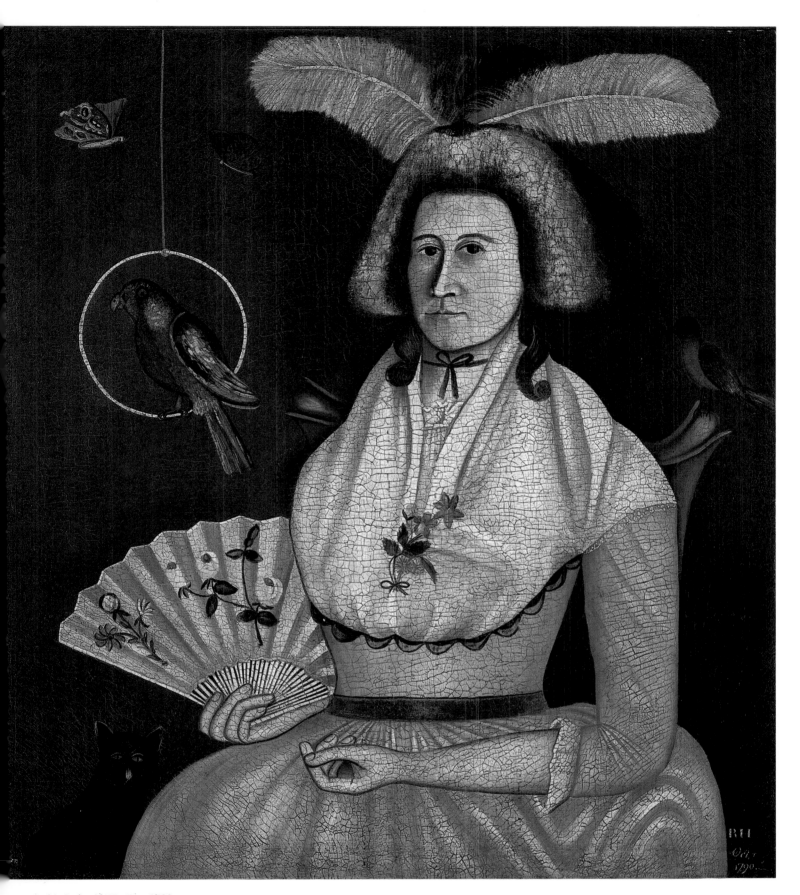

21 Lady with Her Pets, 1790
Rufus Hathaway, 1770(?)–1822
Oil on canvas; 34¼ x 32 in.
(87 x 81.3 cm.) Gift of
Edgar William and Bernice
Chrysler Garbisch, 1963
(63.201.1)

EARTHENWARE PLATE

Earthenware clay, found locally and easily fired at low temperatures, was used for the earliest ceramics made by the Colonists. From the mid-eighteenth to the late nineteenth century, earthenware containers were produced in abundance for the preparation, storage, and service of food. Common red clay was plentiful in Pennsylvania, where, according to historical records, most of the potters were German. The boldly stylized decorations of this exceptional plate suggest the decorative repertoire of this ethnic group.

The green, orange, and ocher colors of the decoration were achieved by glazing, while the contours of the bird, flower, and inscription are sgraffito, a technique in which a coating of cream-colored slip, or liquid clay, is applied to the surface of a vessel, and using a sharp quill pen, designs in the original red clay are revealed by scratching away the surface.

The inscription "1793 H.R." has been incised within a decorative border on one side of the plate, leading scholars to suggest that the craftsman may be Henry Roudebuth, who was active in Pennsylvania during this time.

23 Jagging Wheel
American, early 19th c.
Steel; L. 11⅛ in. (28.3 cm.)
The Sylmaris Collection,
Gift of George Coe Graves,
1930·(30.120.158)

22 Plate
Pennsylvania, ca. 1793
Possibly Henry Roudebuth,
act. 1790–1816
Red earthenware; H. 1⅞ in.
(4.8 cm.), Diam. 12¼ in. (31.1 cm.)
Gift of Mrs. Robert W. de Forest,
1933 (34.100.124)

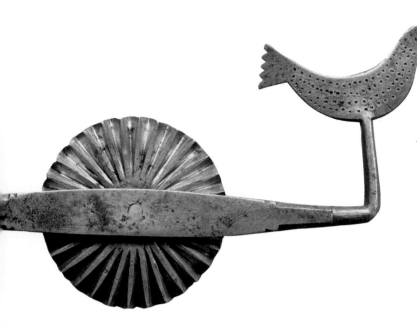

JAGGING WHEEL

This simple steel jagging wheel, or pastry cutter, was made by a competent metalworker, probably a rural blacksmith. Intended as a tool to cut and crimp pastries, the jagging wheel was designed for a practical function. But with an individuality and license typical of folk artists, this maker has allowed himself to ornament a bit, adding charm to an everyday tool. The handle end tapers to a double-pronged terminal, while the cookie-cutter pattern of a bird, stippled as dough might be, stands atop a perch and appears to scout.

SAMPLER

While academic painting and the decorative arts developed in America, a provincial and untutored tradition of folk art was growing as well. Folk artists were often anonymous; they were rural women and children stitching samplers or quilts, craftsmen making utilitarian objects, or itinerant painters recording the American scene. Though often inspired by the highly disciplined work of the more stylish painters and craftsmen, folk artists filtered these influences through their own aesthetics. They used distortion, exaggeration, and repetition, along with a fine sense of the power of pure color, shape, and surface design, to compose their own expressive vocabulary—the folk-art idiom.

This small sampler was stitched with silk threads on a linen background by a young girl, Rebekah Munro, in 1792. Rebekah grew up in Providence, Rhode Island, and made this sampler to complete an assignment for Mary Balch's embroidery school. It illustrates a popular verse of the time, the point of which seems to be to encourage young girls to keep mind and body occupied with wholesome endeavors. It opens, "With Shebas queen ye American fair. To adorn your mind bend all your care," and later enjoins, "Whole useful hours successive as they glide/ The Book the Needle and the Pen divide." Ironically, the verses are illustrated by a pair of courting couples; the upper register shows them in contemporary dress beneath a tree, while in the lower register they are shown in pastoral costume amid a flock of sheep. A meandering blue line separates these scenes and the text from a crewelwork border of flowers growing out of pots.

The sampler is part of the collection of Barbara Schiff Sinauer, given to The Metropolitan Museum of Art in 1984. The collection includes another sampler that illustrates the same verse and was also produced for Mrs. Balch's class in Providence.

24 Sampler
Providence, Rhode Island,
ca. 1792
Rebekah Munro
Silk on linen; 14½ x 18½ in.
(36.8 x 47 cm.) Gift of
Barbara Schiff Sinauer, 1984
(1984.331.13)

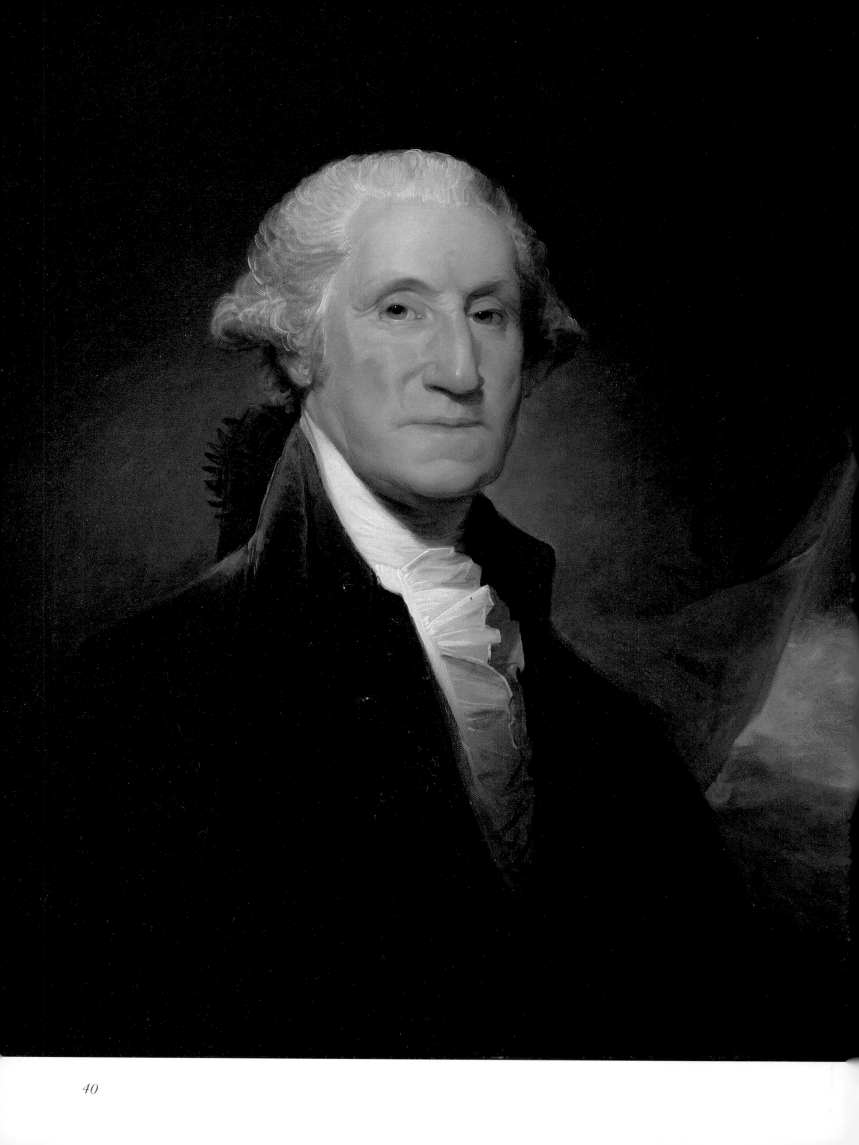

GILBERT STUART
George Washington

As a young boy in Newport, Rhode Island, Gilbert Stuart received his artistic training from the Scottish portraitist Cosmo Alexander. Throughout Stuart's life, portrait painting was to remain his abiding interest as well as his livelihood. He became, in time, the leading painter of his period, although his inability to manage his financial affairs kept him in a state of monetary distress all his life.

Stuart went to England at the beginning of the Revolutionary War, more because he found his pool of sitters to be dwindling than because of any ideological commitment. He was treated most generously by the American expatriate artist Benjamin West, with whom he lived and worked for five years. When he established his own London studio in 1782, his ability led him to great success. Stuart became a leading portrait painter and might well have ended his days in England, had not his indebtedness caused him to flee the country.

On his return to America in 1793, Stuart rapidly developed an admiring following and painted most of the prominent people of his time, including the first five American presidents. Even after his exposure to British styles and techniques, he retained a straightforward realism characteristic of American art, reducing the frills of decor to a minimum in order to concentrate on his exploration of the face. His work is characterized by skillful drawing, excellent composition, and a sensitive use of color.

There are twenty-two portraits by Stuart in The Metropolitan Museum's collection, including three of George Washington. Stuart painted the president for the first time in 1795, and his work was greeted with such enthusiasm that thirty-nine replicas were ordered, although only seventeen are known to exist. The original painting, acquired by Samuel Vaughan and known as the Vaughan Washington, was the basis for the one seen here, known by the names of its early owners as the Gibbs-Channing-Avery Washington. It is one of the finest and earliest replicas, and it has been suggested that the immediacy and energy of the president's features indicate that it was painted, at least in part, from life. Stuart may well have prepared several canvases at once, for use whenever his sitter was available.

25 George Washington, 1795
Gilbert Stuart, 1755–1828
Oil on canvas; 30¼ x 25¼ in.
(76.8 x 64.1 cm.)
Rogers Fund, 1907 (07.160)

OVERLEAF:

ROOM FROM THE WILLIAMS HOUSE *(Page 42)*

The decades that followed the adoption of the Constitution in 1786 are known as the Federal Period. During this time the former colonies again experienced a burst of growth and expanded trade that was accompanied by a demand for new furniture forms and styles. Architects and cabinetmakers in the new republic looked to London, where during the American Revolution a new style had been developing. Stimulated by the extensive finds at Pompeii and Herculaneum, European design had reacted against the fanciful Rococo and was reviving classical forms. The foremost exponent of Neoclassical fashion was the Scottish architect Robert Adam, who made drawing studies of ancient sites and published them in his *Works on Architecture* (1773–79). Classical forms appealed to America for patriotic as well as aesthetic reasons; the republics of Greece and Rome and the democratic ideals they represented were appropriate models for revolutionaries both in Europe and America. Neoclassicism and the designs of Robert Adam reached America through the pattern books of Thomas Shearer, George Hepplewhite, and Thomas Sheraton.

This lavish parlor from the house of William C. Williams in Richmond, Virginia, represents the transition in Federal Period architecture from the classical restraint of Adam to the full-blown Greek Revival that became popular in the 1820s and 30s. The influence of the French Empire style is evident in the massive proportions of the doorways and windows, which are framed to unusual effect by heavily worked dark mahogany. The baseboards are of another surprising material: gray King of Prussia marble, named for the town near Philadelphia, Pennsylvania, where it is mined. The walls are covered with facsimiles of a French scenic wallpaper—a popular embellishment for Federal houses from New England to Virginia. First published by the French firm of Dufour in 1814, the paper celebrates the monuments of Paris.

The Williams Room is furnished with examples of the work of two of the most prominent New York cabinetmakers of the period, Duncan Phyfe (1768–1854) and Charles-Honoré Lannuier (1779–1819). Of particular note is the suite of mahogany chairs with "Grecian cross" legs, commissioned from Phyfe in 1810 by Thomas Cornell Pearsall. Their distinctive shape is based on the curule, or folding seat, used by Roman magistrates—a design that was available in both French and English pattern books of the early nineteenth century.

41

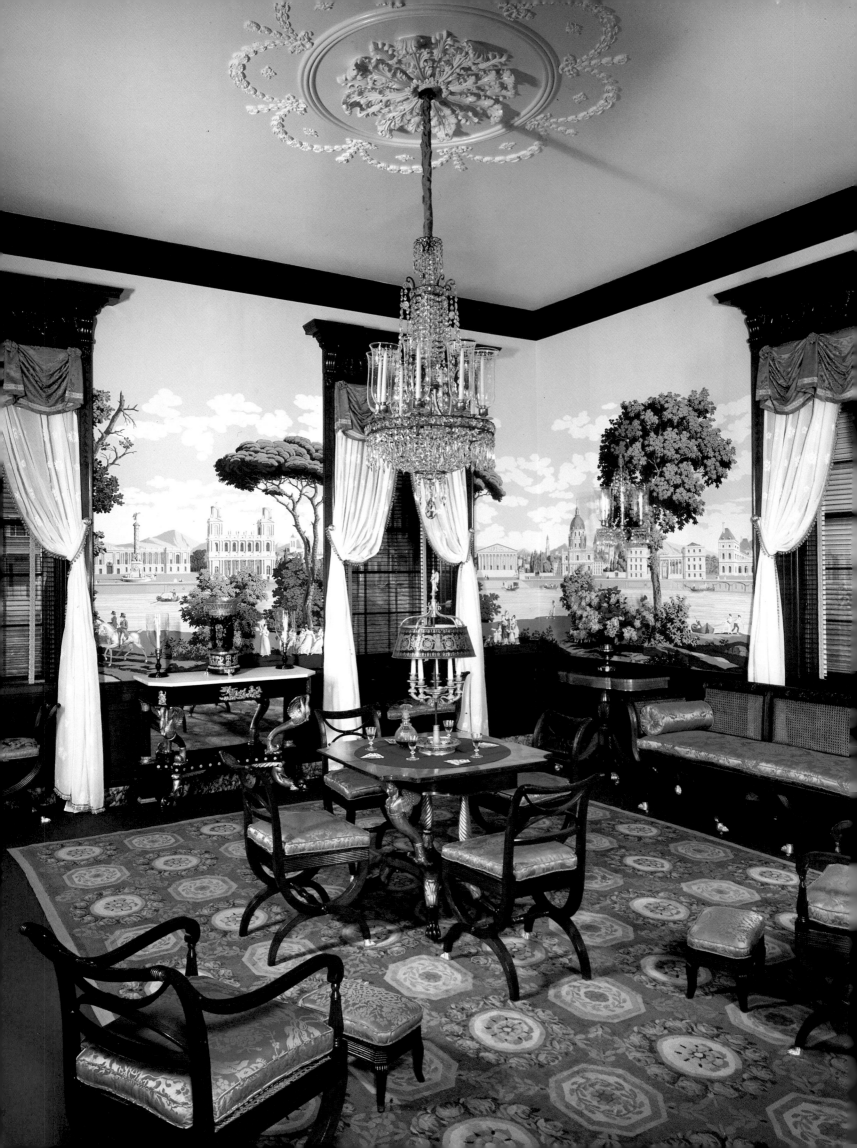

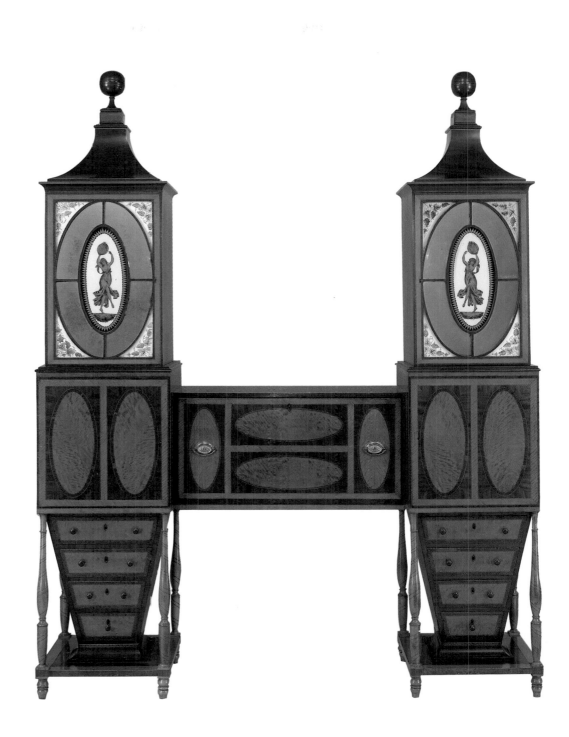

26 *Room from the Williams House*
Richmond, Virginia, 1810
Original owner: William C. Williams
H. 13 ft. (3.96 m.), L. 19 ft. 9 in.
(6.05 m.), W. 19 ft. 11 in. (6.07 m.)
Gift of Joe Kindig, Jr., 1968 (68.137)

27 *Desk and Bookcase*
Baltimore, ca. 1811
Mahogany, satinwood, verre
églomisé; 91 x 72 x 19⅛ in.
(231.1 x 182.9 x 48.6 cm.)
Gift of Mrs. Russell Sage and
various other donors,
by exchange, 1969 (69.203)

BALTIMORE DESK AND BOOKCASE

Well situated on the Patapsco River, a deep estuary of Chesapeake Bay, Baltimore served as an official port of entry during the Federal Period and had an active trade reaching as far as Ireland and the Caribbean. Prosperity brought an influx of skilled craftsmen to the city, and nowhere in the young republic were English furniture prototypes adopted more faithfully both in terms of construction and ornament.

The design for this lady's desk and bookcase was taken from Plate 38 of Thomas Sheraton's *Cabinet Dictionary* (1803), where it is called "Sister's Cylinder Bookcase." The piece is made primarily of mahogany but, in typical Federal style, ovals and rectangles of pale satinwood are inlaid through-

out, and a delicate double-lined inlay spirals down the turned legs.

Typical of a small number of pieces of Baltimore furniture are the unusual oval panels of painted glass (*verre églomisé*) that adorn the upper portions of the pedestals. Painting or gilding the backs of glass panels for pictorial effect was a technique known since antiquity and one that took particular hold in Baltimore.

A penciled inscription on the bottom of one drawer—"M Oliver Married the 5 of Oct. 1811 Baltimore"—records the wedding of the daughter of a wealthy local merchant who is likely to have used this desk.

TEAPOT

Tea was introduced to Europe from the Orient in the 1600s. It became fashionable in London about 1650 and reached the Colonies at the end of the century. Its great popularity led to a proliferation of vessels in which to serve it. Unlike coffee and hot chocolate, which are brewed and then placed in a pot for serving, tea leaves must be steeped—hence the evolution of the stouter-bellied teapot.

This Federal-style silver teapot is part of a service made in about 1800 by the famous Boston patriot Paul Revere. The fluted facets of its classical design are echoed in all three pieces as are the gouged or "bright-cut" festoons and ornamented bands. The son of a Huguenot, Apollos Rivoire (who Americanized his name to Paul Revere), Paul Revere, Jr., had many talents and is the best known of Colonial silversmiths. In addition to fashioning plate for various patrons, Revere engraved silver, made trade cards, bill heads, and copperplates for paper currency, and also engraved scenic views, portraits, and political prints (see Plate 17).

EDWARD GREENE MALBONE
Two Miniatures

A miniaturist of great sensibility and delicacy, Edward Malbone had only twelve years in which to establish the reputation that has survived him by almost two centuries. At the age of seventeen, he left home to make his way in the world. He spent the next five years traveling among the wealthy towns of the Eastern Seaboard—Boston, Philadelphia, Providence, Charleston—painting miniature portraits of eminent citizens and building his reputation as the foremost miniaturist of the day.

A self-taught artist, Malbone employed few of the technical devices that were commonly used by miniaturists. His very simplicity created a style that is easily recognized. He almost always painted on ivory, using a thin, transparent watercolor that may have been strengthened by the addition of a medium such as gum water, which adds body without diminishing the transparency. His delicate handling of color created flesh tones that were startlingly true to life. He would lay down a thin preliminary wash of flesh color and then model the features with fine lines of shading colors that were almost invisible but that skillfully reproduced the texture and tones of skin.

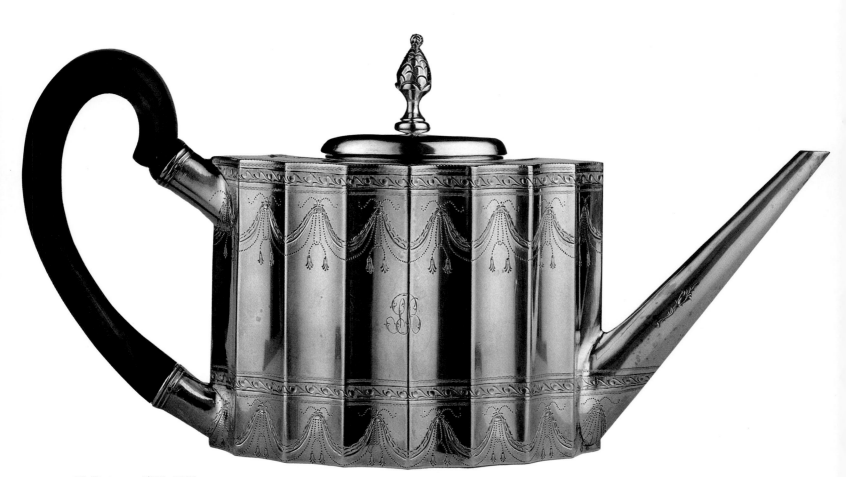

28 *Teapot*, ca. 1790–1800
Paul Revere, 1735–1818
Silver; H. 6⅛ in. (15.6 cm.),
L. 11⅞ in. (30.2 cm.) Bequest
of Alphonso T. Clearwater,
1933 (33.120.543)

29 *Robert Macomb* and *Mary Cornell Pell*, 1806
Edward Green Malbone, 1777–1807
Both portraits: oil on ivory;
3¾ x 3 in. (9.5 x 7.6 cm.)
Bequest of Irving S. Olds, 1963 (63.122.1,2)

COVERED GOBLET

A remarkable episode in the history of glassmaking in America was the brief enterprise of a German immigrant, John Frederick Amelung, at the New Bremen Glass Manufactory in Maryland. Amelung arrived in America from Bremen, Germany, in 1784, bringing with him sixty experienced workmen, and attempted to transplant a German glassworks to the Maryland countryside.

This covered goblet, or "pokal," was produced by the New Bremen Glass Manufactory in 1788 and is among the finest fully identified surviving pieces of eighteenth-century glass. Characteristic of Amelung glass is the superb engraving, inverted baluster stem, domed foot, and plain rim. In style, the goblet looks back to the generous curving forms of the Baroque and Rococo rather than to the classical restraint popular in the other decorative arts of this time.

30 Covered Goblet
Frederick County, Maryland, 1788
New Bremen Glass Manufactory, 1784–95
Glass; H. with cover 11¼ in. (28.6 cm.)
Rogers Fund, 1928 (28.52)

John Vanderlyn
Panorama of the Palace and Gardens of Versailles

John Vanderlyn was an artist of great talent who, through a mixture of bad luck and poor judgment, never fulfilled his early promise. As a young art student, he came to the attention of politician Aaron Burr, then still a gilded figure on the American political scene. Burr paid for Vanderlyn's lessons with Gilbert Stuart and then, in 1796, sent him to further his studies in Paris. With only a brief, but successful, stay in America from 1801 to 1803, Vanderlyn remained in Paris for the next twenty years.

It was, unfortunately, too long for the good of his career. In the interval, Aaron Burr had fallen from grace; not only did Vanderlyn lose his powerful patron, but his very association with Burr counted heavily against him in influential circles. Furthermore, in the intervening years, a whole generation of talented and ambitious artists had filled the places that had beckoned Vanderlyn before he left for Europe. For the remaining years of his life he struggled to reestablish himself, but slid further and further into failure and eventual destitution.

This panorama, *The Palace and Gardens of Versailles*, was painted from 1816 to 1819, shortly after Vanderlyn resettled in New York, when his hopes were still high. There is evidence from his own writings that, though he labored long and

46

hard on this 165-foot circular work, he never considered it to be on the same artistic level as his portraits. It was his intention to use it to beguile the American public, whom he considered artistically immature, into visiting the Rotunda, a building Vanderlyn planned as the forerunner of a national gallery to house art of a more serious nature. The exhibition was successful, but poor management and misfortune caused the long-term plan to fail. Vanderlyn's panorama spent the next few years in warehouses, on tours, and even as stage scenery.

The work is, however, an excellent example of illusory art. Great attention has been paid to the perspective, so that everything is carefully scaled to allow for the distortion caused by the circular form of the canvas. The painting itself affords a glimpse into the post-Napoleonic world of Paris: Louis XVIII, representing the restored monarchy, is glimpsed on the palace balcony, and scattered among the fashionable strollers are various members of the armies of occupation maintained by the allies as a precautionary measure. Standing on a central platform, viewers can get the fleeting impression that they, too, are walking on a late summer afternoon past the fountains in the splendid water garden facing the western facade of the palace.

31 Panorama of the Palace and Gardens of Versailles. 1816–19
John Vanderlyn, 1775–1852
Oil on canvas; 12 x 165 ft.
(3.7 x 50.3 m.) Gift of
Senate House Association
Kingston, New York, 1952 (52.184)

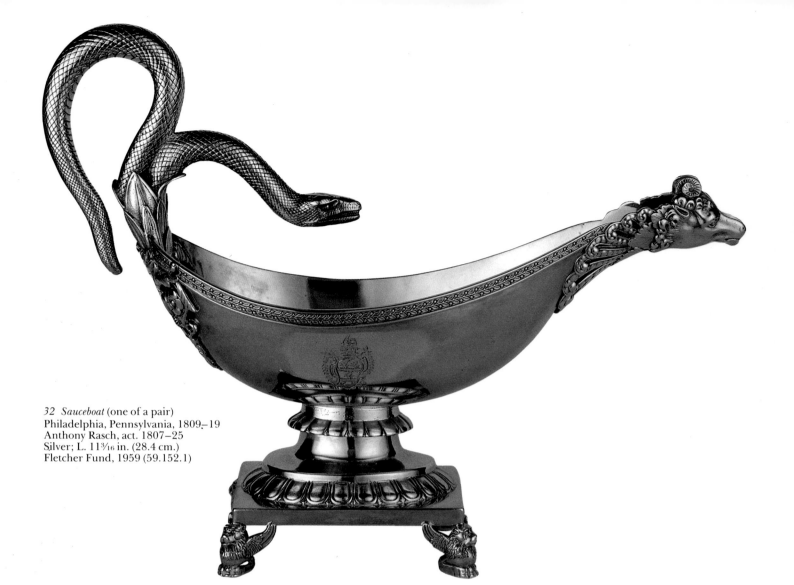

32 Sauceboat (one of a pair)
Philadelphia, Pennsylvania, 1809–19
Anthony Rasch, act. 1807–25
Silver; L. 11³⁄₁₆ in. (28.4 cm.)
Fletcher Fund, 1959 (59.152.1)

33 Dish
Possibly New England, 1830–50
Pressed glass; L. 9⁵⁄₁₆ in. (23.2 cm.),
W. 7⅞ in. (20 cm.)
Gift of Mrs. Charles W. Green, in
memory of Dr. Charles W. Green,
1951 (51.171.160)

SILVER SAUCEBOAT

The silversmith Anthony Rasch emigrated from Passau, Bavaria, to Philadelphia in 1804, at the age of twenty-six, bringing with him a style heavily influenced by *le style antique*, or classical style, of the French Empire. Once in the United States, he ran a highly successful business from 1808 to 1819.

With this silver sauceboat, which is one of a pair, Rasch incorporated animal forms popular in antiquity to display the technical virtuosity possible in the manufacture of silver vessels. On the basic boat form, he fashioned a ram fleeing before a stalking serpent. The serpent rises from a patch of flowers and imbricated leaves, and his arching tail forms the handle. The sauceboat rests on two tiers of baluster shape, which are, in turn, supported by four tiny, winged lions. Rasch's expertise as a silversmith is evident in the carefully chiseled scales of the serpent, in the modeling of the straining ram's head, and in the intricate cut-card mounts (a silversmith's version of ormolu) that decorate either end of the sauceboat. The overall design achieves a balance typical of Empire furniture and silver by juxtaposing smooth surfaces of polished silver with excursions into elaborate ornament.

LACY GLASS DISH

The technique of pressing glass was introduced in America in the late 1820s and served to revolutionize the glass-making industry. Where glassmaking had previously been limited to the blowpipe technique, glass could now be produced mechanically by pressing molten metal into iron and brass molds.

The process first developed as an inexpensive and mechanical way to imitate cut glass, but it was soon discovered that molds could be made with more minute facets and precise detail than the glass-cutter's wheel could ever achieve. The product now depended on the talent of the mold maker, who could chisel and etch an infinity of patterns and designs. Since molten glass often contained impurities, and these defects could be disguised by the elaborate lacy patterns of the molds, the mechanical process was widely adopted.

This rare, lacy, shell-shaped dish was probably made in New England. Like the furniture of the period, the design revives motifs culled from Classical, Gothic, and Rococo sources. The icy blue of its transparent facets, cut and stippled to refract light, lends it the shimmer of a snowflake.

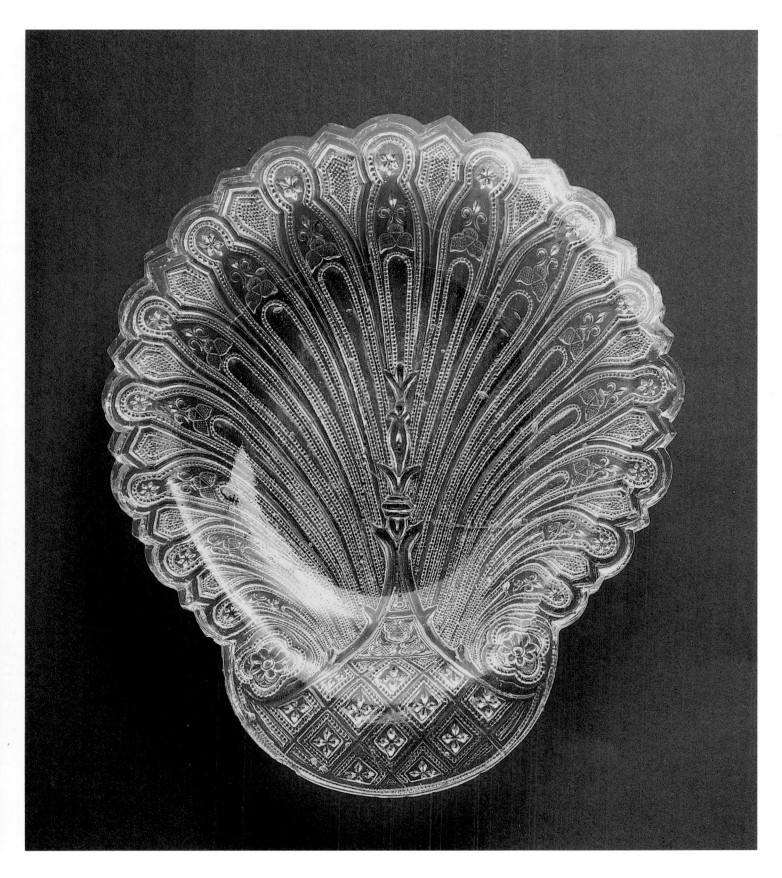

PIER TABLE

From 1786 to 1790, Philadelphia was the nation's capital, and until about 1810, when it was surpassed by New York, it was the most populous, most fashionable, and most culturally active of all American cities.

This pier table bears the label of Joseph B. Barry, who was active from about 1794 to 1838. One of Philadelphia's great Federal Period cabinetmakers, Barry was born in Dublin, Ireland, and emigrated to Philadelphia before 1790. He had such a successful business there that he was able to open a branch shop in Baltimore.

His pier table provides a uniquely American interpretation of classical taste by combining the English Neoclassical style with the French Empire forms that filtered into America through pattern books. Itself a new form during this period, the pier table and its various ornaments provide a visual textbook of Federal Period cabinetmaking. The decorations include the gilding, carving, turning, richly contrasting veneers and ormolu mounts typical of the Empire style. The panel at the back shows griffins, Pompeiian scrolls, laurel sprays, and a lyre, a design based on Thomas Sheraton's "Ornament for a Frieze or Tablet" from his 1793 drawing book.

THOMAS APPLETON
Pipe Organ

Thomas Appleton's pipe organ is one of the most imposing and important instruments of this type to be found in a public building in the United States. It was built in 1830 and was originally installed in South Church, in Hartford, Connecticut.

Appleton, the son of a carpenter, was originally apprenticed to a cabinetmaker, and went on to learn organ construction. He did well, subsequently married his employer's sister, and, by 1833, had made forty organs which, constructed in Massachusetts, were sold as far away as California and South Carolina. He was essentially a conservative builder whose work reflects the influence of British design of seventy-five years earlier. The Appleton organ is enclosed in a 16-foot-tall Greek Revival case made of Honduras mahogany, and mahogany and rosewood veneers over pine. The gold-leafed facade pipes are grouped in three towers flanking two flats over the recessed console. The outer towers have modified Ionic capitals under cornices, and the central tower is surmounted by a carved pipeshade and cornice flanked by bronzed baroque ornaments. There are 836 pipes in all, two fifty-eight-note keyboards, and a twenty-seven-note pedal-board. The wind is supplied to the pipes by hand-pumped bellows, operated by a lever on the right.

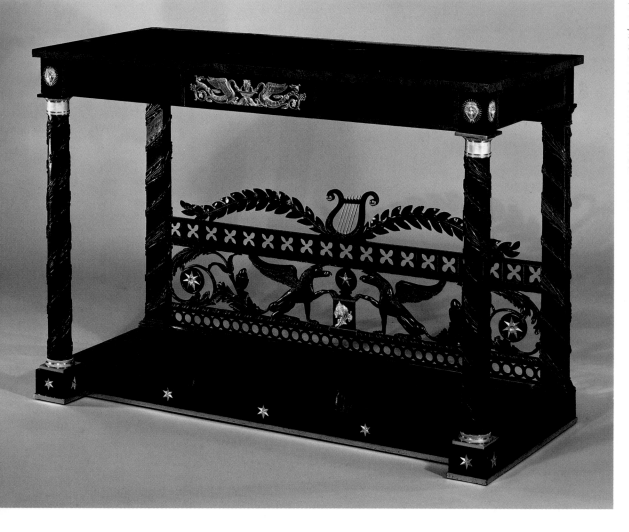

34 Pier Table
Philadelphia, Pennsylvania, 1810–15
Joseph B. Barry, act. 1794–d. 1838,
and Son. Mahogany, satinwood,
amboyna, gilt brass; 38⅝ x 54 x 23¾ in.
(98.1 x 137.2 x 60.3 cm.) Purchase,
Friends of the American Wing Fund,
Anonymous Gift, George M. Kaufman
Gift, Sansbury-Mills Fund; Gifts of the
Members of the Committee of the
Bertha King Benkard Memorial Fund,
Mrs. Russell Sage, Mrs. Frederick
Wildman, F. Ethel Wickham,
Edgar William and Bernice Chrysler
Garbisch and Mrs. F. M. Townsend,
by exchange; and John Stewart
Kennedy Fund and Bequests of
Martha S. Tiedeman and W. Gedney
Beatty, by exchange, 1976 (1976.324)

35 Pipe Organ
Boston, Massachusetts, 1830
Thomas Appleton, 1785–1872
Wood, metal, and various other
materials; H. 16 feet 1 in. (4.88 m.)
Purchase, Margaret M. Hess Gift,
in memory of her father,
John D. McCarty, 1982 (1982.59)

51

Shaker Retiring Room

Concurrent with the various furniture revivals of the Victorian Period, with their emphasis on opulent materials, fine workmanship, and borrowed ornament, was the emergence of a novel and radically different aesthetic created by the United Society of Believers in Christ's Second Appearance, better known as the Shakers. One of the earliest communitarian sects to organize, the Shakers reached the height of their popularity from about 1830 to 1860, during which time they numbered over six thousand and found spiritual refuge and harmony in nineteen communities from Maine to Kentucky.

Their prophet and founder was Mother Ann Lee who came to America from England in 1774 and believed she was the embodiment of the spirit of God. Shakers lived according to the rigid Millennial Laws which were recorded by the Shaker community of New Lebanon, New York, in 1821, and which prescribed all actions and behavior. The "sisters" and "brethren," as they were called, lived by rules of celibacy, pacifism, and separation from the world. Worship was extremely important, regularly scheduled, and intensely communal, the distinctive feature being the frenzied dance that gave the Shakers their familiar name.

This room from the Shaker community in New Lebanon embodies the purity, simplicity, and practicality characteristic of Shaker life. The room was used for sleeping and for the half-hour period of rest that preceded evening prayer. During this time, up to four occupants sat in silence to "labor for a sense of the Gospel." Typical of their dwellings are the white plastered walls, scrubbed floors, warm ocher woodwork, and the built-in cupboards, drawers, and ubiquitous pegboard on which they hung the chairs when preparing to "shake."

Shaker furnishings derive from simple Colonial forms. Shaker craftsmen rejected the worldly ornament of contemporary Victorian revival furniture and sought pure function and form, and in the process of their search, they were extremely inventive. They added "tilters" to ladderback chairs to reduce wear, they placed their stoves in the center of the room for maximum heat, and the invention of the swivel chair is thought to be a result of the ingenuity of the Enfield, Connecticut, Shakers.

The Millennial Laws even went so far as to include instructions for furnishing a retiring room: "...bedsteads should be painted green—comforters should be of a modest color, not checked, striped, or flowered." Beds were often equipped with large wooden rollers, seen here, to facilitate cleaning. The wheels, however, were unable to pivot so the bed could only move in one direction. A quote from the Millennial Laws distills the atmosphere of this room: "All should retire to rest in the fear of God, without playing or boisterous laughing, and lie straight."

36 Shaker Retiring Room
New Lebanon, New York, 1830–40
Purchase, Emily C. Chadbourne Gift,
1972 (1972.187.1–.3)

53

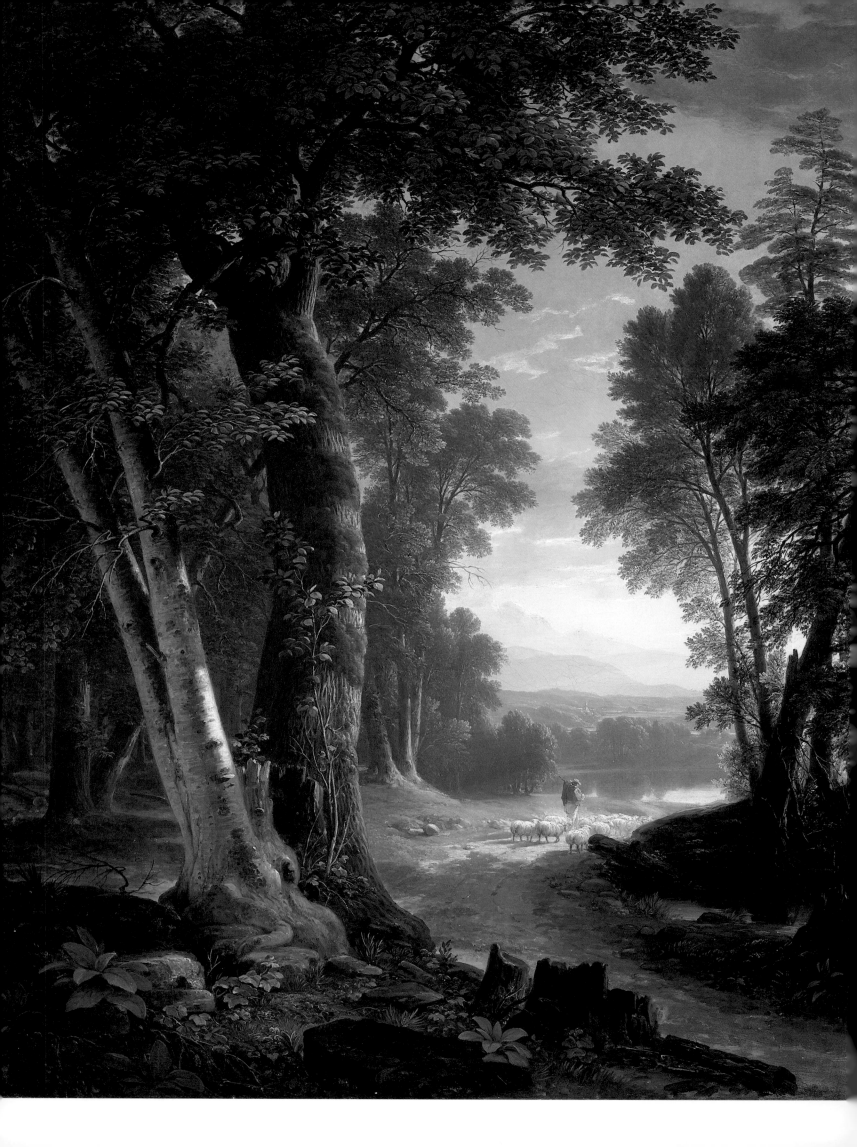

ASHER BROWN DURAND
The Beeches

Before he became a painter, Asher Brown Durand was America's foremost engraver. Around 1836, however, encouraged by Luman Reed, an important patron of the arts, Durand switched to painting.

His earliest paintings were somewhat uninspired, but after his trip to Europe in 1840, when he discovered the work of landscape painters Claude Lorrain and John Constable, his sense of composition improved greatly. Furthermore, his experience of engraving lent his painting technique a precision that provided an almost crystalline clarity.

The Beeches is unlike most landscapes of the period in that it has a vertical format (befitting its subject). The influence of Constable is detectable in the softening of the scenery as a result of the introduction of domestic details—a farmer and sheep. Also like Constable, Durand worked on his large landscapes in his studio, basing them on quick sketches made on the spot. He was especially adept at drawing trees—a gift of particular value to a landscape painter in a land that was then still filled with unspoiled forests.

37 The Beeches, 1845
Asher Brown Durand, 1796–1886
Oil on canvas; 60⅜ x 48⅛ in.
(153.4 x 122.2 cm.) Bequest of
Maria DeWitt Jesup, from the collection
of her husband, Morris K. Jesup,
1914 (15.30.59)

THOMAS COLE (Pages 56–57)
View from Mount Holyoke, Northampton, Massachusetts, After a Thunderstorm (The Oxbow)

Known as the Father of the Hudson River School of landscape painters, Thomas Cole holds a prominent place in the history of American painting, both for the quality of his own works and for the influence he exerted over a generation of nineteenth-century painters and photographers.

Cole loved the unspoiled woods and valleys of the Hudson River and Catskill area and painted them again and again. At once a realist and a romantic, Cole infused his precise renderings of tne effects of light and atmosphere on trees and foliage with a sense of sublime grandeur. In later years he was upset by the destruction being wrought upon the land by technological progress, and he began to paint from memory landscapes as they had been before they were scarred or destroyed. His influence on his contemporaries —including Thomas Doughty, John Frederick Kensett, and Asher Brown Durand—led to the formation of the Hudson River School, although in reality Cole had only one actual pupil, Frederic Edwin Church.

Cole was fascinated by the oxbow formation of the Connecticut River below Mount Holyoke in Massachusetts, and in 1836 he produced this magnificent panorama of the valley just after a thunderstorm. He depicted himself at work in the foreground, and there is a charming inconsistency in the fact that the storm, which had soaked the countryside, leaving it cleansed and glistening, seems to have avoided him and his possessions entirely. Cole loved tempests, and in this picture we can see the beginnings of Luminism—that concern for the effects of light that was to become a dominant theme for many painters and photographers in the coming years.

38 View from Mount Holyoke,
Northampton Massachusetts, After a
Thunderstorm (The Oxbow), 1836
Thomas Cole, 1801–48
Oil on canvas; 51½ x 76 in.
(130.8 x 193 cm.) Gift of
Mrs. Russell Sage, 1908 (08.228)

39 *Fur Traders Descending the Missouri,*
ca. 1845
George Caleb Bingham, 1811–79
Oil on canvas; 29 x 36½ in.
(73.7 x 92.7 cm.)
Morris K. Jesup Fund, 1933 (33.61)

GEORGE CALEB BINGHAM

Fur Traders Descending the Missouri

Genre painting—the depiction of the life and activities of common people—provides us with priceless documentation of the past, before the invention of photography. However, in this work, George Caleb Bingham elevated genre painting far above mere documentation.

In *Fur Traders Descending the Missouri*, Bingham portrays a moment in the life of a French-Canadian fur trader, still living the existence of a *voyageur*, or rover. The *voyageurs* combined commerce with exploration and adopted many of the ways of the wild. They frequently married Indian women and lived a life balanced between two cultures, ferrying furs and objects for barter between the settlers' outposts and the wilderness encampments of the Indians. Here, the sleek, dark hair and olive skin of the trader's son suggest that his mother was, indeed, Indian.

Bingham has raised the painting above the mere narrative level by the excellence of his composition; the quiet moment in these harsh lives is presented almost as a still life. The head of the boy is set exactly in the break in the foliage of the middle ground, and the old trader's cap peaks just at the right-hand edge of the trees. The figures and boat are depicted with great simplicity of line and shape. And Bingham has created a striking contrast between the strong, clear depiction of the foreground figures and the soft, misty rendering of foliage and sky in the background. Despite the fact that this was painted before Bingham visited Europe, the use of parallel planes receding into the distant background suggests that he was already familiar with engravings of European paintings.

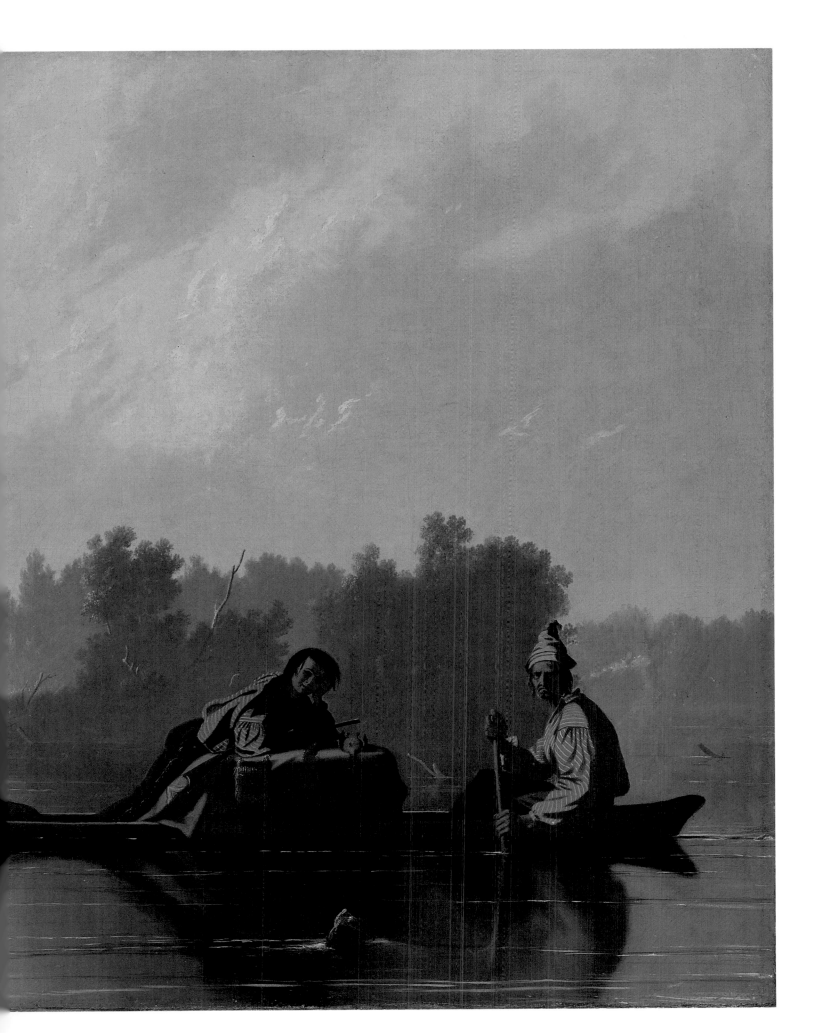

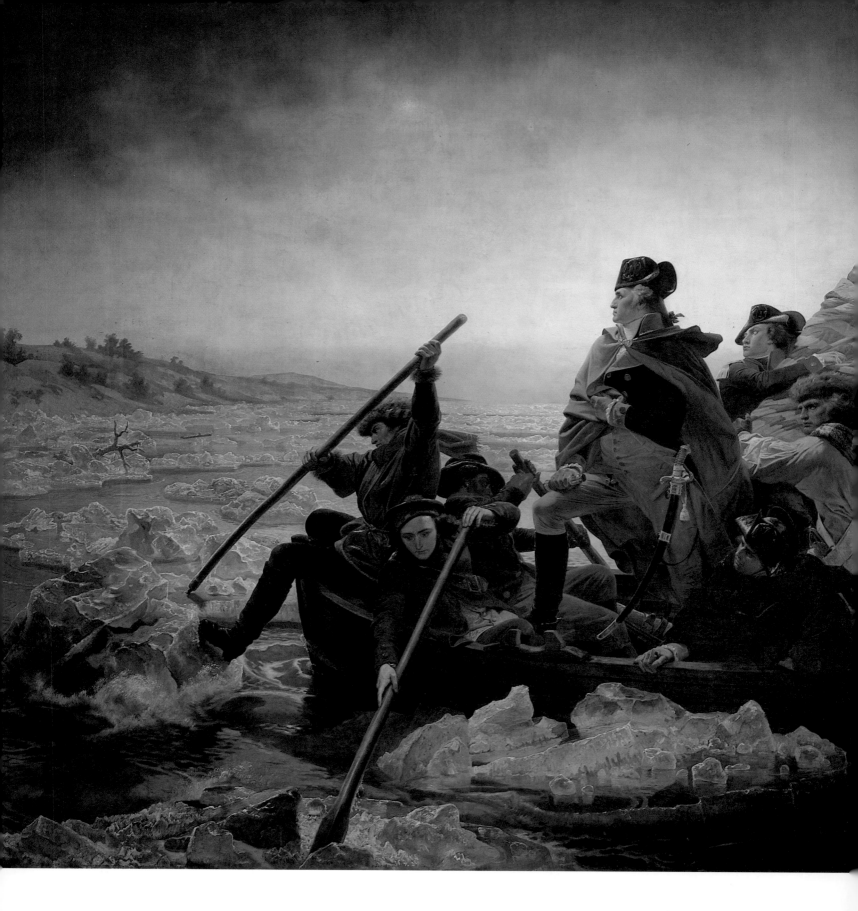

EMANUEL GOTTLIEB LEUTZE
Washington Crossing the Delaware

Emanuel Leutze, a theatrical, somewhat unconvincing, but technically skillful painter of historical scenes, produced several versions of this famous, if not precisely authentic, scene from the American Revolution. Many people would no doubt be surprised to learn that this quintessentially American picture was, in fact, painted in Germany by a German-born artist who lived half his life in Europe. Leutze came to America with his family at the age of nine and settled in Philadelphia. He became such a successful portrait painter that funds were raised by patrons to send him to Europe to broaden his artistic experience. He remained there for ten years and established a studio in Düsseldorf, where the original version of this painting was made. It remained in Germany, at the Kunsthalle in Bremen, where it perished in a bombing raid during the Second World War.

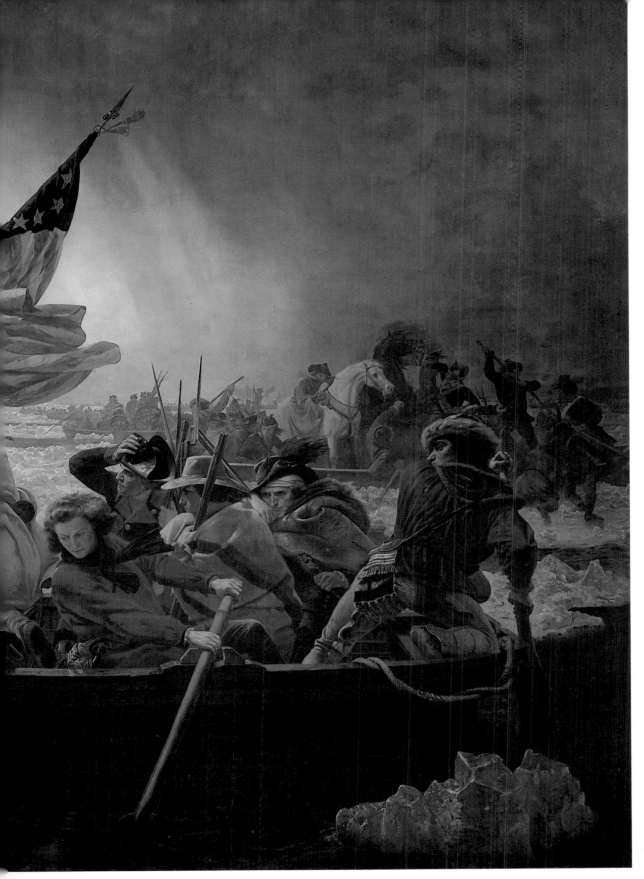

40 *Washington Crossing the Delaware*, 1851
Emanuel Gottlieb Leutze,
1816–68
Oil on canvas; 149 x 255 in.
(378.5 x 647.7 cm.)
Gift of John S. Kennedy,
1897 (97.34)

Leutze painted a second version, seen here, and sent it to America where it was exhibited throughout the country. The third version, a small one about one-third the size of the one in The Metropolitan Museum, was commissioned for use by a Paris engraver, who in 1853 produced a print that gave the painting the status of a national monument. It had already won the acclaim of members of Congress, who tried to buy it for the White House when the Museum's version was exhibited in Washington in 1851. Since it had already been purchased by a New York collector, this plan fell through, and although Leutze offered to paint another version, the idea appears to have been dropped.

Certainly, despite its flaws and inaccurate details—for instance, the iron boats really used were much larger than those in the picture, and the flag, as depicted, was not introduced until six months after the event—the painting captured and has held the affection of succeeding generations of Americans.

41 *Chief Justice Lemuel Shaw*, 1851
Albert Sands Southworth, 1811–94,
and Josiah Johnson Hawes, 1808–1901
Daguerreotype; 8½ x 6½ in.
(21.6 x 16.5 cm.) in frame
Gift of Alice M. Hawes and
Marion A. Hawes, 1938 (38.34)

42 *A Midnight Race on the Mississippi*, 1860
Nathaniel Currier, 1813–88, and
James Merritt Ives, 1824–95
Hand-colored lithograph; 18 x 27¾ in.
(45.7 x 70.5 cm.) Bequest of
Adele S. Colgate, 1962 (63.550.56)

PRINTMAKING AND PHOTOGRAPHY

By the 1840s, every major East Coast city in North America
had a studio specializing in daguerreotype portraits, which
were replacing the painted portrait as a means of recording
the likenesses of prominent citizens. The Boston studio of
Albert Sands Southworth and Josiah Johnson Hawes was
one of the best known. The exceptionally high quality of
their portraits made them popular with the intelligentsia of
their day—among their sitters were Daniel Webster and
Harriet Beecher Stowe.

This portrait of Massachusetts Chief Justice Lemuel Shaw
was executed in 1851. Shaw's left hand rests on a large book,
a symbol of his profession and erudition, much as in painted
portraits where sitters were shown with identifying attributes.
While obviously posed in formal attire (despite the wrinkles,
the half-closed button at the bottom of the coat, and the
crooked tie.pin), Shaw does not look deadpan into the camera
as did so many sitters for early photographs. Rather, his
head is slightly tilted, and his gaze is directed to one side as
if engaged in deep thought. His rugged features combine
with the strong, dramatic shadows cast over his face to yield
the sense of a powerful intellect. Interestingly, the shadows
were a happy accident. While awaiting preparation of the
photographic plate, Shaw stood beneath a skylight. Struck
by the powerful effect of the shadows, the photographers
asked their sitter to remain there, and in a matter of seconds
the portrait was taken. Lemuel Shaw has not been prettified,

as was customary in many portraits of the time. It is the power of his character that Southworth and Hawes have memorialized in this portrait.

While the advent of the daguerreotype threatened the role of the painted portrait, the dissemination of popular images, whether of newsworthy events, historical scenes, or famous paintings, remained the province of lithography. The New York City firm of Currier and Ives, founded in 1835, was one of the best-known firms of commercial lithographers in the United States.

In response to the growing national enchantment with the Mississippi, the firm produced a series of more than thirty prints of the great river. The most popular of these were depictions of steamboat races, of which *A Midnight Race on the Mississippi* is one of the best.

This print illustrates the race between two majestic side-wheelers, the *Natchez* and the *Eclipse*. Lit by the shimmering, delicate light of the moon —momentarily uncovered by the parting clouds—it is a romantic rendering of the Mississippi, which remains a powerful image for Americans.

GHT RACE ON THE MISSISSIPPI.

43 Etagère
New York, ca. 1850
Alexander Roux, act. 1837–81
Rosewood, chestnut, poplar, maple;
H. 86 in. (218.4 cm.)
Sansbury-Mills Fund, 1971
(1971.219,220)

ROCOCO REVIVAL ETAGERE

In the 1830s, furniture designers in Europe began to turn
to the recent past for ideas and inspiration. Among the styles
they sought to revive was the French Rococo, which had
originated during the reign of Louis XV. The serpentine
lines and S-curves of the original style were reinterpreted
by nineteenth-century craftsmen to express the literal mean-
ing of the French *rocaille,* or rockwork, used in eighteenth-
century grottoes.

The style appeared in America during the 1840s and
became prevalent in the following decade. This étagère, a
perfect example of the Rococo Revival style, was made by
Alexander Roux, based in New York.

The étagère was a new form during the Victorian Period.
Basically, it was composed of a pier table surmounted by
shelves or *étages,* intended for the display of curiosities, ob-
jets d'art, and other symbols of travel or taste. Here the
shelves support an extensive collection of unglazed porce-
lain called Parian ware. Developed in England and intro-
duced to America in the middle of the last century, Parian
ware is named for its resemblance to marble quarried on
the Aegean island of Paros. Like the carved woodwork of
the étagère itself, Parian ware has abundant decoration.

GOTHIC REVIVAL COUCH

One of a number of revival styles popular in the early nine-
teenth century, the Gothic became a significant trend in
America in the 1830s. Like the Renaissance and Rococo
revivals, the Gothic sought, through an eclectic choice of
ornament, to evoke the romantic aura of the past—a sim-
ilar goal was pursued in the literature and art of the period.
Gothic Revival-style furniture bears no resemblance to ac-
tual Gothic prototypes but borrows a vocabulary of ornament
—the pointed arches, crockets, and finials of Gothic archi-
tecture—and uses it to embellish furniture types from the
earlier 1800s.

The style was brought to America by English-trained ar-
chitects and through the designs of numerous illustrated
books on architecture. The American architect Alexander
Jackson Davis popularized the style in the United States. He
reassured his patrons, who were "foolishly frightened by a
few crockets and finials," and suggested revival furniture
styles appropriate for each room. The Elizabethan and Ro-
coco were to be used in parlors and in sitting rooms, and
the Gothic in libraries and halls. Davis left a legacy of Gothic-
style villas throughout the country.

The strange form of this Gothic Revival couch derives
from the French sofa known as a recamier after the Pari-
sian socialite, Mme. Récamier (1777–1849), in whose salon
such a daybed was used. The form was initially borrowed
from classical antique furniture and has been updated here
in the fashionable Gothic manner with richly tufted uphol-
stery and Gothic ornament. The back suggests a Gothic tower
crowned by three elaborate finials and a trefoil arch. The
stiles that frame it are pierced in the Gothic fashion and the
arms serve as buttresses. Although the maker is unknown,
the couch closely resembles a set of four hall chairs made
for the antebellum house of Frederick Stanton in Natchez,
Mississippi.

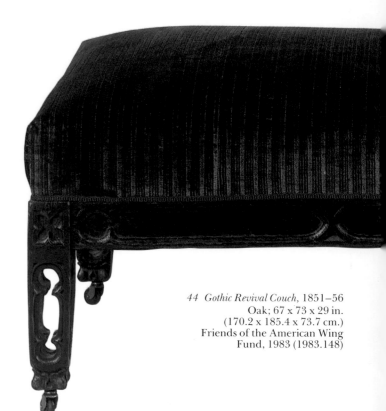

44 Gothic Revival Couch, 1851–56
Oak; 67 x 73 x 29 in.
(170.2 x 185.4 x 73.7 cm.)
Friends of the American Wing
Fund, 1983 (1983.148)

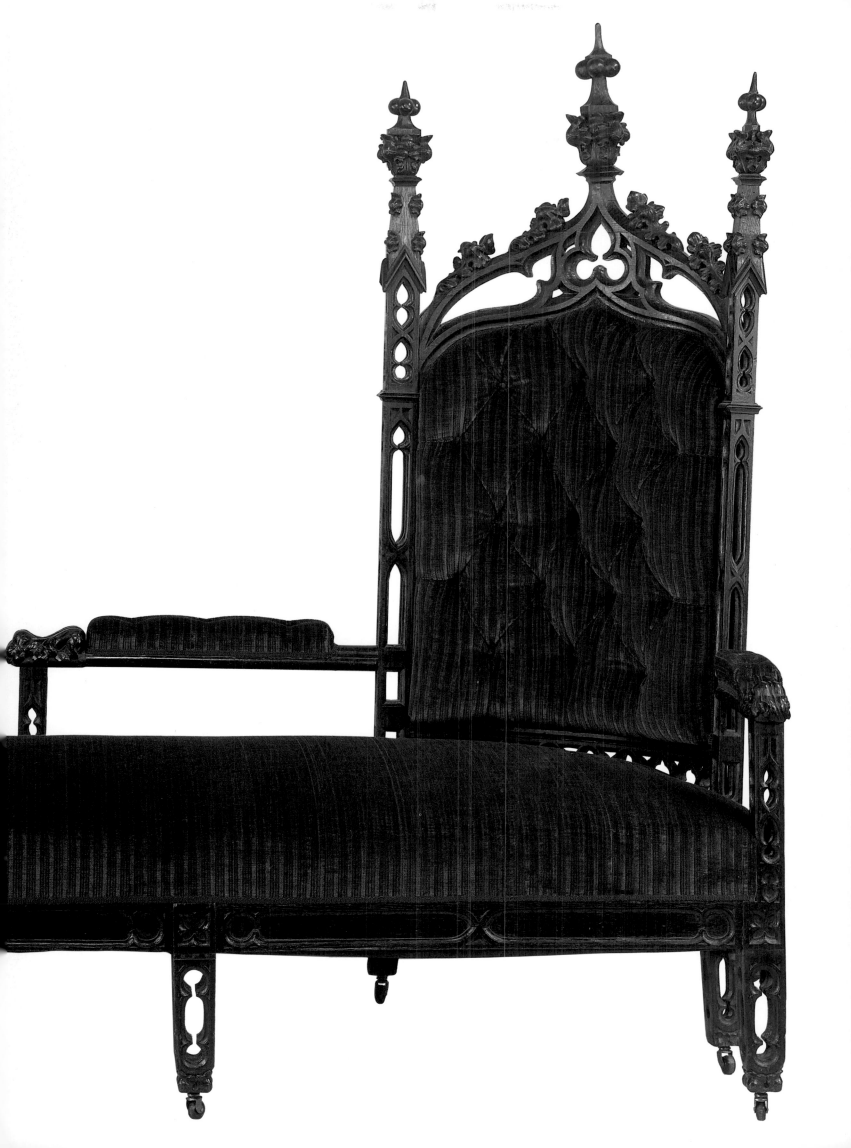

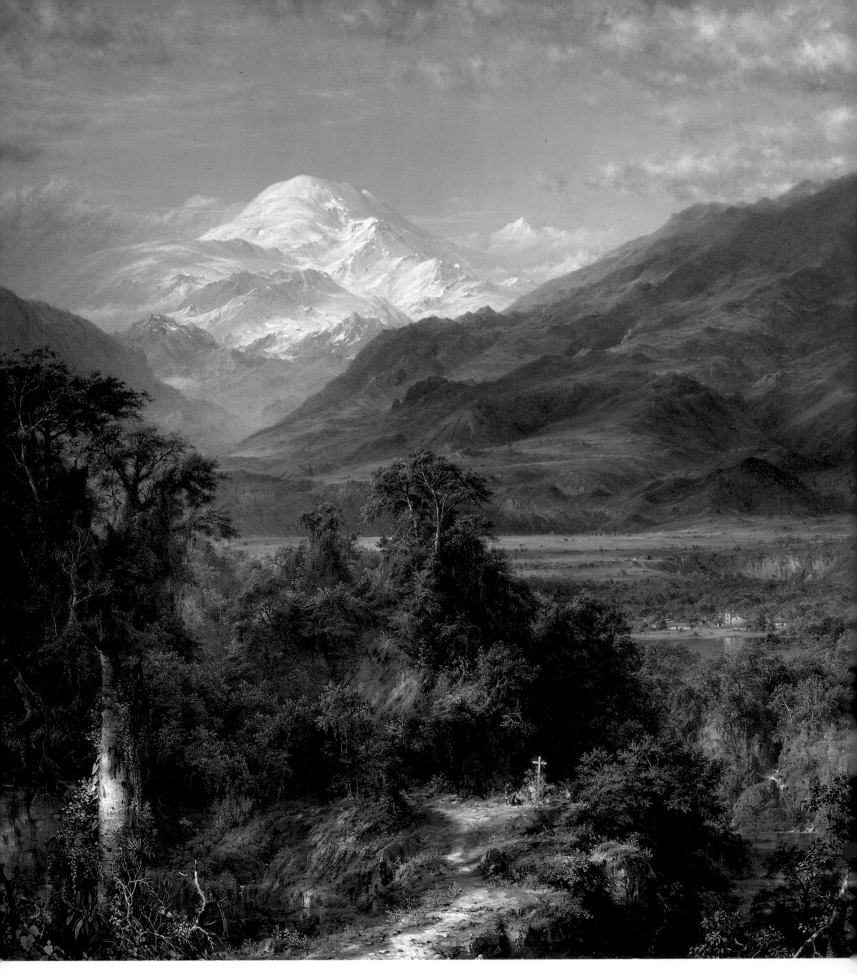

45 Heart of the Andes, 1859
Frederic Edwin Church, 1826—1900
Oil on canvas; 66½ x 119¼ in.
(168.9 x 302.9 cm.) Bequest of
Margaret E. Dows, 1909 (09.95)

Pages 68—69: text and details

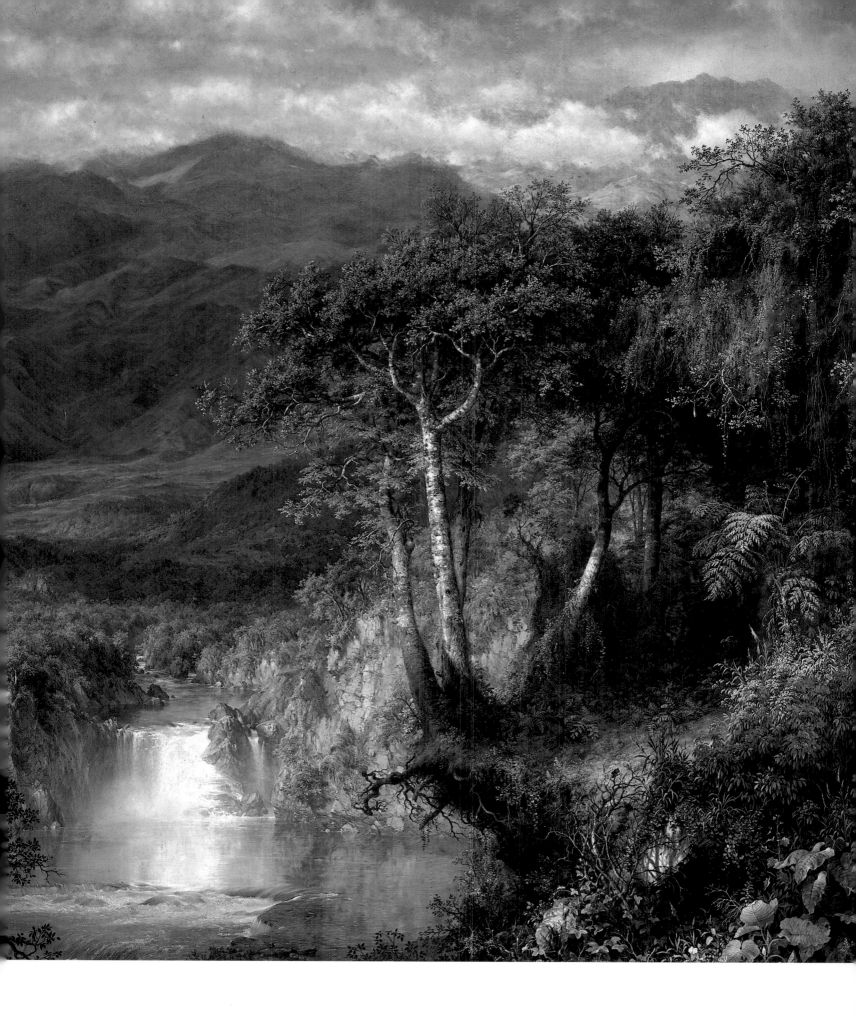

Frederic Edwin Church (Pages 66–67)
Heart of the Andes

Just as Thomas Cole stands out as the major figure in the first generation of Hudson River School painters, so Frederic Edwin Church dominates the second. He was the only pupil Cole actually taught, although Cole's influence spread wide, and, together with Albert Bierstadt, Jasper Cropsey, and various other painters, he carried on the work of memorializing the preindustrial beauty of America. Indeed, when European critics saw Church's *Niagara*, painted in 1856, they found that it opened "an entirely new and higher view both of American nature and art."

Unlike his predecessors, Church did not confine himself to views of New York and New England. By the 1850s, influenced by the writings of the great explorer Alexander von Humboldt, he was journeying to South America and making sketches that were the basis of his great tropical panoramas.

Church painted nature with an almost religious fervor and sense of awe. Like many of his contemporaries, he was convinced that the opening of frontiers and westward expansion were America's destiny. These scenes of nature's vastness reflected a growing sense of national history and the belief that there was a God-given future for the American people. Yet at the same time there was a creeping awareness that the unspoiled innocence of all this beauty was threatened by the advances of man.

When *Heart of the Andes* was first shown to the public in 1859, it caused a sensation. It was artfully placed in a darkened gallery in the Tenth Street Studio Building in New York, set in a frame made to look like a window, surrounded by tropical plants, and highlighted by gas jets. After taking in the magnificence of the whole panorama, viewers were handed tubes through which they could isolate small areas and explore the almost photographically reproduced details of the flora. In many ways, this painting carried the ideas of the Hudson River School to their culmination.

Left and right: details of *Heart of the Andes* (Plate 45)

46 *The Coming Storm*, 1859
Martin Johnson Heade, 1819–1904
Oil on canvas; 28 x 44 in.
(71.1 x 111.8 cm.) Gift of
Erving Wolf Foundation and
Mr. and Mrs. Erving Wolf, 1975
(1975.160)

MARTIN JOHNSON HEADE
The Coming Storm

For about fifteen years in the third quarter of the nineteenth century, a small group of American painters experimented with the effects of light on the landscape, thus earning themselves (retrospectively) the label Luminists. The main exponents of this trend were Martin Johnson Heade, Fitz Hugh Lane, and to a lesser extent, John Frederick Kensett and Sanford R. Gifford. Their attempt to omit any evidence of their presence from their paintings, minimizing visible brush-strokes and creating an almost glassy stillness and clarity, has a kinship to the works of the twentieth-century Photo-realists. They were assisted in their attempt to create an eerily intense atmosphere by the recent development of new chemical paints that created hot and sharp colors.

Heade was not a great success in his own time. In common with the later Hudson River School painters, he found that his carefully detailed, painstakingly clear style was considered

old-fashioned by an art-buying public that was beginning to enjoy the work of the Impressionists. In his early life he earned his living by painting portraits that were almost photographic in their facial detail, but his chief pleasure lay in landscapes. As his work matured, he became increasingly fascinated by the beauty of the sea and the ominous glow of stormy light.

The Coming Storm, one of a series of storm-threatened seascapes, was painted in 1859. The lowering darkness of the background, set against the sharply sunlit foreground, produces an atmosphere of almost surreal intensity. The pure, cold clarity of these marine paintings is in great contrast to another series of paintings that occupied Heade at the same period: lush studies of birds and flowers in the tropical landscapes that he visited on his travels in South America, portrayed with exacting detail.

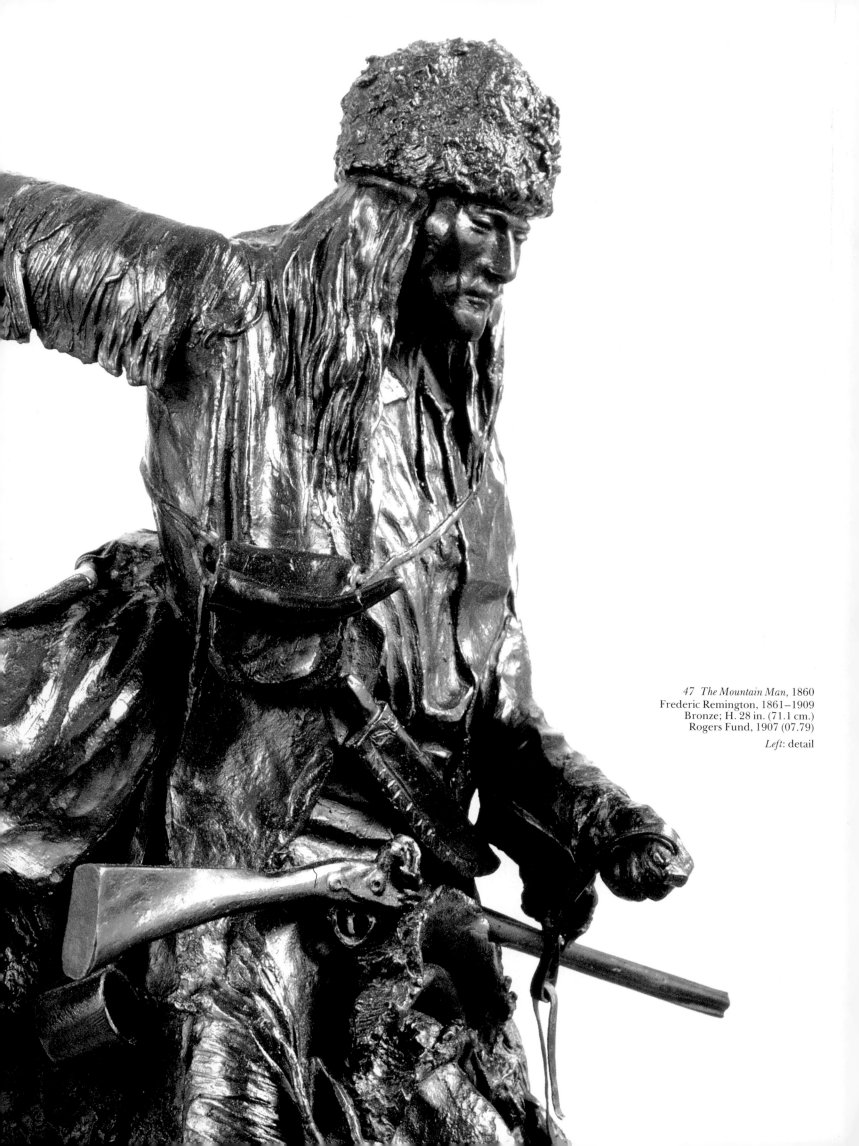

47 The Mountain Man, 1860
Frederic Remington, 1861–1909
Bronze; H. 28 in. (71.1 cm.)
Rogers Fund, 1907 (07.79)

Left: detail

FREDERIC REMINGTON
The Mountain Man

Toward the end of the nineteenth century, after the surge westward and the self-confident implementation of the theory of Manifest Destiny, Americans began to feel nostalgic for what was already rapidly becoming the "Old West." For some time, American artists had been expressing their concern for the passing of the old, unspoiled beauty of the land, but Frederic Remington was interested in quite another aspect of the passing age: the old ways of the wilder times that were becoming obsolete as the country settled into a more regulated existence.

Remington grew up and lived most of his life in the East, but his heart was definitely in the old frontier West. After a year at the Yale Art School, he went out west and tried ranching, saloon-keeping, working as a cowboy, and fighting Indians with the army—activities that provided him with subjects for his art for the rest of his life. On his return to the East, he became an illustrator and writer; he turned to bronzes partly as an additional source of income. Many of his statuettes were interpretations of his own drawings and paintings, and they were highly sought after.

The Mountain Man, of which there are about forty extant castings, was one of four statuettes bought directly from the artist in 1907 by The Metropolitan Museum. It depicts an Indian trapper guiding his horse cautiously down a steep mountain trail. The stance of both man and beast testifies to the skill, trust, and cooperation that made the old way of life possible, and in retrospect, so romantic.

48 *The Indian Hunter*, 1860
John Quincy Adams Ward, 1830–1910
Bronze; H. 16 in. (40.6 cm.)
Morris K. Jesup Fund, 1973 (1973.257)

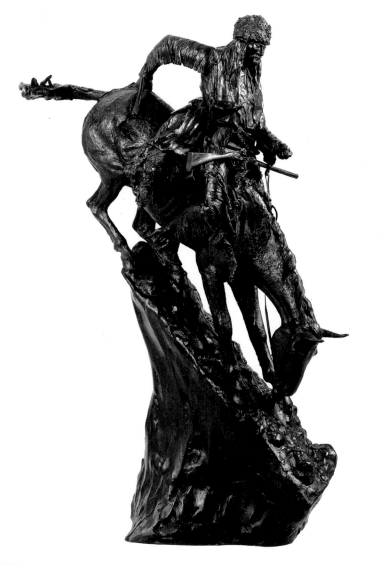

JOHN QUINCY ADAMS WARD
The Indian Hunter

The Indian Hunter, one of the first large works by John Quincy Adams Ward, was modeled in 1860 from sketches the artist made from life when traveling in the Dakotas. A large version of the statuette was bought for placement in Central Park in New York, and it led to a constant stream of commissions for portraits and monuments thereafter.

Ward gained his early experience as a sculptor working as a studio assistant, and from 1861 on he worked as a designer of small decorative objects, making hilts, handles, and inkwells cast in precious metals. He did not follow the usual path of the young American artist and go to Europe for his training. Indeed, he had strong feelings about American expatriate artists, because he was convinced that "we shall never have good art at home until our best artists reside here."

Ward became one of the leading American sculptors of the second half of the nineteenth century. His work marked the turn from a classical to a naturalistic style and influenced such disparate artists as Augustus Saint-Gaudens and Frederic Remington.

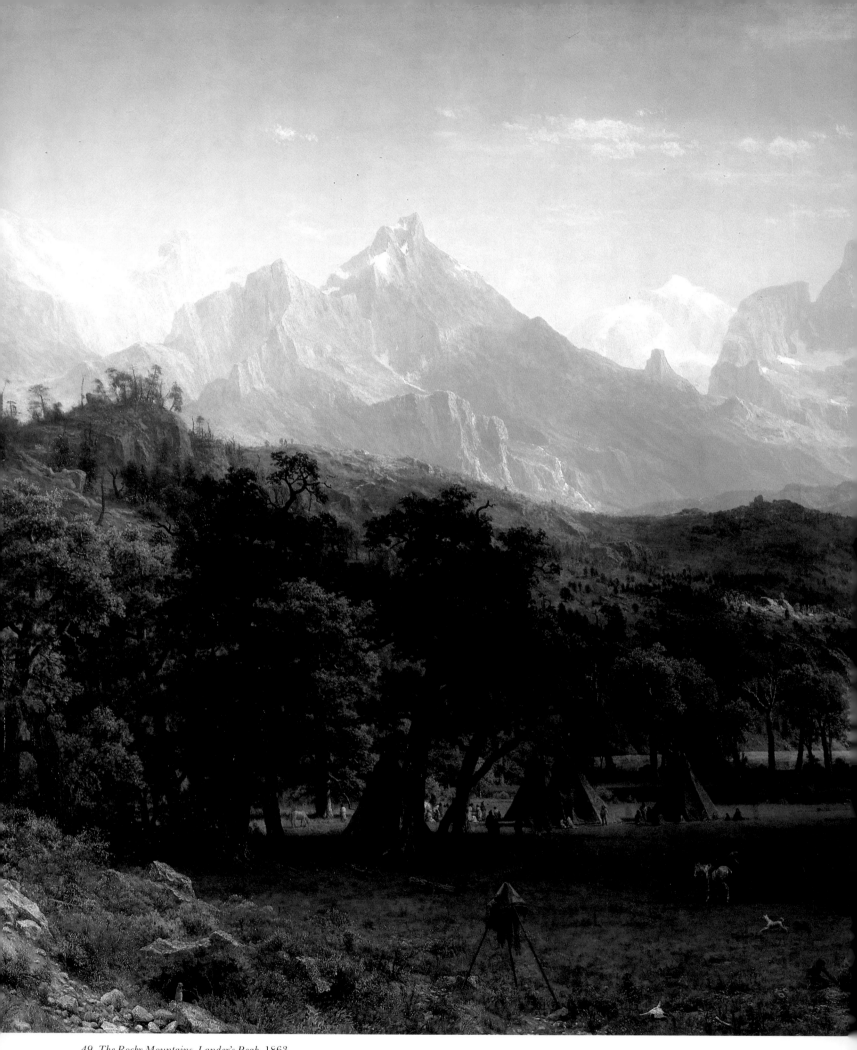

49 The Rocky Mountains, Lander's Peak, 1863
Albert Bierstadt, 1830–1902 Oil on canvas;
73¼ x 120¾ in. (186.1 x 306.7 cm.)
Rogers Fund, 1907 (07.123)

Page 76: text

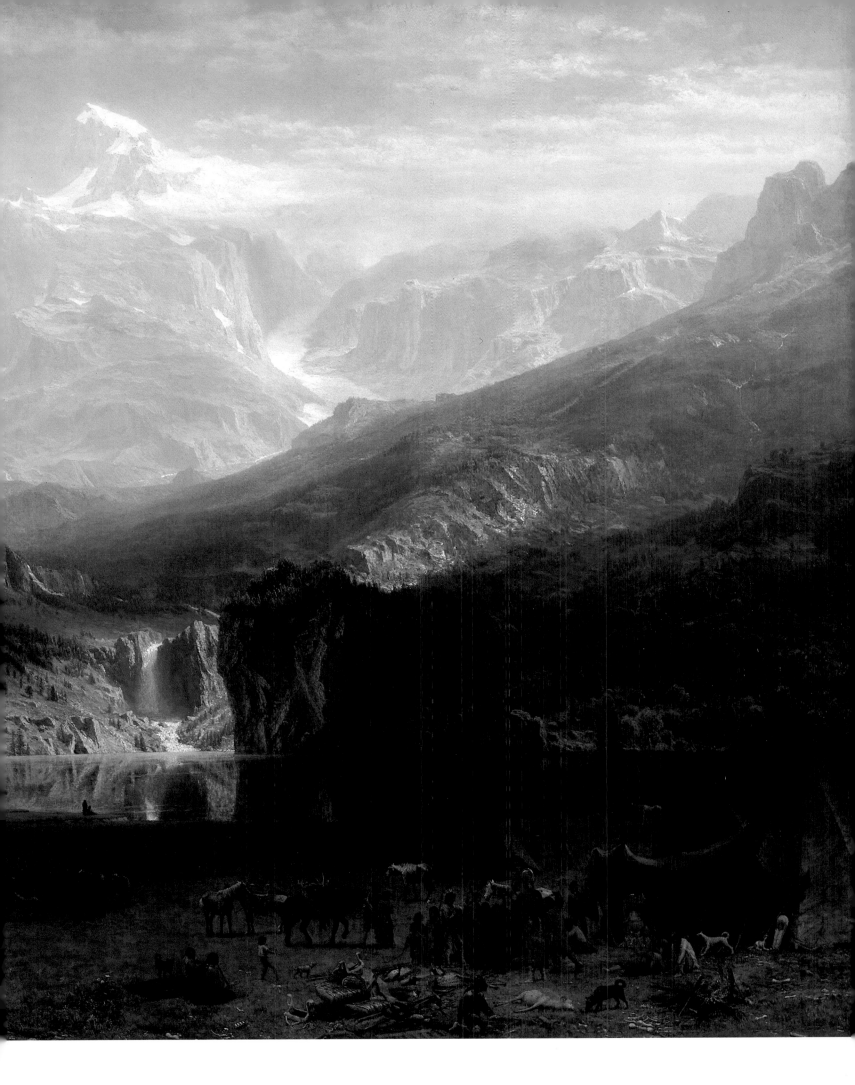

ALBERT BIERSTADT *(Pages 74–75)*

The Rocky Mountains, Lander's Peak

The mid-nineteenth century was a time of great optimism in America. The vast expanses of the West were no longer terra incognita; America was becoming increasingly acquainted with the farthest reaches of its territory and was getting down to the business of domesticating them. There was a conviction that it was the ordained destiny of the European settlers to develop the almost overwhelming potential of the land, and that the abundance of fertile space was God-given.

Albert Bierstadt certainly believed this. He came to America from Solingen, Germany, as a young child and settled with his family in New Bedford, Massachusetts. He trained as a landscape artist and went to Düsseldorf in the 1850s to study art. When he returned to America in 1857, Bierstadt specialized almost immediately in paintings of the West. In 1859, he joined the expedition led by Colonel Frederick William Lander to survey an overland wagon route westward. This was the first of three cross-country journeys during which Bierstadt was overawed by the beauty of the soaring mountains and fertile valleys and the untrammeled simplicity of life there. He likened the majesty of the Rockies to that of the Bernese Alps and said of the Indians, "... they are still as they were 100s of years ago, and now is the time to paint them."

The Rocky Mountains, Lander's Peak, was based on studies and sketches he made that summer of the Shoshone Indian encampment near Lander's (now Fremont) Peak, Wyoming. Bierstadt's passion for the West, with its majestic scenery and Edenic expanses, is recorded here with the clarity and minute detail that established his reputation.

50 *Prisoners from the Front*, 1866
Winslow Homer, 1836–1910
Oil on canvas; 24 x 38 in.
(61 x 96.5 cm.) Gift of
Mrs. Rachel Lenox Porter, 1922
(22.207)

WINSLOW HOMER

Prisoners from the Front

During the Civil War, from 1861 to 1865, Winslow Homer was employed by *Harper's Weekly* as an artist-correspondent, attached to the Union troops. He sent back sketches for engraving, and at this time, he began to experiment with oils and watercolors. *Prisoners from the Front,* which was exhibited in 1866, brought him immediate fame both for its innate artistry and also because its timely subject matter touched a nerve in a people shocked by the uniquely agonizing experience of civil war. The Union officer in the painting, Brigadier General Francis C. Barlow, went on to become the attorney general who prosecuted the notoriously corrupt head of the New York political machine, Boss Tweed. And Homer went on to become known, in his own lifetime, as "the greatest American artist."

After the war and a trip to Europe, Homer settled down as a professional painter in New York. His exposure to French art had come at a very exciting time, and his work after this period shows clear signs of having been deeply impressed by both Manet and the Japanese prints that were sweeping Paris, particularly in his choice of lighter colors and his willingness to allow flat, unadorned surfaces in his work. His paintings during these years also show his movement away from narrative to designed composition.

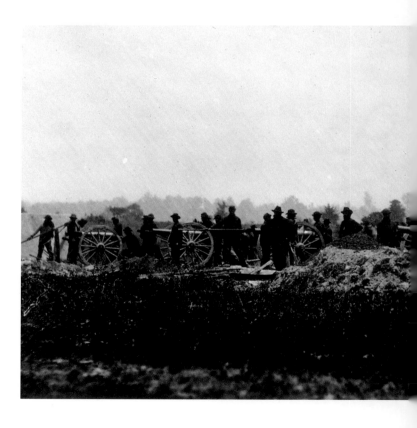

51 Battery With Cannon, 1864
Studio of Mathew Brady
Albumen print; 3 x 7⁷⁄₁₆ in.
(7.6 x 18.8 cm.)
Harris Brisbane Dick Fund,
1933 (33.65.241)

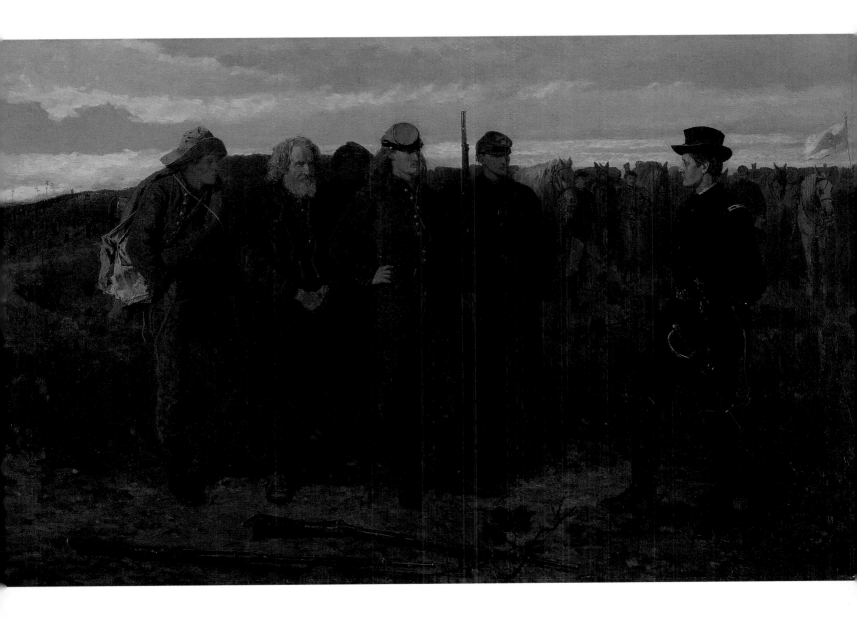

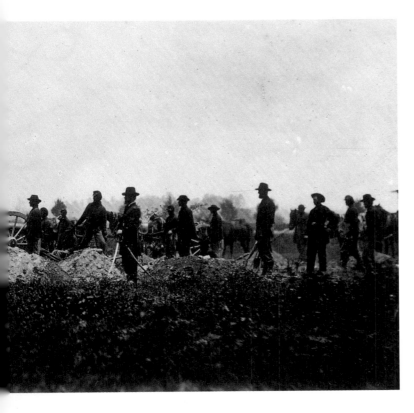

STUDIO OF MATHEW BRADY
Battery with Cannon

Mathew Brady was an extremely successful commercial photographer when he undertook the monumental task of documenting the Civil War. Conquering seemingly insurmountable difficulties, Brady remained on the battlefield throughout the war, employing a team of photographers and using wagons as darkrooms.

Because of the long exposure time needed for wet-plate photography, Brady and his team could not obtain action shots. Rather, most of his pictures show the effects of battle, depicting the devastation of life and land wrought by this most destructive and divisive war. Since Brady considered all photographs taken by his team to be "Brady photographs," we do not know for certain who took this picture of a battery poised on a battlefield.

The tremendous financial costs of Brady's Civil War project ruined him, and the photographer died penniless.

52 *View on the Columbia River – Cascades*, 1868
Carleton E. Watkins, 1829–1916
Albumen print from wet collodian negative;
15¾ x 20⅝ in. (40 x 52.2 cm.)
The Warner Communications Purchase Fund,
and the Harris Brisbane Dick Fund, 1979
(1979.622)

CARLETON E. WATKINS
View on the Columbia River–Cascades

The American wilderness was recorded by photographers as well as painters in the nineteenth century. The government expeditions that mapped the railroad to the Pacific employed photographers, as did the government geological surveys that began after the Civil War. It was the advent of wet-plate photography that enabled photographers to take the wide, panoramic views necessary for recording the wilderness, though this process compelled them to carry a good deal of cumbersome equipment, glass plates, and chemicals over extremely rough terrain.

Carleton E. Watkins was one of the most important wilderness photographers of his generation. In his *View on the Columbia River–Cascades*, we can see that Watkins attempted more than documentation of the wilderness: He has imposed an order and design on the natural scene before

him, and the picture is artfully composed. The artistry of Watkins's composition is most evident in his treatment of the trees in the foreground. The left-hand tree is bisected by the picture's edge, and the half that is shown is itself bisected into vertical areas of light and shadow. The upright, straight line of this tree is softened by the gently curving one next to it. The fallen tree on the right leads our eye to the middle ground, and the trees on the opposite bank lead us into the background. The transitions from foreground to middle ground to background are further smoothed by the echoing shapes of the land masses. The triangle of foreground land is reiterated by the land behind it and counterpoised by the mass jutting in on the right; the treetops on the land in the left middle ground have their counterpart in the silhouette of the mountain in the right background.

78

53 Lake George, 1869
John Frederick Kensett, 1816–72
Oil on canvas; 44¼ x 66⅜ in.
(112 x 168.6 cm.)
Bequest of Maria DeWitt Jesup,
from the collection of her husband,
Morris K. Jesup, 1914 (15.30.61)

JOHN FREDERICK KENSETT
Lake George

Like several other American painters known for their clarity of detail—including Asher Brown Durand and William Michael Harnett—John Frederick Kensett came to painting via engraving, which he learned from his father and uncle in the family business. He worked hard at engraving but did not enjoy it, although the patience and accuracy necessary for this technique were to prove useful in his painstaking oils later on. His meeting and developing friendship with the painter and engraver John Casilear broadened Kensett's horizons and led him to landscape painting. In 1840, he went to Europe in the company of Durand and Casilear. He stayed in England for five years; later he said he felt that his real life began when he studied the English countryside. Kensett treated his landscape paintings with an almost scientific approach. He was particularly interested

in the effects of light and would often paint the same view at different times of day or in different weather conditions. Together with Fitz Hugh Lane, Martin Johnson Heade, and Sanford R. Gifford, he painted works in the style now called Luminism. He is also considered one of the Hudson River School artists, whose aim was to commit to canvas the grandeur and unspoiled beauty of the American landscape. The soft luminescence of his scenes is more akin to the light in the Hudson River paintings than to the hard, glassy quality of Heade and Lane.

Lake George, painted in 1869, is considered by many to be Kensett's masterwork. It is a perfect example of his ability to convey atmosphere by his use of light, and also of his popularity: It originally sold for three thousand dollars, which was then a very large sum for a painting.

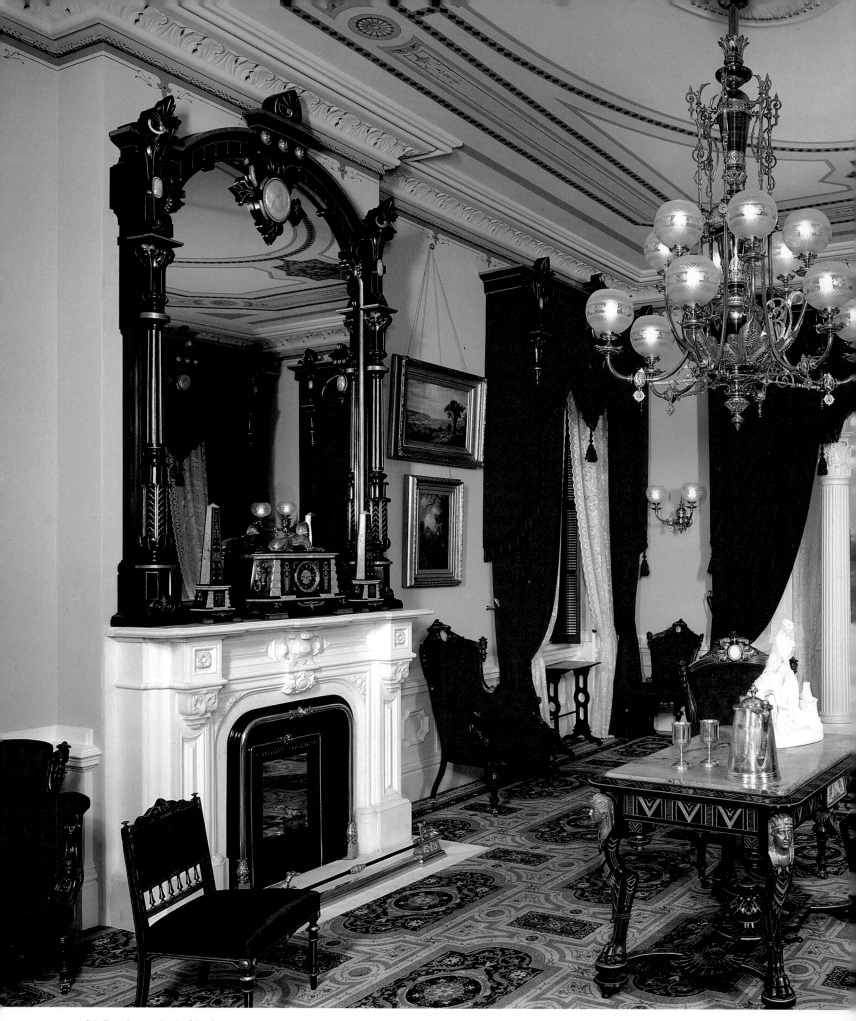

54 Renaissance Revival Parlor
Meriden, Connecticut, 1868–70
33 ft. ¾ in. x 17 ft. 7⅜ in. x 13 ft.
(10.1 x 5.4 x 4 m.)
Architecture and selected furnishings:
Gift of Josephine M. Fiala, 1968
(68.133.7)

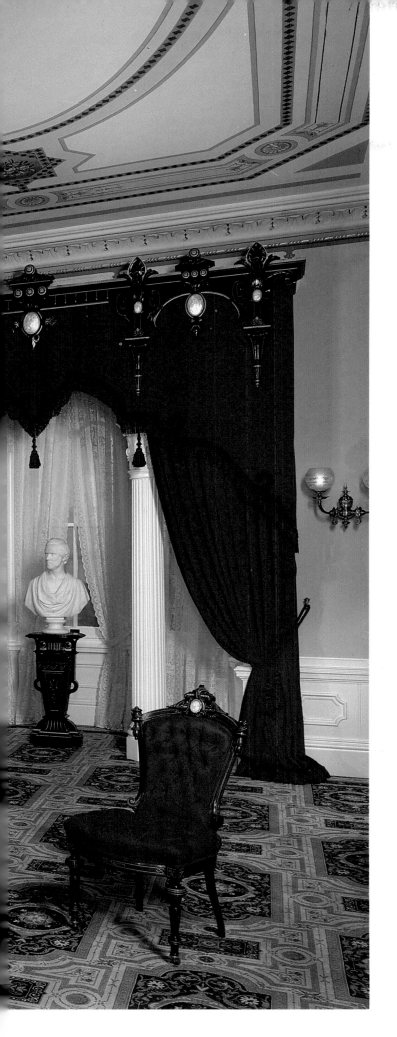

RENAISSANCE REVIVAL PARLOR

This parlor is one of two rooms salvaged from the forty-room mansion of Jedediah Wilcox in Meriden, Connecticut. The house was begun in 1868, amid a burst of post-Civil War prosperity, as the stylish residence of a women's haberdasher who had first made his fortune manufacturing carpetbags and then increased it with the production of hoops for crinoline skirts. The house was built over a period of three years, during which time roughly two hundred thousand dollars were spent on the construction, furnishings, and decorations; in November 1870, Mr. and Mrs. Wilcox moved in.

Though but one of many rooms in the house, this rear parlor displays the revival styles—Renaissance and Neo-Grec in particular—popular in America during the 1870s. The Renaissance Revival is characterized by massive forms and deeply carved ornament; the Neo-Grec, by the application of Greek ornament to Renaissance shapes. The parlor was described in the *Meriden Daily Republican* (1870) as being "fitted up in the Marie Antoinette style of art." Classical elements include the Corinthian columns and pilasters that frame the projecting niche at the east end of the room, and the mother-of-pearl medallions, carved with classical figures, that decorate and punctuate the woodwork.

The architect, Mr. A. Truesdale of Rockville, Connecticut, seems to have been involved in both the construction of the room and in all of its decoration and detail. The motif of the raised cabochon, for example, can be seen in the great wood cornices, the window mullions, the white marble surrounding the fireplace, and in the crests of the furniture.

All of the woodwork is original to the room and is installed in the Museum in its exact dimensions and proportions. Most of the furniture is also original and has been attributed to John Jelliff of Newark, New Jersey. It forms a parlor suite consisting of two armchairs, a sofa, and two side chairs. The suite is decorated with oval medallions of mother-of-pearl that can also be seen on the cornices, valances, and overmantel mirror. The furniture has been re-covered with a reproduction of its original scarlet silk damask. An example of the heavy curtains of this period and the architectural importance of the valances from which they were hung can also be seen in a contemporary portrait of the Hatch Family by Eastman Johnson (Plate 57).

As elaborate as the cornices that surround the windows and doorways is the spectacular painted ceiling, which crowns and seems to distill the opulent taste of the Wilcox house. Painstakingly drawn in pastel colors, the ceiling is covered with a medley of decoration that includes palmettes, fans, and urns, interspersed with trompe-l'oeil rosettes. In the center is a carved stucco rosette from which a twelve-arm gilt chandelier is suspended.

When fashions changed, the Wilcox fortune dwindled. In the mid-1870s the house passed to Charles Parker, a wealthy local merchant who had once been mayor of Meriden, and in the early 1950s it became a home for the elderly. In 1968, to make room for a highway, the Wilcox mansion was razed.

55 *Cabinet*
New York, ca. 1865
Alexander Roux, act. 1837–81
Rosewood, ebony, porcelain, gilt
bronze; 53⅜ x 73⅜ x 18⅜ in.
(135.5 x 186.4 x 46.7 cm.)
Purchase, The Edgar J. Kaufmann
Foundation Gift, 1968 (68.100.1)

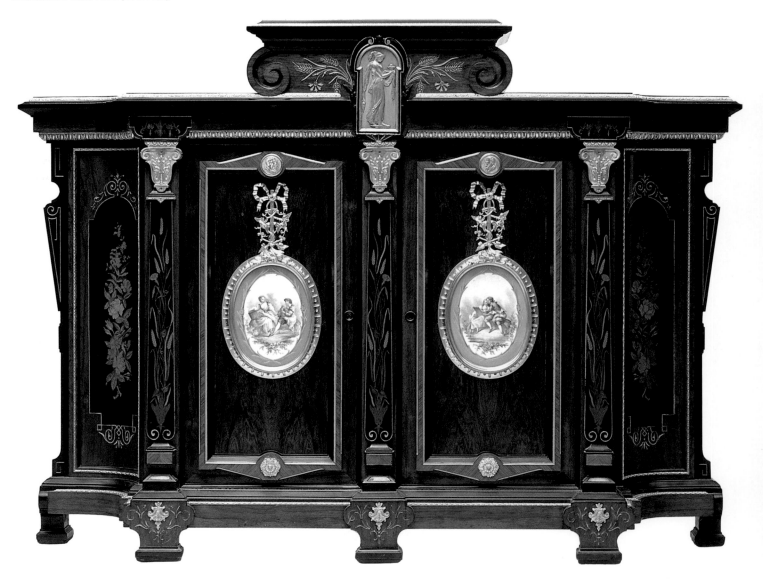

RENAISSANCE REVIVAL CABINET

The so-called Renaissance Revival style was popular in America during the 1850s and 60s. One of a number of Victorian revivals, the Renaissance style borrowed selectively from actual Renaissance prototypes and overlaid these borrowings with the ornamentation of other historical periods. It was a style greatly favored by the new furniture factories producing in mass for a middle-class clientele.

Made from rosewood, which was greatly favored by the early Victorians, this cabinet is an eclectic combination of a Renaissance credenza, or sideboard, with ornaments derived from classical antiquity, the French Louis XVI period, and the Orient. Assembled here, they seem to attempt to arouse a nostalgia for these widely disparate cultures. Classical antiquity is evoked by the long pilasters with their fanciful Ionic capitals and the maiden clad in loose drapery, shown in profile on the central plaque. The ormolu mounts in the form of bows, the painted porcelain ovals they suspend, and the elaborately patterned inlay or marquetry all suggest Louis XVI's France. The inlaid wisps of wheat that decorate the narrow pilasters suggest the Orient.

The cabinet bears the label of Alexander Roux, a French emigré who became one of the leading New York cabinet-makers of his day (see Plate 43). Newspapers found behind the porcelain plaques date the piece to 1866.

EGYPTIAN REVIVAL SIDE CHAIR

As a result of Napoleon's North African campaign of 1798, Egyptian motifs began to enter the vocabulary of European design. Drawings by archaeologists who accompanied the campaign provided designers with winged sphinxes, lotus flowers, and furniture types decorated with various combinations of human and animal forms. Because these motifs frequently appear in the context of the Neoclassical style, which was current at the same time, it is not surprising that they are sometimes found on American Greek Revival furniture.

This side chair combines Neoclassical and Egyptian decorative motifs and, though originally called "Neo-Grec," is today viewed as representative of the Egyptian Revival style. It is thought to be the work of the New York firm of Auguste

Pottier and William Stymus, who have been credited with some of the most eclectic and exuberant furniture produced in America in the latter part of the nineteenth century. The firm catered to the carriage trade, counting among its patrons some of this country's legendary plutocrats: Henry Flagler, George Westinghouse, William Rockefeller, Charles Crocker, and Leland Stanford. It was not only a furniture-making establishment but also a large-scale interior-decorating concern. At one time, Pottier and Stymus counted over seven hundred men and women as employees, assigned to specialized departments such as tapestry-weaving, bronze-casting, veneering, and upholstery. They never manufactured furniture in mass quantities but concentrated instead on luxury items.

56 *Side Chair*
New York. ca. 1875
Probably Auguste Pottier and
William Stymus
Rosewood, cedar veneers, walnut;
37⅛ x 18 x 17½ in.
(94.3 x 45.7 x 45 cm.) Purchase,
Charlotte Pickman-Gertz Gift,
1983 (1983.68)

OVERLEAF:

EASTMAN JOHNSON
The Hatch Family

(*Pages 84–85*)

Social history before the age of photography is often brought to life for later generations by genre painters, who specialized in the candid depiction of daily life and its round of routine activities. Eastman Johnson painted portraits for the purpose of earning a living, but his real interest was in painting life as it was going on around him. This is often apparent in his portraits, where background details and small, more casual asides sometimes obtrude in the most formal works.

The Hatch Family, commissioned in 1871, is an example of the type of formal family portrait, known as a "portrait interior," that became fashionable during the prosperous decades that followed the end of the Civil War. It immortalizes three generations of a wealthy Victorian family in the library of their solidly respectable house on New York's Park Avenue, at Thirty-Seventh Street. Indeed, the setting of the family group provides excellent and detailed documentation of a domestic interior of the period. The painting consists of an interesting combination of natural poses and classic formality—blending the relaxed look of the genre painting with the conventional stiffness of a commissioned portrait.

57 *The Hatch Family,* 1871
Eastman Johnson, 1824–1906
Oil on canvas; 48 x 73⅜ in.
(122 x 186.4 cm.) Gift of
Frederic H. Hatch, 1926 (26.97)

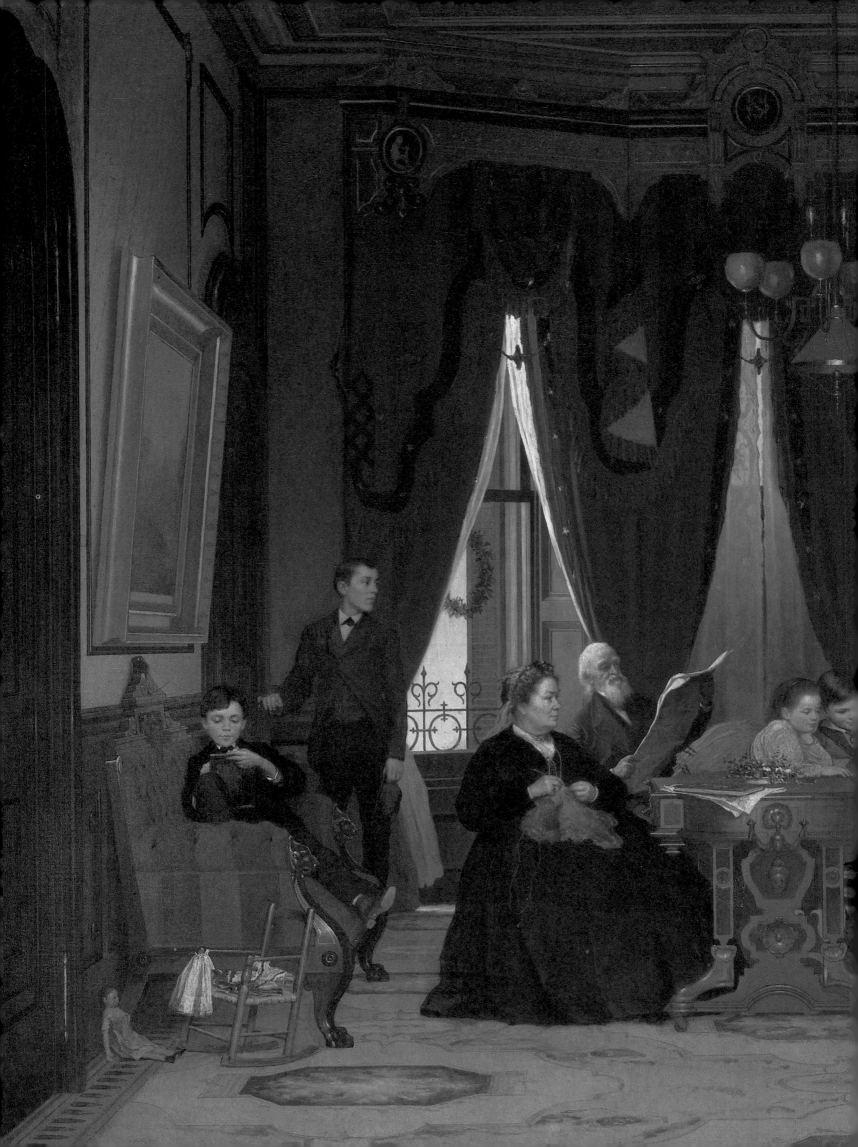

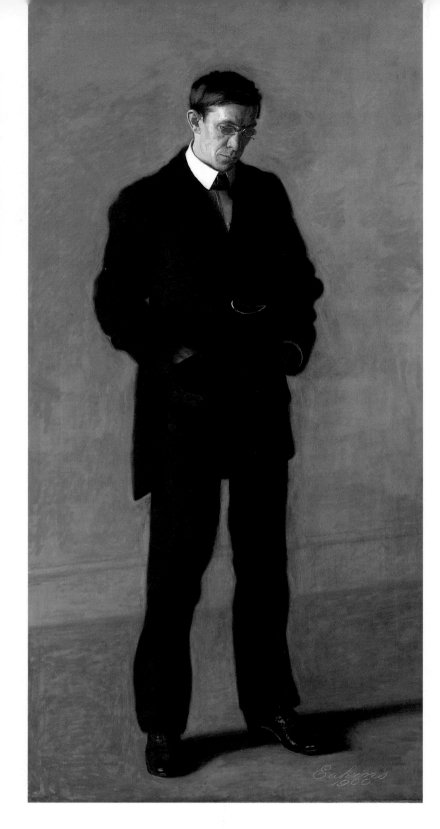

58 *The Thinker:*
Portrait of Louis N. Kenton, 1900
Thomas Eakins, 1844–1916
Oil on canvas; 82 x 42 in.
(208.3 x 106.7 cm.)
John Stewart Kennedy Fund,
1917 (17.172)

works of this type. Perhaps it was this earnestness and lack of leavening that robbed his works of their public appeal.

The Thinker: Portrait of Louis N. Kenton was painted in 1900, when Eakins was aging and lonely. He had already left his teaching position at the Pennsylvania Academy of the Fine Arts amid great dissent, and there is a sense of isolation and solemnity in this painting that almost says more about the state of mind of the artist than of the sitter.

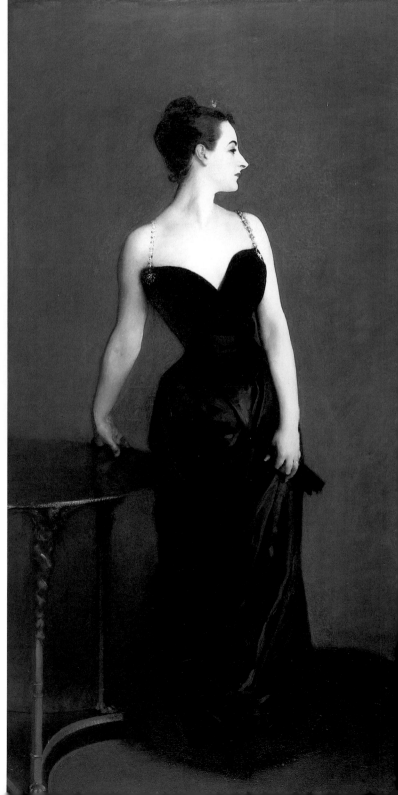

THOMAS EAKINS
The Thinker: Portrait of Louis N. Kenton

On a visit to the Prado Museum in Spain, Thomas Eakins was deeply impressed by Velázquez and Ribera, particularly with the format of vertical full-length portraits. Manet, Sargent, Whistler, and Chase all painted vertical portraits, but Eakins succeeded more completely than any of them in creating an ideal harmony of form, content, and style. He also absorbed and made his own Velázquez's way of portraying the inner persona of his sitter by means of a transient pose. Eakins was at all times a serious painter; he even brought a sense of sobriety to his genre paintings that sets them apart from the generally documentary or lighthearted

JOHN SINGER SARGENT
Madame X (Madame Pierre Gautreau)

Madame Gautreau, the subject of this early painting by John Singer Sargent, was born Judith Avegno, of New Orleans, Louisiana. She was one of the many American beauties who were paraded before the rich and aristocratic sons of Europe —transatlantic travel having become the sine qua non of the newly rich, who had made quick fortunes in the American hinterland and now wished to acquire a Continental chic.

Sargent met Madame Gautreau and recognized her at once as a dramatic foil for his talent. She agreed to have her portrait painted, and unfortunately it proved to be his undoing so far as Paris society was concerned. The painting had a difficult birth: Madame Gautreau was an inconsiderate sitter, and Sargent found her very difficult to paint, "... struggling, with the unpaintable beauty and her hopeless laziness. ..." The finished portrait was exhibited at the Salon of 1884 and caused an outcry among reviewers who were scandalized by the impropriety of the lady's décolletage and the heavy lavender makeup she wore. Distressed by the scandal, Sargent moved to London, where he settled for the rest of his life.

59 *Madame X (Madame Pierre Gautreau)*, 1882–84
John Singer Sargent, 1856–1925
Oil on canvas; 82⅛ x 43¼ in. (208.6 x 109.9 cm.)
Arthur Hoppock Hearn Fund, 1916 (16.53)

JAMES McNEILL WHISTLER
Arrangement in Flesh Colour and Black: Portrait of Théodore Duret

James McNeill Whistler and his fellow American expatriate, John Singer Sargent, became the two most lionized portrait painters in Europe during the last quarter of the nineteenth century, although they did not necessarily appeal to the same audience.

Théodore Duret was a powerful French art critic, an early supporter of the Impressionists, and Manet's champion in his struggle against the old guard. Like Whistler, he loved Oriental art, and when Manet introduced the two men in the early 1860s, they became fast friends.

As was the case with many of Whistler's works, the painting of Duret is candidly titled as a color study. The flesh tones of the man's face, the domino draped over his left arm, a vermilion fan clutched in his hand, and the artist's butterfly signature add color to a palette that otherwise consists of white, black, and grey. Whistler's style was very much his own, although there are clear indications of a variety of influences in his work. His choice of color was affected by his enthusiasm for Spanish painting (especially Velázquez) but his brushwork incorporates the beginnings of Impressionism, and the romantic aura of his style carries overtones of the Pre-Raphaelites. The large blank masses and the reduction of content to basics testify to the influence of Japanese woodcuts on Whistler's style.

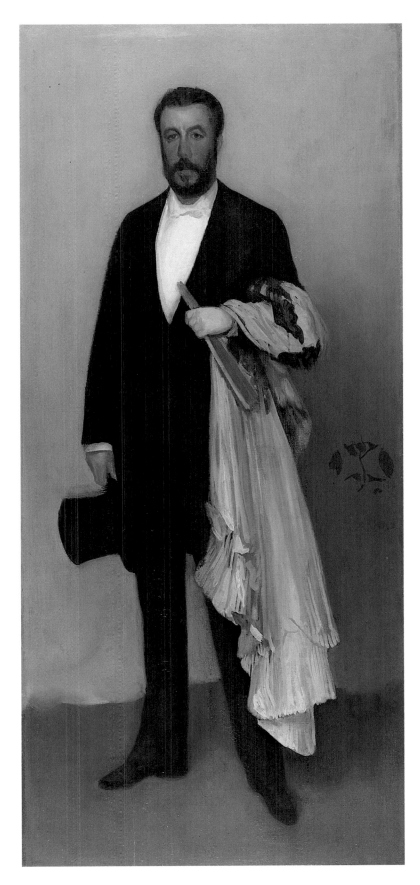

60 *Arrangement in Flesh Colour and Black: Portrait of Théodore Duret*, ca. 1883
James McNeill Whistler, 1834–1903
Oil on canvas; 76⅛ x 35¾ in. (193.4 x 90.8 cm.) Wolfe Fund, Catharine Lorillard Wolfe Collection, 1913 (13.20)

61 Max Schmitt in a Single Scull, or
The Champion Single Sculls, 1871
Thomas Eakins, 1844–1916
Oil on canvas; 32½ x 46¼ in.
(82.6 x 117.5 cm.) Purchase,
The Alfred N. Punnett Endowment
Fund and George D. Pratt Gift,
1934 (34.92)

Thomas Eakins

Max Schmitt in a Single Scull, or *The Champion Single Sculls*

In some ways, Thomas Cowperthwait Eakins is much more typical of the painter as he lives in the public imagination than most of the artists of his time and place. A man of great intensity, whose vision was penetrating and tinged with a detached intellectualism, Eakins was out of tune with the taste of his time and was never to achieve commercial success. In his old age, he even left his teaching position at the Pennsylvania Academy of the Fine Arts because of the harsh criticism of his teaching methods, which included the use of a male nude model in a class that included women. After this episode, he led a solitary life painting works that he knew were purely for his own satisfaction. America after the Civil War had become conservative, and Eakins simply did not fit in very well.

In his youth, Eakins trained as an anatomist at Jefferson Medical College, and there is in his works a deep concern for observation and logic that must both have led him to his early studies in anatomy and resulted from them. And yet, he never simply copied what he saw, for he believed that "the big artist does not sit down monkey-like and copy . . . he keeps a sharp eye on Nature and steals her tools." His paintings often depict events in daily life, but they are not really genre paintings because they are more conceptual abstraction and less straightforward reportage.

This painting of his close friend, Max Schmitt, reflects several elements of both Eakins's personality and his abilities. A keen rower, he produced several boating pictures that conveyed his pleasure with the sport. But at the same time he was able to maintain an intellectual distance from his subject, studying the composition and arrangement with care (he made several studies for the work), and concentrating on the sharpness of his draftsmanship. The reflection and refraction of the water demonstrate his precise scientific observation, but at the same time, like Julian Alden Weir (see Plate 74), he obviously derives enjoyment from the contrast between the mechanical exactitude of the bridge and the natural curves of the trees on the riverbank. Max Schmitt is in the foreground, crystal clear and dominant, but tucked immediately behind him on the right is the artist himself, as if unable to stay away from so attractive a scene. There is a mixture of detached observation and human warmth that lends the painting its complexity.

James McNeill Whistler

Nocturne

In the late 1870s, James McNeill Whistler returned to printmaking, which he had learned in his youth while at West Point. He took up etching and drypoint, and, with the expert guidance of a master printer, the less familiar skill of lithography. Given to experimenting, and ruthlessly critical of his own work, Whistler was at this time especially interested in the tonal possibilities of printmaking. By carefully controlling the ink left on the copperplate after wiping, and by the application of thin layers of lithographic crayon in solution (lithotint) on the stone, he explored the effects of light and time of day. During his active career he produced over 450 etchings, drypoints, and lithographs. His work was deeply respected by other artists—William Merritt Chase advised a prospective art buyer, "By all means get a set of Whistler's etchings. . . ."

Whistler had an enduring fondness for London's River Thames, and in this series of lithographs he moves beyond the romanticized riverscape to work on the picturesque aspects of modern life—the wharves and warehouses of the industrial landscape. The buildings that loom out of the mists of *Nocturne* are not the *palazzi* and churches of Venice, but the begrimed, sturdy facades of working buildings in London.

62 Nocturne, w.5, 1878
James McNeill Whistler, 1834–1903
Lithograph;
6¾ x 10⅛ in. (17 x 25.7 cm.)
Harris Brisbane Dick Fund, 1917
(17.3.159)

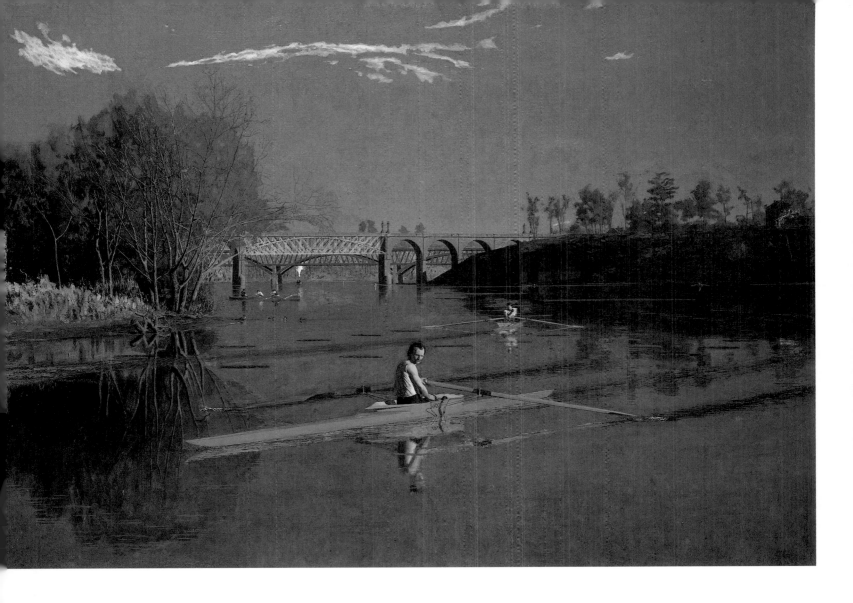

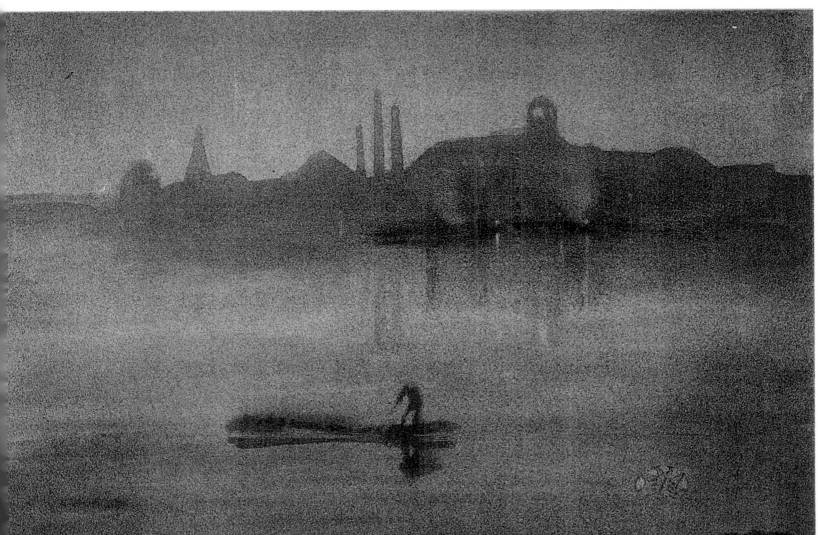

"DOLLY VARDEN" WALKING SUIT

The young, middle-class New Yorker who wore this costume in the warm months of 1872 was consciously trying to achieve the sweet simplicity that she saw as characteristic of the late eighteenth-century Polonaise or "Shepherdess" dress. The popular American fashion periodicals that she read, such as *Harper's Bazaar* and *Peterson's Magazine*, introduced the "Dolly Varden" fashions into the United States a year after they had appeared in England. The two main features of this dress were its fabric—generally a chintz or cretonne printed in a delicate, often floral, pattern—and its bodice, which buttoned down the front and was joined to a swagged over-skirt that was drawn up at the back by interior tapes. This costume was completed with a leghorn hat with a small crown and a limp brim trimmed with small flowers and ribbons with streamers called "follow-me-lads."

The English named this costume for Dolly Varden, the coquette in Charles Dickens's historical novel *Barnaby Rudge*, which was set in London in 1780, at the time of the Gordon Riots. Dickens described Dolly Varden as having

the very pink and pattern of good looks, in a smart little cherry-coloured mantle . . . a little straw hat trimmed with cherry-coloured ribbons, and worn the merest trifle on one side—just enough in short to make it the wickedest and most provoking head-dress that ever malicious milliner devised.

Charles Dickens was very popular with Americans, having completed an exhaustive tour of the United States during which he read from his own works, just two years before his death in 1870. There were "Dolly Varden" dresses, hats, and shoes; popular songs extolled her beauty and virtue; and short stories told what happened to young ladies who wore "Dolly Vardens"—they caught husbands!

63 *"Dolly Varden" Walking Suit*, ca. 1872
Sateen, chambray, and Valenciennes lace
Gift of the New York Historical Society,
1979 (1979.346.2ab)

64 *Tailored Wedding Ensemble*
(afterward a travel costume), 1887
Wool trimmed with passementerie
Gift of Mrs. James G. Flockhart,
(CI 68.53.5abcdefgh)

TAILORED WEDDING ENSEMBLE

Louise Whitfield wore this gray wool traveling costume on the afternoon of April 22, 1887, when she married one of the richest men in the world, the great American steel and railroad industrialist and philanthropist Andrew Carnegie. Although in the nineteenth century it was not unusual for ordinary people to wed in their best "going away" clothes, it may seem surprising that a woman of Louise Whitfield's wealth and social standing chose to wear a dress of such austere—though elegant—simplicity. No doubt the bride selected the fabric, pattern, and fine braid passementerie that enlivens the bodice and cuffs when she ordered the ensemble from her tailor, H. Rofsberg, of West Thirty-second Street in New York City.

This traveling dress is an excellent example of the highest quality dressmaking and construction. The bodice-jacket, with its long sleeves and collar, is boned to further mold a tightly corseted torso, and it is lined in matching striped satin. The rose-gray passementerie is arranged in a foliate pattern to simulate a breastplate (plastron) and cuffs, and to create a decorative panel on the skirt. The fashionable late Victorian silhouette is exemplified in the graceful drapery, which flows around and over the ample bustle skirt. On the interior of the skirt, whalebone and ties reinforce the shape of the bustle and secure the neat box-pleating at the hem.

Louise Whitfield and Andrew Carnegie were married quietly before thirty relatives and close friends at the bride's home on West Forty-eighth Street. An hour later, they boarded the steamship *Fulda* for their honeymoon in Scotland and England. The simplicity of the ceremony can be best explained by the long and difficult courtship of the bride and groom. Both had old, ailing, widowed mothers, and in keeping with the self-sacrificing morality of the day, both believed that their first loyalties were to their mothers. Indeed, Andrew Carnegie had promised his mother that he would not marry during her lifetime, and that he would remain her constant companion. He kept his promise during his seven-year, on-again, off-again engagement to Louise, until his mother's death in 1886. They married five months later, when Louise was thirty years old, and he fifty-one and in mourning for his brother as well as his mother. Given the circumstances of the courtship and marriage, this modest and respectable traveling costume served as a perfectly appropriate wedding dress.

65 *Arques-la-Bataille*, 1885
John Henry Twachtman, 1853–1902
Oil on canvas; 60 x 78⅞ in.
(152.4 x 200.3 cm.)
Morris K. Jesup Fund, 1968 (68.52)

JOHN HENRY TWACHTMAN
Arques-la-Bataille

Most of the leading American artists of the eighteenth and nineteenth centuries journeyed to Europe to broaden their education, and most, but not all of them, ended up in France. A smaller group, among them John Henry Twachtman, Frank Duveneck, and William Merritt Chase, looked to the German school, and to the Munich Academy in particular, for instruction. Twachtman's early works clearly attest to his stay in Munich; the forceful brushstrokes, heavy application of paint, and limited, low-key palette are all techniques that were fashionable in German art circles of the period.

In 1883, however, after some years back in America, Twachtman enrolled at the Académie Julian in Paris and studied there for the next two years. At this point his style changed considerably: His palette remained low-key, but the overall effect was lighter, and his brushwork became more subdued. Over the next few years, his style continued to change as he was increasingly influenced by the Impressionists on both sides of the Atlantic. This was especially noticeable in his looser, thinner application of paint, although at no time did Twachtman surrender his careful control of the form of his compositions.

Twachtman never received true critical acclaim, a fact that distressed him increasingly as he grew older. He supplemented his income by teaching and by illustrating magazines. But he was respected by his fellow artists and was a founding member of Ten American Artists ("The Ten"), a group that included Childe Hassam and Julian Alden Weir, and that came into existence to promote Impressionism in America, in defiance of the conservative National Academy of Design.

Arques-la-Bataille represents the finest period of Twachtman's work. It was painted in 1885, when he was studying in Paris, and in its subdued color, loose brushwork, and calligraphic elements, it shows strong evidence of the influence of James McNeill Whistler's tonal studies and of the Japanese prints that were so popular among French artists at the time (see Plate 77). The view is of a river near Dieppe, on the coast of Normandy—a popular area among French Impressionists. The strength of the work lies in the discipline of the composition, with its forceful horizontality, relieved by the calligraphic upward thrusts of the reeds in the foreground. Twachtman ignored convention by placing the reeds very close and central while allowing the rest of the painting to be so flat as almost to deny perspective. Mood is more important than representation in this painting, and both the brushwork and palette are subdued and carefully controlled.

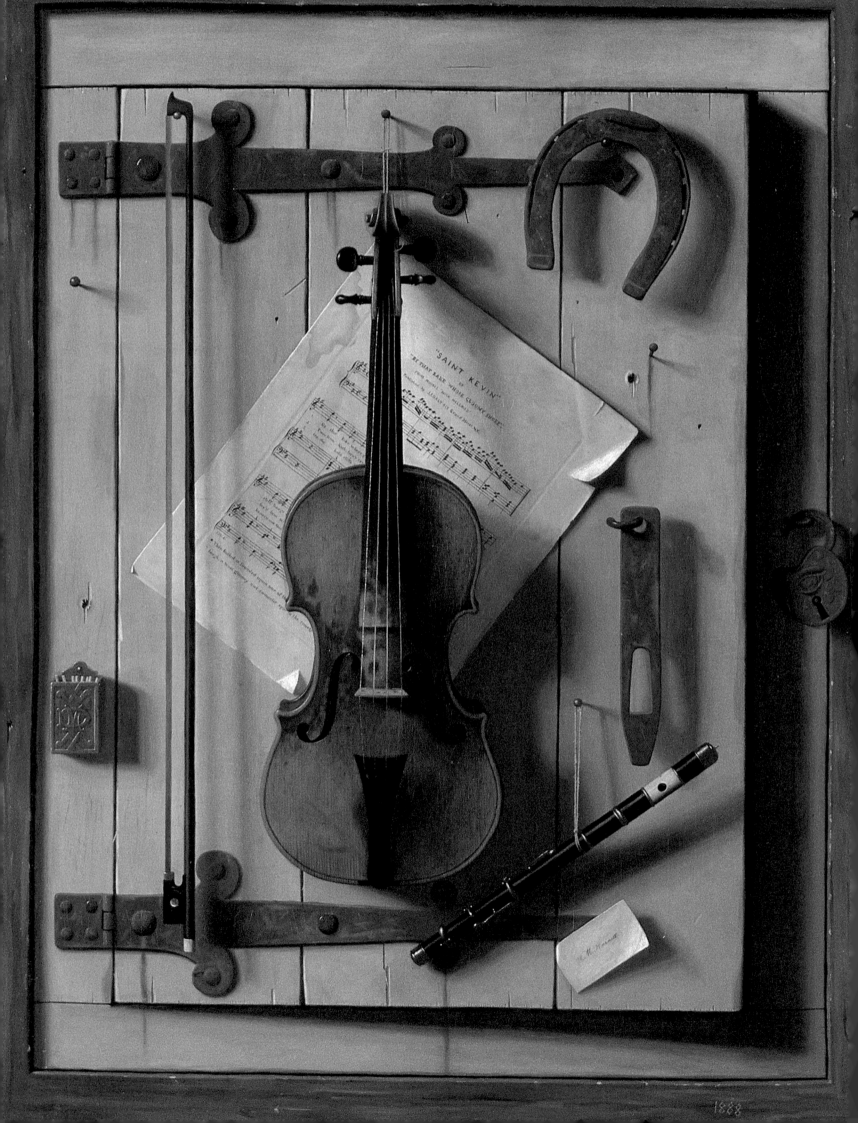

WILLIAM MICHAEL HARNETT
Still Life—Violin and Music

Public imagination often pictures the artist starving in a garret while his genius goes unrecognized. Sometimes, however, reality runs counter to this image, and William Michael Harnett is an example of just such a case. During his lifetime, Harnett's trompe-l'oeil paintings were adored by the public and brought him both acclaim and financial success, even though the art critics sneered at them as technical exercises in imitation. But, with the passing of the passion for trompe-l'oeil works, Harnett's reputation dwindled, and it was not until a retrospective exhibition of his work in 1939 that there was renewed appreciation for his talent —and this time the critics concurred.

In *Still Life—Violin and Music*, Harnett presents his objects in layers of space. At the very back is the partly opened door, and the objects suspended from it lie at different distances from their common background, creating a truly three-dimensional effect. The textures and colors, ranging subtly through shades of brown, with touches of black and white, enhance the convincing look of reality. The painting is also known as *Music and Good Luck*—a reference to the horseshoe—although it has been suggested that, on the contrary, there is a touch of melancholy in the mournful Irish ballad on the sheet music and the upside-down horseshoe that is traditionally supposed to leak out its store of good luck in that position.

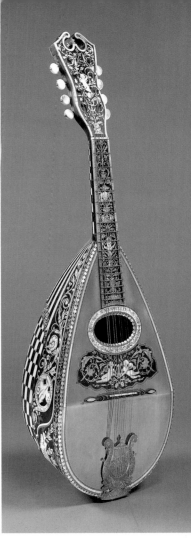

67 Mandolin
New York, ca. 1900
Angelo Mannello, 1858–1922
Wood, tortoiseshell, ivory, metal;
L. 24⅝ in. (62.4 cm.) Gift of
Family of Angelo Mannello, 1972
(1972.111.1)

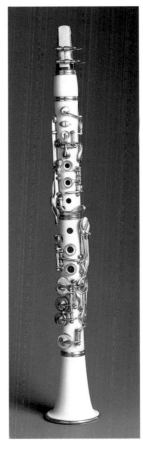

66 *Still Life—Violin and Music*, 1888
William Michael Harnett, 1848–1892
Oil on canvas; 40 x 30 in.
(101.6 x 76.2 cm.) Wolfe Fund,
Catharine Lorillard Wolfe Collection,
1963 (63.85)

68 Clarinet in E-flat
New York, 1880–90
Thomas Berteling, 1821–89,
or successor
Ivory, silver, rosewood;
L. 16⅝ in. (42.2 cm.) Rogers
Fund, 1982 (1982.18)

ANGELO MANNELLO
Mandolin

From time to time, composers of rank, such as Beethoven and Mozart, have written serious works to be performed on mandolins, but in general, they are associated with Italian popular music. They were scarce in America until the 1880s, when, with the first great wave of Italian immigrants, they became commonplace in the urban centers where the newcomers clustered.

The mandolin seen here represents the early, highly ornate work of Angelo Mannello. It is based on the Neapolitan models he had seen in his youth. Made around 1900, it has a rich checkerboard pattern on the deeply-vaulted back, made of ivory and tortoiseshell segments rimmed with German silver (which, in fact, contains no silver). The instrument is decorated with engraved ivory inlay, and the top and sound hole are edged with beading. The mandolin has evidently been played little: Its design suggests that it was intended as a decorative showpiece.

THOMAS BERTELING
Clarinet in E-flat

Around 1848, a young Prussian named Thomas Berteling left Germany and headed for America. He settled in Boston and, for the first few years, worked for a company that manufactured brass instruments. When he began to make clarinets, he was immediately successful. In 1857, he moved to New York, opened a shop, and was soon a major maker of woodwind instruments for professionals.

The E-flat clarinet fashioned by Berteling, or his successor, is an elegant instrument made of ivory in four sections, with eighteen cupped silver keys and a rosewood mouthpiece (which may have been a later addition). Four of the keys have rollers and four have open rings, and they are all pillar-mounted. There is a thumbrest screwed to the back of the instrument. The maker's name appears on an oval plaque fastened to the front.

95

69 Northeaster, 1895
Winslow Homer, 1836–1910
Oil on canvas; 34⅜ x 50¼ in.
(87.3 x 127.6 cm.) Gift of
George A. Hearn, 1910 (10.64.5)

WINSLOW HOMER

Winslow Homer's early years were spent as a freelance maga-
zine illustrator. During the Civil War he worked as an artist-
correspondent with the Union troops, sending action
illustrations to *Harper's Weekly*. After a year in France, he
concentrated more and more on painting, and by 1875 had
given up illustration entirely.

The year 1881–82 seems to have been a turning point in
Homer's life, both personally and as an artist. He spent it in
the English fishing port of Tynemouth, and when he re-
turned to America, he found that he no longer liked city
life and moved to the coastal town of Prout's Neck in Maine.
With the exception of annual vacation journeys to the South
and to the Caribbean, he spent the rest of his life there, cut
off from the major art circles of the period. His work dur-
ing this latter period divides almost sharply into his small
watercolors—some of the countryside and daily life in Maine,
but most depicting the brilliant sunlit scenes of his southern

70 Hurricane, Bahamas, 1898
Winslow Homer, 1836–1910
Watercolor and pencil;
14½ x 21 in. (36.8 x 53.3 cm.)
Amelia B. Lazarus Fund, 1910
(10.228.7)

trips—and the large, strongly brushed seascapes portray-
ing the constant struggle between man and the turbulent
ocean.

Northeaster is an excellent example of Homer's later work
in oil. The composition is reduced to the simplicity of a force-
ful diagonal and the broad, sweeping brushstrokes enhance
the sense of harshness and drama. Homer's openness to
innovation and his ability to develop his own inventive style
probably owe much to his minimal exposure to the conser-
vative forces of academic training.

Hurricane, Bahamas, painted in 1898, evokes the same sub-
ject in a different medium and a different climate. The vio-
lence of the wind is just as strongly felt, thanks to the
windblown trees and lowering clouds. The brilliant colors
that are so often found in Homer's sun-drenched Caribbean
watercolors have been toned down here, overpowered by
the threatening darkness.

EWER WITH PLATEAU

This ewer with plateau is among the finest expressions of Art Nouveau—a style characterized by sweeping curves and organic forms. Its lip resembles a languid jack-in-the-pulpit, while the handle is formed by the arching back of a naked woman, her feet melting into the body of the vessel and her hair and arms into the spout. The female reappears among repoussé eddies, as do the heads of fish and what appears to be aquatic plant life. All is bobbing motion; forms dissolve into one another and give the hard metal the impression of liquid or deliquescence.

Unique in their design, the ewer and plateau are excellent examples of a line of silver known as Martelé that was produced by the Gorham Manufacturing Company under the design direction of William Codman. Codman sought to make individual handwrought pieces in the "new" art style from silver both purer and softer than sterling. The minute attentions of the craftsman are evident in the hammer marks still visible on the plain patches of silver. Martelé ware was expensive to produce and is quite rare—it is said that no two pieces were made alike.

72 Vase
New York, 1873–75
Tiffany & Company, estab. 1853
Silver; H. 8½ in. (21.6 cm.)
Purchase, Mr. and Mrs. H. O. H.
Frelinghuysen Gift, 1982
(1982.349)

71 Ewer with Plateau
Providence, Rhode Island, 1901–1905
Gorham Manufacturing Company,
1865–1961
Silver; H. with plateau 21½ in.
(54.6 cm.), Diam. of plateau 17⅛ in.
(43.5 cm.) Gift of Mr. and Mrs.
Hugh J. Grant, 1974 (1974.214.26a,b)

TIFFANY & CO.
Vase

The influence of Japanese art, which became known in the West after Japan was opened to trade in the 1850s, was felt by English designers in the 1860s and was evident in the American decorative arts by the early 1870s. Tiffany & Co.'s first venture in the Japanese style was its "Japanese" flatware pattern, patented in 1871. The production of hollowware in this style, of which this vase is an outstanding example, is not documented until 1873.

The vase is decorated with elements often used on Tiffany objects in this style between 1873 and about 1875—applied fish and an engraved, stylized seaweed motif. On this piece, a blade of grass and a shell (on the other side) are also applied, giving additional low relief to a composition that is indebted to Japanese influence for its asymmetry and restraint as well as for its motifs. The band at the top, with arclike compass forms and conventionalized flowers, and the wide geometric border at the bottom, with motifs of a crane, a sprig of blossoms, and palmlike leaves in the interstices, are both die rolled and appear on other examples of "Japanese" hollowware produced by Tiffany

FAVRILE GLASS VASE

In the words of its chief propagandist, Walter Crane, the central belief of the Arts and Crafts Movement was that "the true root and basis of all Art lies in the handicrafts," and the mission of the movement was to "turn our artists into craftsmen and our craftsmen into artists." The Arts and Crafts Movement developed in England during the late Victorian era through the inspiration and teachings of John Ruskin and William Morris. Its influence spread to America during the 1870s and is manifest in the favrile glass made by Louis Comfort Tiffany in the last decade of the nineteenth century.

The son of Charles L. Tiffany, founder of the New York silver store, Louis studied landscape painting before pursuing a career in the decorative arts. He opened glass furnaces in Corona, New York, and after working with stained glass for almost fifteen years, he began to experiment with the freeblown variety in 1893. "Favrile" is a term Tiffany claims to have adopted from the Old English "fabrile," meaning pertaining to a craft or craftsman. Grounded in the traditions and ideals of the Arts and Crafts Movement, Tiffany's favrile glass also embodied the characteristics of the fashionable Art Nouveau, of which style he became America's leading designer. Tiffany was by far the most important innovator in glass; by 1898 he had created over five thousand colors and varieties of his favrile glass, and it had gained him international renown.

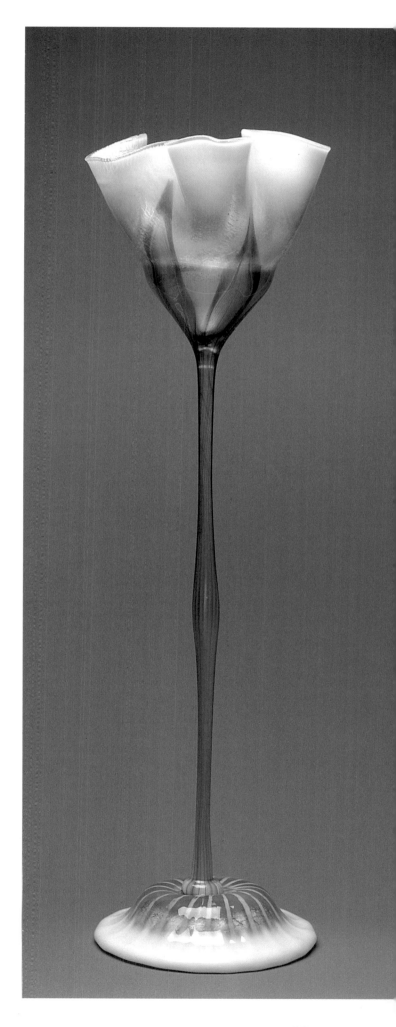

73 Favrile Glass Vase
Tiffany Glass and Decorating
Company (1892–1902)
Louis Comfort Tiffany, 1848–1933
Blown Glass; H. 18¹¹/₁₆ in. (47.4 cm.)
Gift of Louis Comfort Tiffany
Foundation, 1951 (51.121.17)

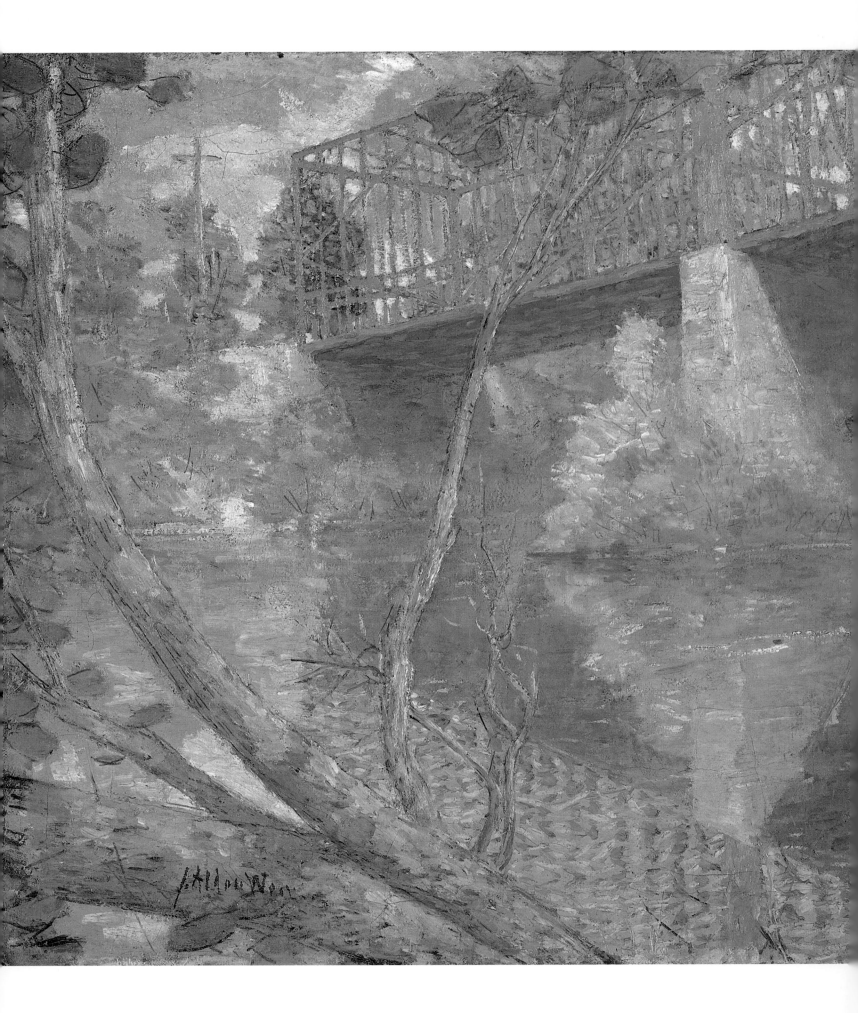

74 *The Red Bridge*, 1895
Julian Alden Weir, 1852–1919
Oil on canvas; 24¼ x 33¾ in.
(61.6 x 85.7 cm.) Gift of
Mrs. John A. Rutherfurd, 1914
(14.141)

JULIAN ALDEN WEIR
The Red Bridge

Julian Alden Weir came from a painting family and studied
both at the conservative National Academy of Design in
New York and, in 1873, at the Ecole des Beaux-Arts in
France. After his return to New York in 1877, he supported
himself by portrait painting and teaching. Weir became a
leading figure in art circles and, with John Henry Twachtman
and Childe Hassam, among others, was a member of the
group of American Impressionists known as Ten American
Artists ("The Ten").

Weir's early work demonstrates the precise techniques of
his academic training, blended with the grace of his own
style. He had a preference for still lifes and watercolors,
and a fondness for seventeenth-century Spanish art that
showed itself in his exploration of the effects of light.

When first confronted with the works of the Impressionists,
Weir reacted with a hostility stemming from his strictly aca-
demic training. But gradually, by the 1890s, curiosity pre-
vailed, and he began to experiment with the new techniques.
During his youthful travels in France he had been impressed
by the works of the Breton peasant-painter, Jules Bastien-
Lepage, who, although not an Impressionist, experimented
with outdoor, or plein-air, painting. Now, twenty years later,
Lepage's influence began to show itself in Weir's works.

The Red Bridge, painted in 1895, is an excellent example
of Weir's later style. The prosaic subject of this study is an
iron bridge near the Weir summer home in Windham,
Connecticut, which replaced a picturesque old covered bridge
across the Shetucket River. Again, Weir reacted with great
dismay to this novelty, but not long after, his imagination
was caught by the colors and shapes of the freshly under-
coated bridge, as well as by the visual contrasts created by
the rigid iron structure, the fluidity of the water, and the
natural curves of the trees. The belated influence of plein-
air painting is evident in the rich, varied surface patterns, in
the choice of pale, muted colors, and in the silvery light that
unites all the geometric elements of this work.

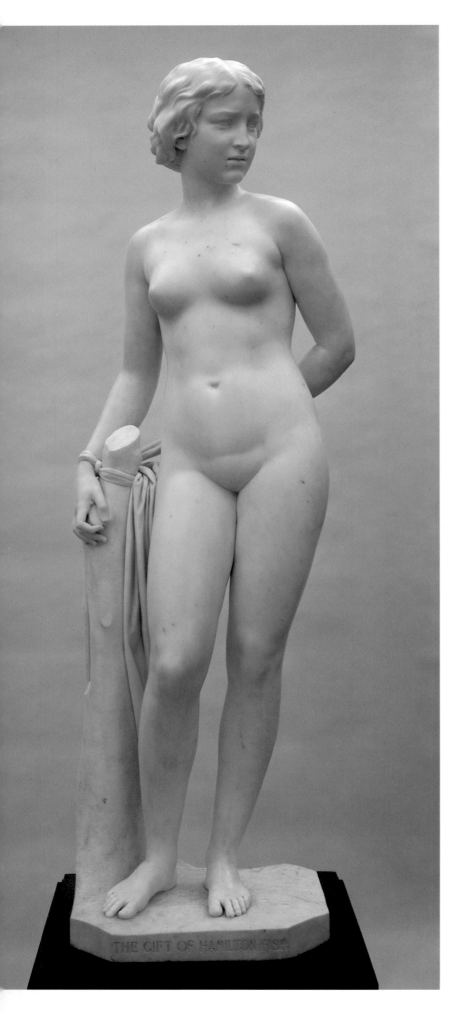

ERASTUS DOW PALMER
The White Captive

Neoclassical sculpture became very popular during the second quarter of the nineteenth century, an era when Americans were beginning to accumulate wealth and to enjoy the acquisition of finer things. In the East, pioneering days were over, and a sense of stability and history had developed. Americans sought to embellish their homes along the lines of wealthy European establishments, and what could be more suitable than the graceful elegance of white marble statuary, with its look of classical antiquity?

Erastus Dow Palmer turned to sculpture almost by accident. An upstate New Yorker, he was a self-taught artist whose expertise lay in his mechanical skills as a carpenter, builder, and pattern maker. He took up the carving of cameos as a hobby, but when he found this too great a strain on his eyesight, he turned to larger sculpture. As his interest grew more serious, he opened a studio in Albany, where he was increasingly employed to create portrait busts of prominent citizens. His tendency toward a religious treatment of his subject matter made him attractive to the clergy, and his cemetery sculptures were in great demand.

Palmer also created "ideal" figures, such as *The White Captive*, seen here. This statue, Palmer's first attempt at a nude, was once prominently displayed in the house of the politician Hamilton Fish, who bequeathed it to The Metropolitan Museum. Palmer worked directly from live models, often his daughters. Despite the prudery of the times, which caused his nudes to create a slight flurry in bourgeois circles, Palmer's idealized statues were generally admired by his contemporaries. He appealed to his public on two levels, providing the classical style that was so popular, but, as in this case, often drawing his subject matter from sources closer to home. Here the reference is to the legends of young girls captured by Indians during the early years of European colonization.

75 The White Captive, 1859
Erastus Dow Palmer, 1817–1904
Marble; H. 66 in. (167.6 cm.)
Bequest of Hamilton Fish, 1894 (94.9.3)

FREDERICK WILLIAM MACMONNIES
Bacchante and Infant Faun

The early death of his father obliged Frederick William MacMonnies to seek menial work while still very young. His innate artistic talent asserted itself, however, when he became a studio assistant to the sculptor Augustus Saint-Gaudens. MacMonnies studied art at night, but he also gained invaluable practical experience assisting in the creation of Saint-Gaudens's monumental works. He went to Paris in 1884, and, except for short trips back to America, remained there until the First World War. He was well received in France and his work developed a distinctly French style —graceful and lively in form. His fame in America was established when he designed the Columbian Fountain for the 1893 Chicago Exposition.

The American public, however, was not always ready for the European worldliness of MacMonnies's statuary. One piece had to be withdrawn from an exhibition in New Rochelle, New York, and, as a result of public antipathy, his statue, *Civic Virtue*, made for New York's City Hall, was removed to a less prominent spot in Brooklyn.

In fact, the presence of *Bacchante and Infant Faun* in the collection of The Metropolitan Museum is due to the furor that was created in Boston when the architect Charles McKim attempted to place it in the courtyard of his newly designed Boston Public Library. Interestingly, it was not the nudity that offended but the "drunken indecency" that roused the Women's Christian Temperance Union to protest. McKim removed the statue and presented it to the Museum, where it is an excellent example of the exuberance of Beaux-Arts sculpture—classical in subject but natural in style.

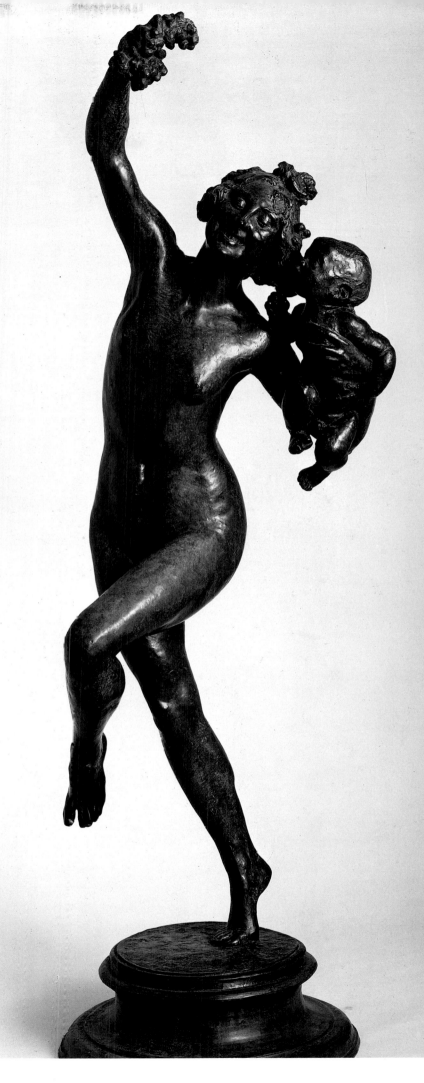

76 Bacchante and Infant Faun, 1893
Frederick William MacMonnies, 1863–1937
Bronze; H. 83 in. (210.8 cm.)
Gift of Charles F. McKim, 1897 (97.19)

103

MARY CASSATT
The Letter

In 1890, there was an exhibition of Japanese ukiyo-e prints in Paris. Mary Cassatt, in common with Degas, Pissarro, and many other French artists, was profoundly impressed by these foreign pictures, and the encounter led her to create a set of ten color prints, which are a felicitous blend of Oriental art and her own very recognizable nineteenth-century European sensibility. She managed to reproduce the flat, linear quality of the Japanese blockprint while softening it with hand-applied color. She also combined her interest in the Japanese prints with a love of the floral decoration to be found in Persian miniatures. This is especially evident in the patterns of the woman's dress and the background wallpaper in *The Letter*.

MARY CASSATT
Lady at the Tea Table

Mary Cassatt, the genteel lady from Philadelphia, became the only American painter to earn herself a place among the French Impressionist band. Domestic scenes, particularly those including women and children, were her specialty; she made them her own domain, much as Jane Austen made the minutiae of nineteenth-century English village life her literary preserve. She used the high-key palette characteristic of Impressionism to create pictures that have great naturalness and warmth without the cloying sentimentality that tends to threaten this sort of subject matter.

In *Lady at the Tea Table*, Cassatt portrayed her mother's cousin, Mrs. Robert Moore Riddle. The painting was intended as a thank-you gift for hospitality received in London. In a letter to her son, Cassatt's mother voiced concern, "... as they [the sitter and her husband] are not very artistic in their likes and dislikes of pictures and as a likeness is a hard thing to make to please the nearest friends." Degas called the painting "*la distinction même*" ("distinction itself"), but Mrs. Cassatt was prescient; the Riddle family found it disconcerting and unattractive, as a result of which it languished in storage for the next thirty years. The picture may well have been disconcerting for its departure from traditional spatial relationships: foreground and background almost merge, in a bow to Degas, Manet, and the Japanese prints that were charming Paris at the time. Within the discipline of a limited palette, however, Cassatt has created many areas of interest: the range of blues, the echoing rectangles behind the lady's head, and the gold rims of the tea service and the picture frame that unify the scene.

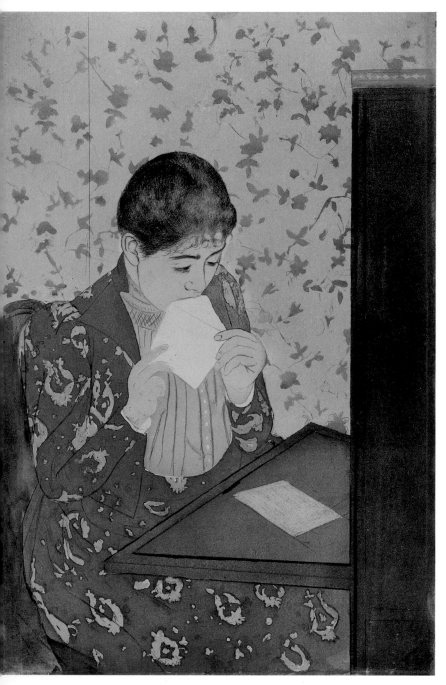

77 *The Letter,* 1891
Mary Cassatt, 1844–1926
Drypoint, soft-ground, and
aquatint, printed in color,
third state; Br. 146; 1891;
13⅝ x 8¹³⁄₁₆ in. (34.6 x 22.7 cm.)
Gift of Paul J. Sachs, 1916
(16.2.9)

78 *Lady at the Tea Table,* 1885
Mary Cassatt, 1844–1926
Oil on canvas; 29 x 24 in.
(73.7 x 61 cm.) Gift
of the artist, 1923 (23.101)

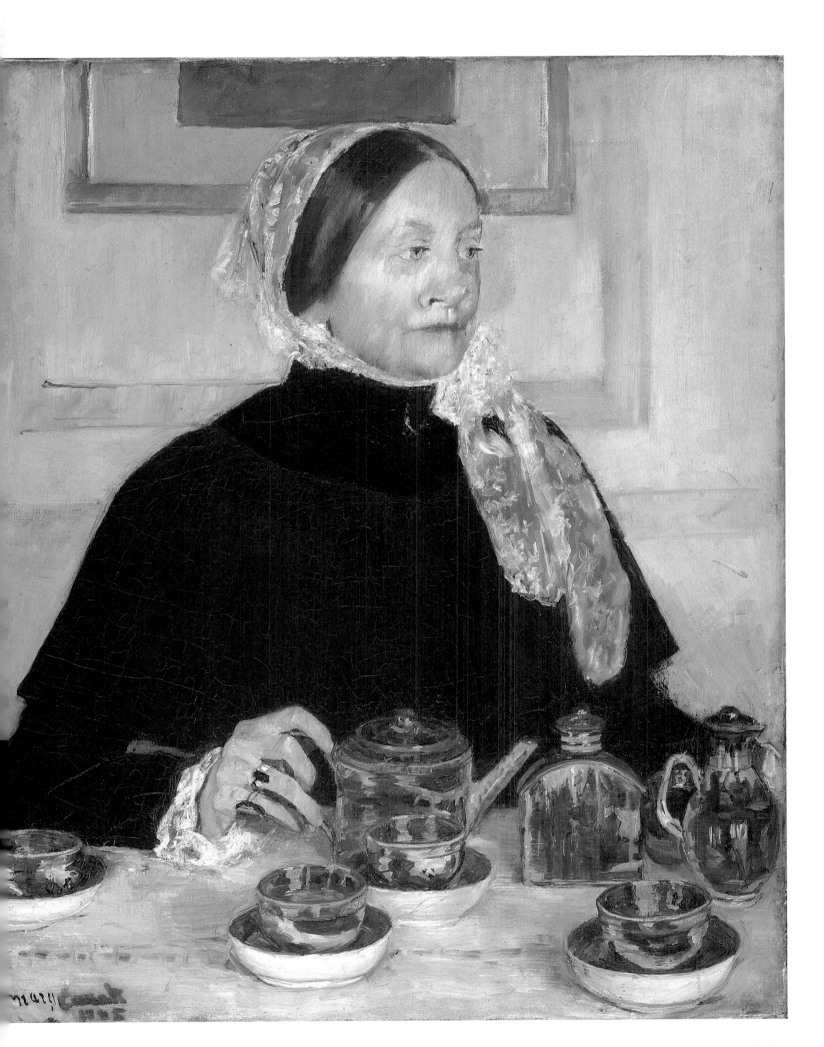

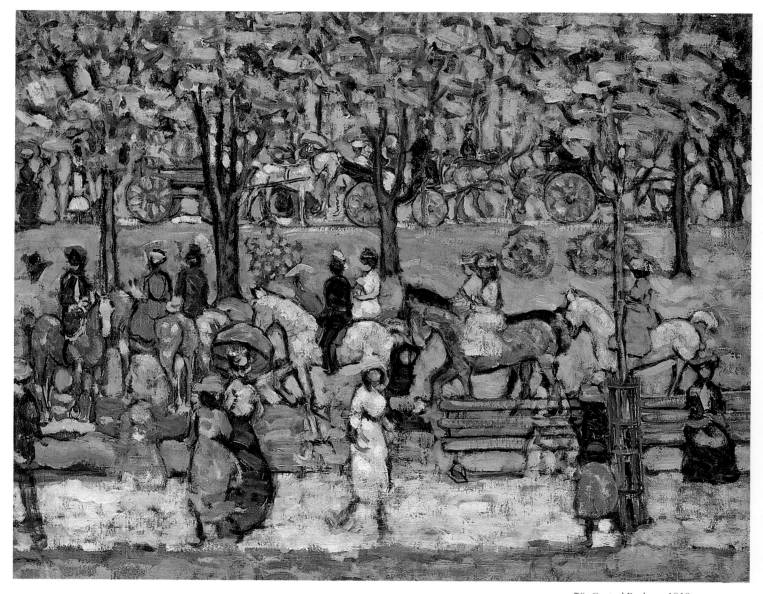

79 *Central Park*, ca. 1910
Maurice Prendergast, 1859–1924
Oil on canvas;
20¾ x 27 in. (52.7 x 68.9 cm.)
George A. Hearn Fund, 1950 (50.25)

Opposite: detail

MAURICE PRENDERGAST
Central Park

Maurice Prendergast was a member of The Eight, a determined group of individualistic painters, which included Robert Henri, John Sloan, George Luks, and William Glackens, who banded together to confront the academics and sentimental moralists with their realistic paintings. They held an exhibition at the Macbeth Galleries in 1908 that was roundly attacked by the critics, and they took part in the iconoclastic 1913 Armory Show. The radicalism of The Eight lay not so much in their technique as in their subject matter. They replaced the uplifting themes of the aesthetes with views of the urban world around them, using ordinary people as models—in some ways creating an updated version of earlier genre paintings.

Central Park, like many of Prendergast's works, is undated because it was conceived over a long period. It was probably made around 1910 but was based on a now-missing 1902 watercolor entitled *The Bridle Path, Central Park.* Many of Prendergast's paintings were reworked over several years and in different mediums. The brushwork is irregular, with strokes on top of strokes in some areas and bare ground in others. The technique owes much to the Impressionists but is adapted to Prendergast's highly individual style. The composition consists of a tapestrylike surface with trees and people creating the warp, and the paths and benches the weft. The way in which the picture plane recedes upward rather than backward is typical of Postimpressionist composition.

80 The Melvin Memorial, 1915
Daniel Chester French, 1850–1931
Marble; H. 12 ft. 2 in. (3.7 m.)
Gift of James C. Melvin, 1912 (15.75)

DANIEL CHESTER FRENCH
The Melvin Memorial

Daniel Chester French was fortunate in both his family and their circle; he grew up in easy circumstances and received wholehearted encouragement to take up his chosen profession. It was his connection with Ralph Waldo Emerson that brought him the commission to create the *Minuteman* statue in Concord, Massachusetts, arguably one of the most famous statues in America.

As a young man, French spent two years in Italy, from 1867 to 1869, and then opened a studio in Washington, D.C., where his father was an assistant secretary at the Treasury Department. His career flourished and he received a great many government commissions. He eventually settled in New York, where he became a leading figure in the art world, a trustee of The Metropolitan Museum, and, for many years, chairman of the Museum's sculpture committee. The statue collection at the Museum is in large measure a tribute to French's guiding taste.

The work seen here, known both as *The Melvin Memorial* and as *Mourning Victory*, was created to commemorate three brothers who died in the Civil War. The original remains in Concord; this copy was presented to the Museum by the Melvin family. Its second name reflects the ambiguity of emotion expressed: Sorrow is portrayed by the downcast figure, but at the same time, the strongly clenched laurels thrust out at the viewer seem to claim triumph.

One of French's last monumental works was the statue of Abraham Lincoln that dominates the Lincoln Memorial in Washington, D.C.

AUGUSTUS SAINT-GAUDENS
Victory

Born in Ireland and raised in New York, Augustus Saint-Gaudens, like Erastus Dow Palmer, came to sculpture via cameo cutting. At the age of nineteen he went to Paris, where he was one of the first Americans to study at the Ecole des Beaux-Arts. During his travels in Europe he had the fortune to meet wealthy Americans who were impressed with his talent, offered him commissions, and introduced him to other prospective clients. His reputation in America was established almost immediately, and throughout his life, Saint-Gaudens remained successful and influential. His art, at once monumental and decorative, was ideal for the grand, important dwellings and public buildings that were being constructed as testimony to the success of this age of enterprise, known as the Gilded Age.

Saint-Gaudens's influence on other Americans of the period was enormous. He led them away from rampant Neoclassicism toward Realism, albeit a Realism embellished with the flourishes and adornments of the Beaux-Arts style. *Victory* derives from a figure in Saint-Gaudens's monument for General Sherman in New York's Central Park.

81 Victory, 1905
Augustus Saint-Gaudens, 1848–1907
Gilded bronze; H. 41¾ in. (106 cm.)
Rogers Fund, 1917 (17.90.1)

FRANK LLOYD WRIGHT

Room from the Francis W. Little House

Frank Lloyd Wright, one of the most original and influential architects of the twentieth century, was born in Richland Center, Wisconsin, in 1867. He began his career in 1888 as a draftsman in the office of the architect Louis Sullivan, in Chicago. After five years, he left Sullivan to begin an independent architectural practice and stayed in Chicago for the next seventeen years.

As part of a generation of midwestern architects influenced by Sullivan, Wright was also a member of the so-called Prairie School, which played a decisive role in the development and dissemination of Sullivan's aesthetic. However, instead of continuing Sullivan's work on the development of skyscrapers, Wright turned his attentions toward redefining domestic architectural design. To replace the boxlike rooms of the Victorian era, he conceived freely arranged, unconstricted spaces, and he substituted long rows of windows, providing continuous bands of light, for the scattered openings of traditional architecture. He used the practical and aesthetic demands of both the patron and the natural site to forge an architectural solution he termed "organic."

From 1912 to 1914, Wright designed this living room for the country house of Francis W. Little and his wife. One of Wright's most important commissions from the 1910s, the Little house was situated in a wooded area overlooking Lake Minnetonka in Wayzata, Minnesota. With it, Wright developed the vision of "total design" he had first explored in his "Prairie" houses, so-called because they were meant to interact with the Illinois plains on which they were built.

The large room demonstrates some of the operating principles of Wright's aesthetic genius. His influence can be felt in every decision and detail, every piece of furniture, work of art, or arrangement of flowers. The living room is unusually long (measuring 48 feet, 9½ inches) with a hipped ceiling; in its grandeur it resembles a public space. The dimensions were adopted for the needs of Mrs. Little, who was an accomplished musician and often gave concerts here. Wright's antipathy for the eclecticism of Victorian interiors, and his preference for an oriental, particularly Japanese, aesthetics is also manifest in his design. The plain ocher surfaces of the walls—outlined in a structural geometry with strips of blond wood—are reminiscent of the teahouses of Japan, and the furniture blends in with line and tone instead of offering a separate focus. The windows, with their electroplated copper finish, have been designed to match the brown tones of the room and to refract light with their facets. His touch extends even to the shade of the autumn leaves gathered in pots and placed on tables.

When the house was torn down in 1972, The Metropolitan Museum of Art bought the interior woodwork and fittings, and much of the furniture.

82 Room from the Francis W. Little House
Wayzata, Minnesota, 1912–14
Frank Lloyd Wright, 1867–1959
H. 13 ft. 8 in. (4.17 m.), L. 46 ft.
(14 m.), W. 28 ft. (8.53 m.) Purchase,
Emily Crane Chadbourne Bequest, 1972
(1972.60.1)

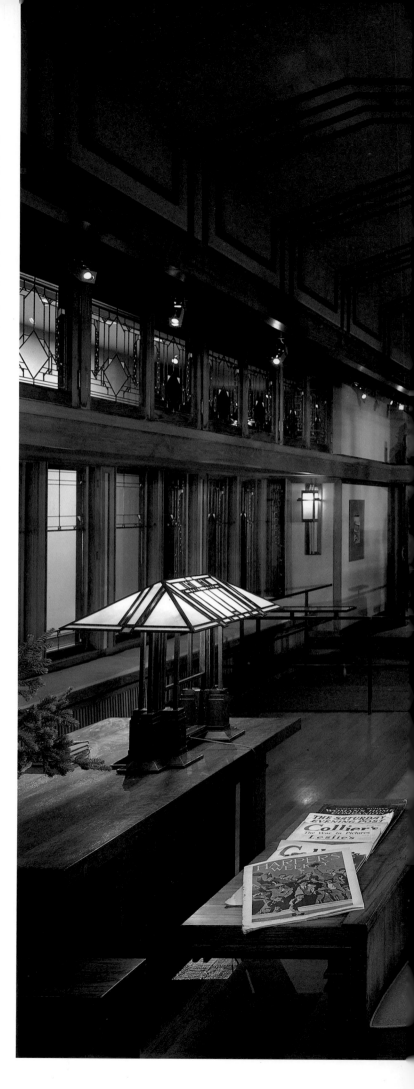

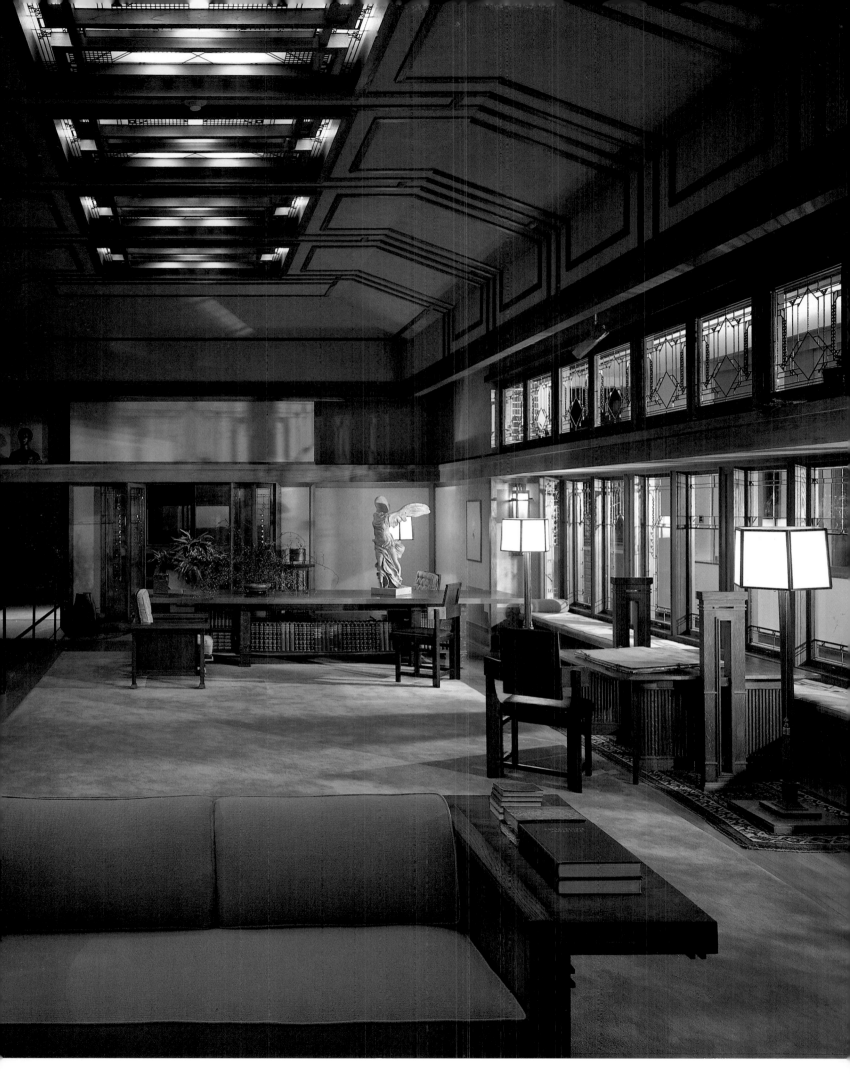

HERTER BROTHERS
Wardrobe

In his *Hints on Household Taste*, published in England in 1868, architect, designer, and critic Charles Lock Eastlake stated:

> The best and most picturesque furniture of all ages has been simple in general form. It may have been enriched by complex details of carved work or inlay, but its main outline was always chaste and sober in design, never running into extravagant contour or unnecessary curves.

Eastlake was a major champion of the Arts and Crafts Movement in England, which sought to trim the excesses of Victorian Revival furniture and restore the decorative arts to a position worthy of the attention of the serious artist. Though the philosophy of this reform movement developed in England—and stemmed from a reform movement begun by A. W. N. Pugin and John Ruskin in the 1830s—it was in America that the style achieved its most sophisticated incarnations.

This wardrobe was made in the 1880s by the firm of Herter Brothers as part of a bedroom suite for the railroad magnate Jay Gould. It was later owned by the actress Lillian Russell. Its straight lines follow the precepts of Charles Eastlake exactly. Christian and Gustav Herter were among the most influential of New York furniture designers. As the Arts and Crafts Movement progressed, they adopted the taste for restraint, simplicity, and the discreet use of oriental motifs popular abroad.

Unlike the case furniture of earlier periods, whose extravagant outlines tapered to pediments and finials, this wardrobe, made in the Japanese style, is perfectly balanced, and its design has the deceptive appearance of being simple. Appropriate to Japanese taste is the restraint and simplicity of the decoration: A scattering of stylized chrysanthemums and petals appear to flutter from a more densely bowered border above. Though apparently simple, the ebonized wood and the delicate shimmer of decoration give the piece the aspect of an intricately wrought Japanese lacquerware box.

83 Wardrobe
New York, ca. 1880
Herter Brothers, 1865/6–1905/6
Cherry, ebonized and inlaid;
78½ x 49½ x 26 in.
(199.4 x 125.7 x 66 cm.) Gift of
Kenneth O. Smith, 1969 (69.140)

ELEVATOR SCREEN FROM THE CHICAGO STOCK EXCHANGE

The juxtaposition of this elevator screen and the wardrobe does much to explain the varied impact of industrialization on design. While the Arts and Crafts Movement (seen in the wardrobe on the left) rejected industrialization and sought to restore and develop the expertise of the individual craftsman, the Chicago architect Louis H. Sullivan sought and found inspiration for a novel aesthetics in the technological advances of the industrial age.

Sullivan and his partner, Dankmar Adler, figured prominently in the building boom that followed the devastating Chicago fire of 1871. Working for a solution to the problem of high urban density, Sullivan combined new, steel-frame construction with refinements in elevator technology to create the architectural novelty of the skyscraper. He looked at the design problems of tall buildings and found his organizing principles in function rather than in historical precedent.

This ironwork grille was designed by Louis Sullivan as an elevator screen for the Chicago Stock Exchange building. Made of industrial iron, the screen is composed of a series of circles fractured into lobes and X shapes that resemble molecular models. A brass push plate in the form of a T provides the focal point of the screen and displays the style of ornament for which Sullivan is known: a mingling of geometric, two-dimensional shapes with plantlike forms.

84 Elevator Screen
From the Chicago Stock Exchange
building, 1893
Louis H. Sullivan, 1856–1924
Wrought iron, brass; 84 x 41 in.
(213.4 x 104.1 cm.) Purchase,
Emily Crane Chadbourne Bequest,
1973 (1973.288)

85 *The Flatiron*
Edward J. Steichen, 1879–1973
Blue-green pigment gum-bichromate over
platinum print, 1909, from 1904 negative;
18¹³⁄₁₆ x 15⅛ in. (47.8 x 38.4 cm.)
Gift of Alfred Stieglitz, 1933 (33.43.39)

86 *Brooklyn Bridge*,1912
John Marin, 1870–1953
Watercolor and pencil on paper;
18⅝ x 15⅝ in. (47.3 x 39.7 cm.)
Alfred Stieglitz Collection,
1949 (49.70.105)

EDWARD STEICHEN
The Flatiron

Until he closed his studio in 1938, Edward Steichen was a leading portrait photographer, whose techniques shaped many modern practices. He became the chief photographer for the Condé Nast publishing company, and he served as chief of all combat photography for the navy during World War II. In 1947 he was appointed the director of the photography department at The Museum of Modern Art in New York.

The Flatiron building in New York was constructed in 1902 and, not surprisingly, caught the eye of many photographers. Alfred Stieglitz photographed it shortly after its completion, capturing a snow scene that is very different from the one here. There is a great deal of painterly art in Steichen's picture. He consciously cropped the building at the top to achieve balance with the surrounding area, and although he took the photograph during the day, he printed it so as to create the impression of night. The color was achieved by washing the finished print with a mixture of watercolor and gum arabic over platinum. The result combines the sensitivity and delicacy of a painting with the sense of depth achieved by the photographic process.

JOHN MARIN
Brooklyn Bridge

John Marin dabbled in art from childhood, but he went to work in an architect's office and did not become a serious artist until 1909, when he was already forty. He became a pivotal member of the American avant-garde, which included Arthur Dove, Marsden Hartley, Georgia O'Keeffe, and Max Weber. Encouraged by them, he experimented with Futurism and Cubism throughout the teens, using geometric forms as a framework for his personal interpretation. But he did not like purely cerebral art, and later in life he returned to a more direct representational painting. After settling in Maine, he painted seascapes with explosive vigor and arbitrary color derived from his early encounters with Cézanne and with the Expressionists.

Brooklyn Bridge was painted around 1912, when Marin was in the midst of his great enthusiasm both for urban life and for the modernist painters. It may be as a result of his architectural experience that he was able to fragment the bridge's structure and yet retain its form, indicating an impressive ability to control his experimentation. There is a resemblance here to Robert Delaunay's Eiffel Tower series, although we do not know if Marin had actually seen it.

MAX WEBER
Athletic Contest

Nine-year-old Max Weber immigrated to the United States from Russia in 1890. The family was poor—his father was a tailor—and despite their respect for education, his parents could not keep him in high school for more than one year. But Weber was ambitious, and he convinced the Pratt Institute to admit him on the basis of his own independent study of art. He was a student of Arthur Wesley Dow—one of the most enlightened teachers of the time (later to teach Georgia O'Keeffe). After finishing school, he became a manual arts teacher in order to save money to study in France. From 1905 to 1908, he absorbed all that Paris art circles had to offer, first with Henri Laurens and then with Matisse.

For the next ten years, Weber experimented with avant-garde art styles: Fauvism, Cubism, Futurism, and abstraction. At the time he remarked, "I discovered the geometry in the work of God," and yet, around 1918, he gave up abstraction and turned to naturalistic landscapes, still lifes, and above all, scenes of Jewish domestic life with strong religious overtones. Appreciation was a long time coming. A small group of rebels—in particular The Eight and Stieglitz—were impressed with his work, but the experimental nature of his pictures shocked most American critics, and it was not until 1925 that he finally began to receive acclaim.

Athletic Contest was painted in 1915 at the height of Weber's artistic experimentation. The faceted figures, broken down into overlapping planes, and the swirling vortices, endow the scene with tremendous energy, and are evidence of the influence of the Futurists, whose goal was to represent the dynamism of twentieth-century life. The letters, numbers, and subdued color ultimately derive from Cubism.

87 Athletic Contest, 1915
Max Weber, 1881–1961
Oil on canvas; 40½ x 55¼ in.
(102.9 x 140.3 cm.)
George A. Hearn Fund, 1967
(67.112)

Opposite: detail

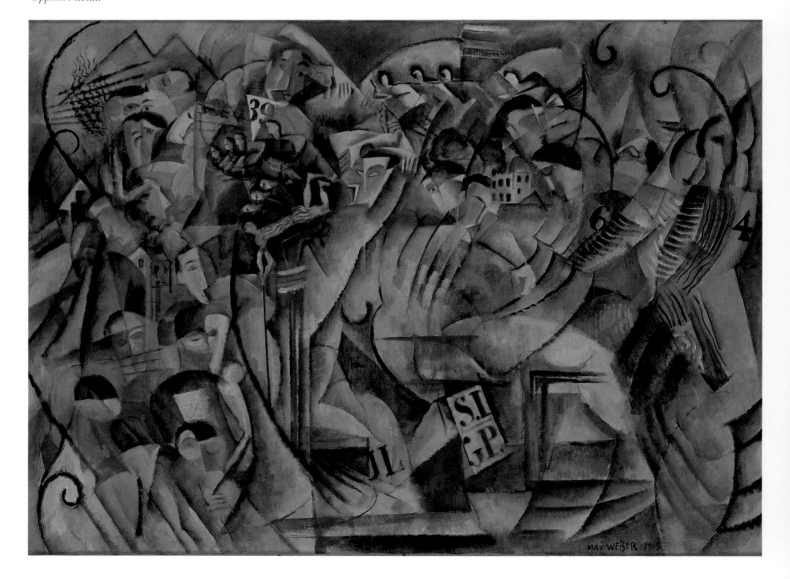

88 The Gondolier
Alexander Archipenko, 1887–1964
Bronze with black paint; 1961 cast of
1914 plaster; H. 34¾ in. (88.3 cm.);
base: 3¾ x 11 x 9¾ in.
(9.5 x 27.9 x 24.8 cm.)
Gift of Ernst Anspach, 1964 (64.2)

ALEXANDER ARCHIPENKO
The Gondolier

Alexander Archipenko was born in the Ukraine in 1887, and studied art in Kiev from 1902 to 1905. In 1908, the young sculptor moved to Paris, where he created his finest and most original sculpture. In these pieces, he applied the concerns of Cubism to three-dimensional form, exploring the relationship of convex to concave, of mass to void.

In *The Gondolier,* one of Archipenko's finest works, the space between the figure's left arm and his torso, and that encompassed by his legs and the sculpture's base, become active compositional elements, independent shapes delineated by the surrounding forms, much as space is treated as a positive component in Cubist painting. The figure's head, torso, and right leg form the central axis of the piece, balanced by the diagonal formed by the oar and the right leg, which are merged to become a single element.

MARSDEN HARTLEY
Portrait of a German Officer

Marsden Hartley produced his best work while living in Berlin during World War I, a time when the city was filled with advanced artists from all over the world. During this period he completed a series of portraits of German officers, works that testify not only to the artist's revulsion at the horrors of the Great War, but also to his fascination with the spectacle, pomp, and vigor that accompanied the war's devastation.

Hartley's contrasting feelings are eloquently resolved in his *Portrait of a German Officer.* Here, the vibrant composition, in which the forms seem to turn and thrust in different directions, combines with vivid colors, varied patterns, and aggressive brushstrokes to form a dynamic yet coherent whole. The background is black, perhaps signifying the dark destruction underlying the pageantry of war.

Hartley denied that the objects in this work have any special significance, but the banners, medals, bottles, and insignia here nonetheless combine to form a "portrait" of the painter's close friend, Karl von Freyberg, a young cavalry officer who had recently died in action. The young man's initials appear in the lower left; his regiment number (four) is in the center; and his age (twenty-four) appears in the lower right.

89 Portrait of a German Officer, 1914
Marsden Hartley, 1877–1943
Oil on canvas;
68¼ x 41⅜ in. (173.4 x 106 cm.)
Alfred Stieglitz Collection, 1949
(49.70.42)

119

EVENING WRAP

This hand-painted velvet evening wrap is a rare and successful example of the collaboration between a fashion designer and an avant-garde artist. Designed by the American *couturière* Valentina, and painted by the Realist artist Morris Kantor, it is among the earliest known examples of each artist's work.

Valentina was born in Kiev, Russia, in 1904. The details of her heritage, her youth studying ballet and acting in Russia until the Revolution, and her daring escape to New York via Turkey, Greece, and the south of France, were later romanticized so as to create a dramatic persona that became Valentina's best advertisement for her fashions. In 1928, Valentina opened a small dressmaking establishment where, through the force of her personality, she dominated a prominent clientele that included New York society, as well as theatrical, opera, and film personalities. Until her retirement in 1957, she was the dominant voice in American fashion; she dressed the Vanderbilts, Astors, and Whitneys, as well as Katherine Hepburn, Gloria Swanson, and Greta Garbo.

Although this evening wrap was made before Valentina opened her shop, in its simplicity of form and detail it bears all of the hallmarks of her mature style. Its only decoration is the graceful, measured shirring from wrist to shoulder on the tapered sleeves. Valentina always used the highest-quality fabric, often cut on the bias, which enabled her to create this elegant wraparound silhouette that fastens only at hip and shoulder. The fabric was hand-painted by the American painter Morris Kantor, who was also a Russian émigré, and who, during his early years, occasionally painted fabric designs to support himself. Kantor painted the wrap in 1926 for the donor, Mrs. Paul Koechl, whose husband was an early collector of Kantor's paintings. According to Mrs. Koechl, Valentina first cut the white velvet, then sent it to Kantor, who executed the design. The fabric was then returned to Valentina to be sewn. This rare example of Kantor's decorative art reflects his experimentation with a variety of sources. The unmodulated abstract design of leaf and butterfly motifs suggests Japanese prints, while the floating quatrefoils and stars are reminiscent of the interiors of William Morris. The sharp outlines surrounding the forms may indicate Kantor's early training as a cartoonist. The palette, now somewhat faded, is sophisticated in its contrast of muted beige, gray, and gold, with areas of jewellike greens and reds.

Valentina's aesthetics can be summed up in a single statement attributed to her: "Fit the century, forget the year." In the effect of total simplicity and elegance, Valentina achieved that classic combination of timelessness and modernity.

90 Evening Wrap, 1926
Wrap designed by Valentina, b. 1904;
fabric designed and hand-painted
by Morris Kantor, 1896–1974
Hand-painted velvet
Gift of Mrs. Paul Koechl (CI 68.47)

Left: detail

Evening Wig
American or European, 1920s
Silver tinsel
Gift of Mrs. C. O. Kalman,
1979 (1979.569.12)

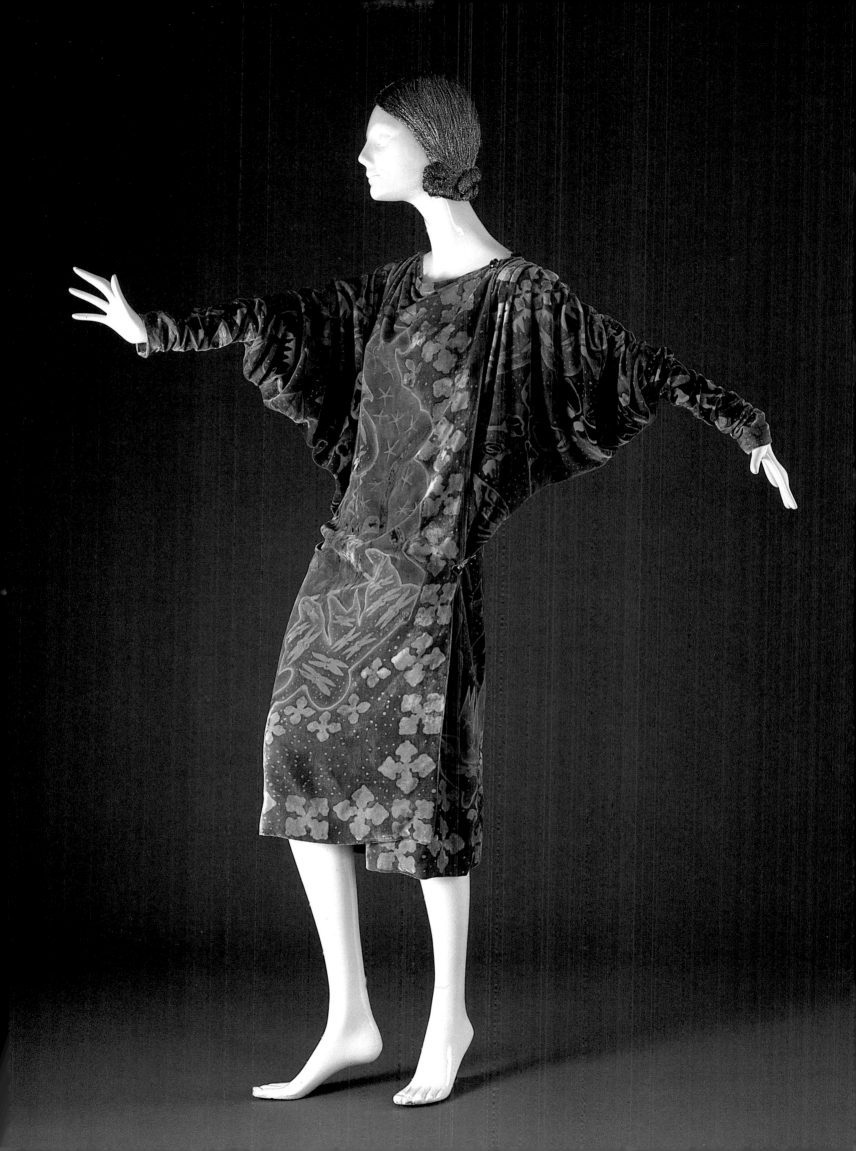

ARTHUR DOVE
Ralph Dusenberry

Arthur Dove, one of America's most important early modern artists, was born in upstate New York in 1880, and moved to New York City in 1903, where he worked as a magazine illustrator. In 1907, when he determined to become an artist, Dove moved to Paris, where he remained until 1909, witness to the rise of Cubism and other movements in modern painting. Dove was one of the first Americans to produce abstract paintings, lyrical expressions of the rhythms and colors in nature that convey his belief in the underlying unity of its many elements.

Ralph Dusenberry, the subject of this portrait, was a friend of Dove who lived on a neighboring houseboat. As in Hartley's *Portrait of a German Officer* and Demuth's *I Saw the Figure 5 in Gold* (see Plates 89 and 95), this is not a literal likeness but an accumulation of objects which together constitute a portrait. The flag may be a fragment of a boat pennant, and the rule is probably a reference to Dusenberry's work as an architect. The wood fragments together form a face, with an eye painted on the upper piece and a pipe-smoking mouth on the lower. The hymn is one Dusenberry often sang when he was drunk. With a minimum of elements, Dove has fashioned a witty, lyrical portrait of his friend.

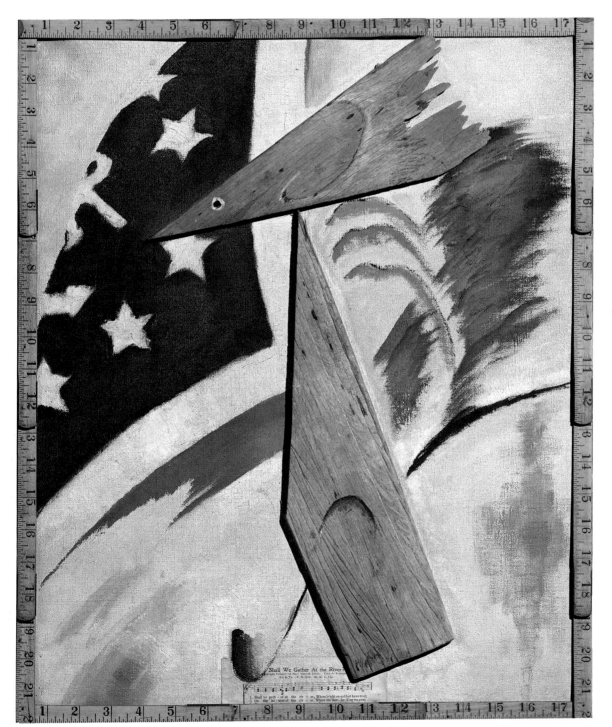

91 Ralph Dusenberry, 1924
Arthur Dove, 1880–1946
Oil on canvas with pasted ruler, wood, and paper;
22 x 18 in. (55.9 x 45.7 cm.)
Alfred Stieglitz Collection, 1949 (49.70.36)

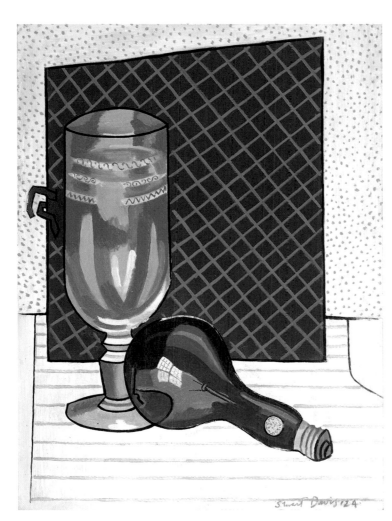

92 *Edison Mazda*, 1924
Stuart Davis, 1894–1964
Oil on cardboard; 24½ x 18⅝ in.
(62.2 x 47.3 cm.) Purchase,
Mr. and Mrs. Clarence Y. Palitz, Jr.
Gift, in memory of her father,
Nathan Dobson, 1982 (1982.10)

STUART DAVIS
Edison Mazda

Stuart Davis, whose parents were both artists, became one of the most influential abstract artists of his generation At the age of nineteen, he exhibited in the 1913 Armory Show, an exhibition that introduced modern European art to the United States.

Davis's painting developed with an internal logic and consistency rarely seen so clearly in an artist's oeuvre. In *Edison Mazda* we see his work undergoing the transition from the representational pictures of his early career to the true abstractions that would blossom in the 1920s. The objects here—an Edison Mazda light bulb, a wine goblet, and an artist's portfolio—are highly stylized and are organized in a flattened, nearly two-dimensional space that shows Davis to have looked carefully at Cubism. Yet, despite the effects of modern European painting on his art, Davis's work is indelibly stamped with a sophisticated wit all his own. Thus, the wine glass, a traditional still-life object, is juxtaposed with a light bulb, a symbol of modern industrial culture. And the windows of the artist's studio are reflected in the bulb, much as we see reflections in the glass, silver, and copper of Old Master still lifes.

The way the light bulb here juts into the picture, giving the composition a jolt of energy, hints at the jazzy, urban dynamism that would characterize the artist's later work. And in Davis's cool, laconic style, embracing the objects of our modern consumer culture, are the seeds of the Pop Art of the 1960s.

OVERLEAF:

EDWARD HOPPER (Pages 124–125)
From Williamsburg Bridge

Edward Hopper painted the alienation and loneliness of contemporary urban life, much as Degas painted the outsiders and down-and-out characters of mid-nineteenth-century Paris. Hopper's figures rarely engage in any social activity, and thus, by their very presence, underscore the sense of isolation that pervades his work.

In *From Williamsburg Bridge*, a lone figure sits in an open window, looking down on the sterile, urban landscape below. The man is featureless, and seems as much a part of the architecture as the arches and keystones that surmount the windows. There is no life to be seen through any of these windows, behind which are either curtains, shades, or simply blackness. as in the room behind the figure. There is no escape for this man: He is surrounded on four sides by the window frame, and the bridge, in an ironic conversion of its function, does not lead anyplace but serves instead to block exit. Furthermore, the buildings and bridge extend beyond the left and right edges of the painting, reinforcing the sense that there is no way out.

93 *From Williamsburg Bridge*, 1928
Edward Hopper, 1882–1967
Oil on canvas; 29 x 43 in.
(73.7 x 109.2 cm.)
George A. Hearn Fund, 1937
(37.44)

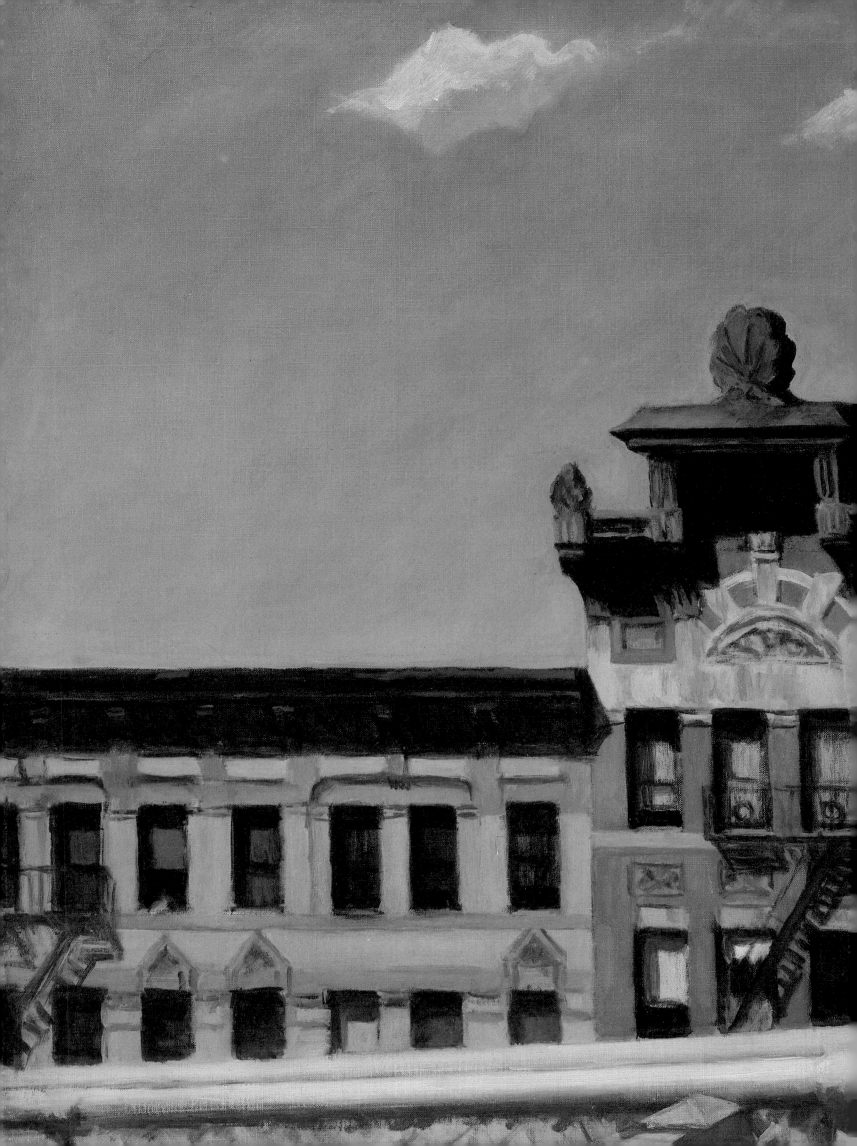

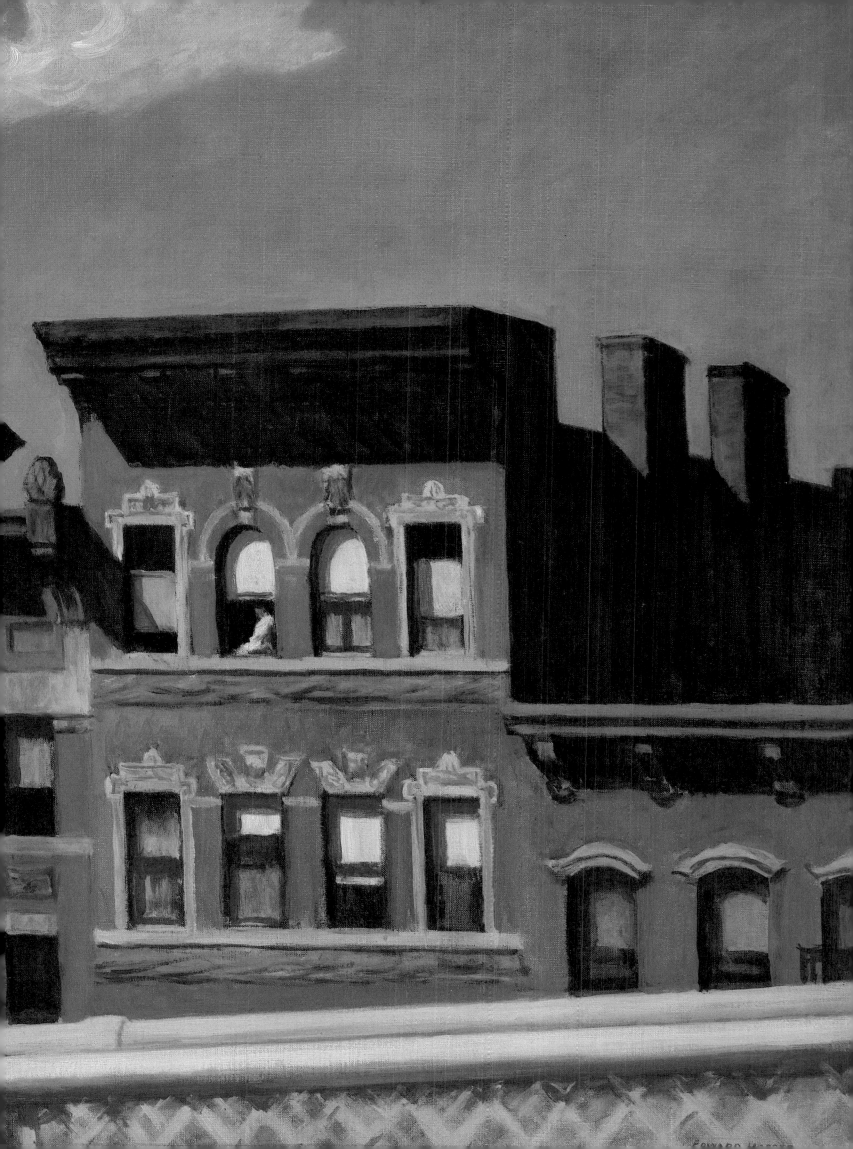

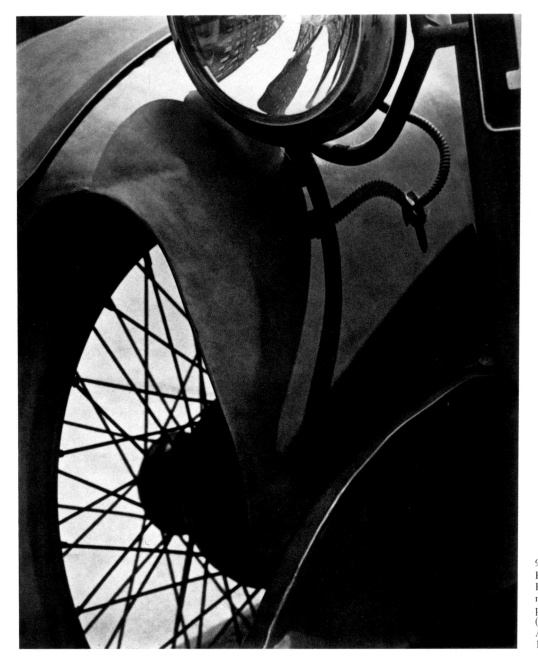

94 *Untitled*, 1917
Paul Strand, 1890–1976
Platinum print from enlarged
negative; image, 12⅝ x 9¹⁵⁄₁₆,
paper, 13 x 10¼ in.
(32.1 x 25.2, 32.9 x 26.1 cm.)
Alfred Stieglitz Collection,
1949 (49.55.318)

PAUL STRAND
Untitled

Radical in politics and in photography, Paul Strand has become a symbol of his time and place. Born of Bohemian Jewish parents, he grew up in New York and, as a young man, worked in his father's business until it was sold and he was free to go to Europe to study. On his return, he started his own business, taking photographs of college buildings as souvenirs for graduating seniors. It was a gamble on the sentimental attachment of ex-students for their alma mater that paid off and provided him with a living while he explored more adventurous areas of photography on his own account.

By 1915, his exposure to the modern influence of Alfred Stieglitz and, through him and his "291" gallery, to the works of such modern painters as Cézanne and Picasso, had moved Strand away from his early attraction to soft-focus pictorialism. Throughout the teens he dabbled in abstraction, focusing sharply on everyday items from unexpected angles to produce an image approaching nonobjectivity. This interest abated after a few years, and most of his mature work consisted of straightforward, sympathetic portraits of nature and of people.

This photograph was made when Strand was immersed in his experiments in nonobjectivity. But, even then, he never quite abandoned his attachment to representation, and choosing the same path as Georgia O'Keeffe and John Marin, he selected his angle in such a way that it was possible to approach his work either as an abstract or as a detail of reality.

95 *I Saw the Figure 5 in Gold*, 1928
Charles Demuth, 1883–1935
Oil on cardboard;
35½ x 30 in. (90.2 x 76.2 cm.)
Alfred Stieglitz Collection, 1949
(49.59.1)

CHARLES DEMUTH
I Saw the Figure 5 in Gold

Charles Demuth was a versatile artist who tailored his style to his subject matter. His watercolors of fruits and flowers are delicate, loosely handled works that pulsate with subtle, exquisitely balanced color, while his paintings of the modern urban and industrial landscape are tightly controlled, hard, and exact, in a style aptly called Precisionist.

I Saw the Figure 5 in Gold is one of a series of portraits of friends that Demuth made between 1924 and 1929. This painting is inspired by a poem by William Carlos Williams, whom Demuth had known since 1905, when both were students in Philadelphia. Like Marsden Hartley's *Portrait of a German Officer* and Arthur Dove's *Ralph Dusenberry* (see Plates 89 and 91), this portrait consists not of a likeness of the artist's friend, but of an accumulation of images asso-

ciated with him—the poet's initials and the names "Bill" and "Carlos" which together form a portrait.

Williams's poem, called "The Great Figure," describes the experience of seeing a red fire engine with the number "five" painted on it racing through the city streets. While it is not an illustration of Williams's poem, we can certainly sense in Demuth's painting "the rain/and lights" and the "gong clangs/siren howls/and wheels rumbling" of the poem. The bold number "five" both rapidly recedes and races forward in space, and the round forms of the number, the lights, the street lamp, and the arcs at the lower left and upper right, are played off against the straight lines of the fire engine, the buildings, and the rays of light, infusing the picture with a rushing energy that perfectly expresses the spirit of the poem.

128

96 *The Midnight Ride of Paul Revere*, 1931
Grant Wood, 1892–1942
Oil on Masonite;
30 x 40 in. (76.2 x 101.6 cm.)
Arthur Hoppock Hearn Fund, 1950
(50.117)

GRANT WOOD
The Midnight Ride of Paul Revere

Grant Wood was a Regionalist, one of the group of painters who turned away from the currents of modern European art in an effort to forge a realistic style that would be identifiably American. Indeed, of the art styles of the 1920s and 30s, Regionalism was the most widely embraced by the American public. Wood's *American Gothic*, for example, an ironic portrait of a Midwestern farm couple, is one of the best-known images of American painting.

Despite his focus on America, Wood traveled to Europe four times during the 1920s. The most important lessons he brought back were from Germany, where he was impressed with the contemporary art movement known as the Neue Sachlichkeit (New Objectivity), which rejected abstraction in favor of an orderly, realistic art. He also admired the primitive Flemish and German painters, particularly for the way in which they depicted mythological or biblical stories in contemporary costumes and settings, making them more relevant to the viewer than an attempt at historical accuracy.

In a similar fashion, *The Midnight Ride of Paul Revere*, painted in 1931, makes no attempt to be historically correct —for example, eighteenth-century houses would surely not have been so brightly lit. Still, this is not a scene Wood's viewers could recognize readily. Rather, the artist has given the picture a sense of dreamlike unreality. Note how the bird's-eye view makes the setting look like a New England town in miniature. Note also the geometric shapes of the buildings and the landscape (even the treetops are perfectly round); the precisely delineated, virtually unmodulated light emanating from the buildings and raking across the foreground; the distinct, regularized shadows; and the way in which the forms in the darker background are almost as clear and visible as those in the brightly lit foreground. With his clean line and his even, unerring hand, Wood has thrown the scene into high relief, heightening reality so as to make it almost otherworldly, a quality that differentiates him from his fellow Regionalists.

Wood's clear, geometric style is akin to that of the Precisionists, including his contemporaries Charles Sheeler and Charles Demuth. But the Precisionists were following in the path set by modern movements in which precision of line was seen to be expressive of modern life, while for Wood such precision evokes the work of eighteenth-century American limners. Unlike his modernist contemporaries, Wood remained committed to regional life in America and, he hoped, the creation of a national modernist style.

97 *Winter Yosemite Valley*, 1933–1934
Ansel Adams, 1902–84
Gelatin silver print;
9¼ x 7¹⁵⁄₁₆ in. (23.4 x 18.5 cm.)
Alfred Stieglitz Collection, 1949
(49.55.177)

GEORGIA O'KEEFFE
Black Iris, III

Virtually all of Georgia O'Keeffe's paintings are inspired by nature—by landscape or flowers or animal skeletons. And yet out of this limited range of subject matter she has created an art of unlimited and subtly nuanced variety. Shortly after her marriage in 1924 to Alfred Stieglitz, O'Keeffe began a series of close-ups of flowers, of which The Metropolitan Museum's *Black Iris, III* is an exquisite example. The exotic flower is viewed at such close range that it has become monumental, expanding beyond the edges of the artist's canvas. In the process, the iris has lost much of its specific identity, and the painting hovers, delicately balanced, between abstraction and representation. At once pristine and extremely sensual, *Black Iris, III* demonstrates O'Keeffe's consummate control of her medium: The colors blossom out in fine gradations from the deepest, most velvety and mysterious black in the center to shades of white, gray, and pink so thin as to be translucent. Where the leaves twist and fold over themselves, O'Keeffe handles the oil paint as delicately as if it were watercolor. She has painted an image of tremendous expansion and efflorescence, endowing the iris with great dignity.

In 1949, O'Keeffe moved from New York to New Mexico, where the open space provided her with her favorite landscape. She remained there until her death in 1986, independent of fluctuations in painting styles and pursuing her individual vision.

98 *Black Iris, III*, 1926
Georgia O'Keeffe, 1887–1986
Oil on canvas; 36 x 29⅞ in.
(91.4 x 75.9 cm.)
Alfred Stieglitz Collection,
1969 (69.278.1)

ANSEL ADAMS
Winter Yosemite Valley

Ansel Adams first discovered Yosemite and the High Sierra mountains of California in 1916, when he was fourteen years old. He fell in love immediately, and the affair was to last for the rest of his life.

In his first photographic efforts, Adams was influenced by the soft-focus pictorialism of the time. However, after meeting Paul Strand in Taos, New Mexico, in 1930, he was led toward the sharp-focus, straightforward approach with which his work is now identified. In addition to taking photographs, Adams taught photography and was a founder of the f/64 group (named for the preferred size of camera lens opening), which included such prominent colleagues as Imogen Cunningham and Edward Weston, and whose aim was to promote "straight" photography as an art form.

Winter Yosemite Valley, is characteristic of the simplicity and delicacy of Adams's early work. There is an intimacy and a subtlety in the landscape, and a powerful use of contrast in the black of the branches and the white of the snow. Light, and the changes it wrought on landscape, were very important to Adams, much as they had been to the Luminist painters, such as John Frederick Kensett (see Plate 53), nearly a century earlier.

99 The Coming of Spring, 1917–1943
Charles Burchfield, 1893–1967
Watercolor on paper mounted on
presswood; 34 x 48 in. (86.4 x 121.9 cm.)
George A. Hearn Fund, 1943 (43.159.6)

CHARLES BURCHFIELD

The Coming of Spring

In *The Coming of Spring*, we can see that for Charles Burchfield landscape was a vehicle for the expression of awe at the mystery and powerful life force of nature. As spring represents the regeneration of life, so the landscape here comes alive, seeming almost to move on the paper. The water cascades down the ravine with palpable energy. The branches, leaves, and flowers twist, writhe, and leap like flames into the air, pulsating with life. We can almost hear the flowers growing.

Burchfield's animated views of nature have a kinship with the film cartoons of such craftsmen as Walt Disney, whose images of a living, feeling nature (complete with talking flowers) have become a part of our general consciousness.

THOMAS HART BENTON

July Hay

Thomas Hart Benton turned away from the modern European art that had inspired his early work in order to create a native American art, much as Grant Wood and many other painters of this period wanted to do. He concentrated on the depiction of physical labor and executed a number of public murals in which the labor of common man is monumentalized and made heroic. One of Benton's favorite subjects was the farm worker, whom he usually depicted in the midst of his toils.

July Hay, painted in 1943, is a fine example of Benton's representation of agricultural labor. The strong light-dark contrasts and the rolling, rhythmic composition subsume landscape and figures into one, expressing the unity of man and the land. The fully rounded figures are not given individual identities but are generalized in form and even stand with their backs to the viewer. In fact, the flowers and insect in the foreground are more detailed than the two men. Thus, rather than representing two specific individuals, these men stand for all workers.

100 July Hay, 1943
Thomas Hart Benton, 1889–1975
Egg tempera, methyl cellulose,
and oil on Masonite;
38 x 26¾ in. (96.5 x 67.9 cm.)
George A. Hearn Fund, 1943
(43.159.1)

CHARLES SHEELER

Charles Sheeler is best known today as a painter of the industrial landscape, but he was an important and first-rate photographer as well. Born in Philadelphia, Pennsylvania, in 1883, Sheeler spent three years at the Philadelphia School of Industrial Art before attending the Pennsylvania Academy of the Fine Arts. Around 1912, Sheeler took up photography, and he continued to work in both mediums. Soon after this he met Alfred Stieglitz, who greatly admired his photographs, and with whom he developed an enduring relationship. Sheeler was also a member of an influential circle of European and American avant-garde artists, poets, dancers, critics, and collectors.

Illustrated here are examples of Sheeler's work both as a painter and photographer, spanning his early and late career. *Bucks County House* is one of a series of photographs Sheeler made of this house in Doylestown, Pennsylvania, where the artist was living at the time. It is a beautifully balanced, harmonious work, a testament to Sheeler's love of the spare geometry of early American architecture. Sheeler has emphasized the chaste, Puritan quality of the house by using a single bright light, yielding strong dark-light contrasts. The stark contrast of the black stove, the area behind the window, and the shadows against the white of the room create a strong visual pattern, and the work delicately treads the line between abstraction and representation. Yet, while obviously attracted to the geometry of the unadorned room, Sheeler has subtly relieved it, photographing the scene so the stovepipe divides the window asymmetrically, and the stove's handle and finial are silhouetted against the floor and wall, acting as fillips, lightening the austerity of the whole.

Water was painted nearly thirty years after Sheeler photographed the Bucks County house. A picture of a power generator of the Tennessee Valley Authority, this is a fine example of the Precisionist style, in which objects are painted with a clarity and exactness reminiscent of photography. Here, not only the architectural forms of the generator, but even the shadows are clearly delineated. It is a classical work in which each object maintains its integrity of form, and there is no trace of the artist's hand. Isolated from any specific, identifiable setting, and depicted in a clear, strong light, these industrial structures are monumental and dignified. The composition is marked by a stately rhythm, emphasized by the measured recession of the raking shadows. A powerful, cleanly rendered image, *Water* is a statement of the artist's faith in the power of human beings to master nature for the good of mankind.

As different as *Water* and *Bucks County House* are both in medium and subject matter, we can sense in them a single underlying sensibility. In each work the artist has eliminated details, exploiting the geometry of the subject for its abstract qualities and in order to endow the scene with a sober dignity. A clarity of vision and the ability to distill a scene to its essence inform all of Sheeler's art, in which the commonplace is made poetic.

101 Bucks County House,
Interior Detail, 1917
Charles Sheeler, 1883–1965
Gelatin silver print;
9⅛ x 6⁷⁄₁₆ in. (23.2 x 15.9 cm.)
Alfred Stieglitz Collection,
1933 (33.43.259)

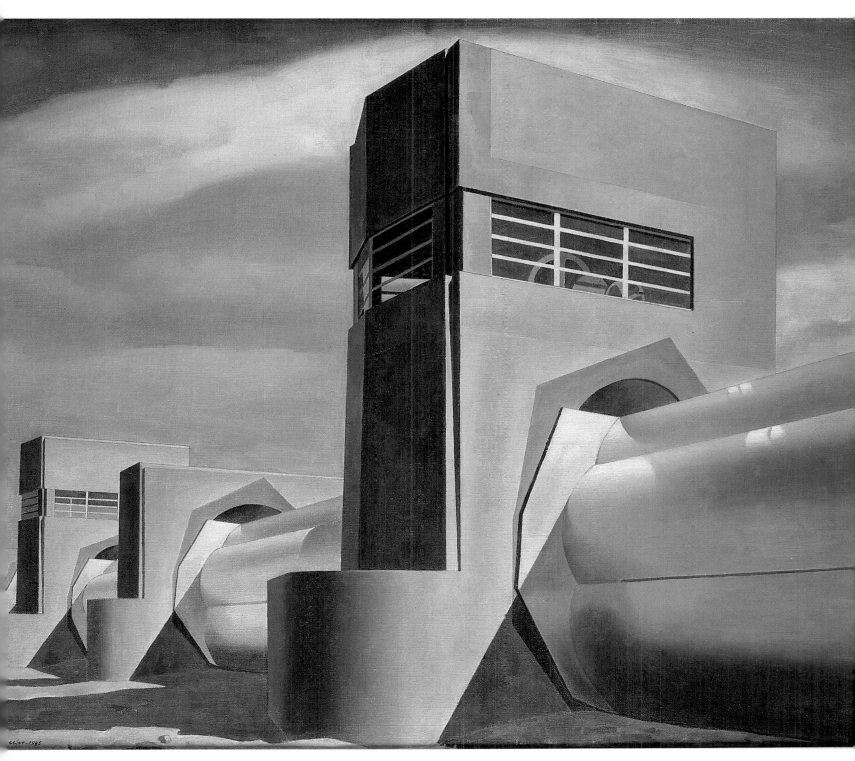

102 Water, 1945
Charles Sheeler, 1883–1965
Oil on canvas; 24 x 29⅛ in.
(61 x 74 cm.)
Arthur Hoppock Hearn Fund,
1949 (49.128)

135

103 *Water of the Flowery Mill*, 1944
Arshile Gorky, 1904–48
Oil on canvas; 42¼ x 48¾ in.
(107.3 x 123.8 cm.)
George A. Hearn Fund, 1956
(56.205.1)

ARSHILE GORKY
Water of the Flowery Mill

Arshile Gorky was born on the shores of Lake Van in old Armenia (now Turkey), but his life was overturned in 1914 when czarist Russia invaded his homeland. Gorky, his mother, and one of his sisters became refugees in Russia, while his father and his other sisters fled to the United States. When his mother died in 1919, sixteen-year-old Gorky and his sister joined his father and sisters in Providence, Rhode Island.

During the early years of his career as a painter, Gorky paid great attention to modern European art, assimilating into his own work the lessons of Cézanne, Picasso, Miró, Matisse, and others. Ironically, it was the direct contact with artists of a major European art movement—the many European Surrealists who found refuge in New York during World War II—that enabled Gorky to look into himself to discover the subject of his art. Surrealism, with its emphasis on the artist's inner world, its use of dream imagery, and the practice of "automatism" (drawing by moving the pencil across the page with as little conscious control as possible), encouraged Gorky to use his imagination, memories, and fantasies as the springboard for his art. He was one of the first American painters to do so.

Although his work points the way to Abstract Expressionism, unlike the painters of that school, Gorky remained tied to the objective world—but not to its imitation. For Gorky, the images of the natural world were filtered through his most personal memories, fears, and desires to produce the biomorphic abstractions for which he is so well known. *Water of the Flowery Mill,* with its suggestions of water, clouds, and other natural elements, is an example of Gorky's mature work. An image of an old sawmill on the Housatonic River in Connecticut, this is a lyrical and evocative painting. Yet despite its ambiguous images and aura of spontaneity, this work shows that at heart Gorky remained a classical artist: The composition, in which the forms and colors are alternately rather dense or spread to an almost transparent skin, is carefully orchestrated and controlled in every area of the work. Beneath the paint that has been allowed to drip and the areas of exquisite color, which were consciously planned to create the illusion of shallow depth, we can see a delicacy of line that reveals how important draftsmanship was to Gorky.

JACKSON POLLOCK
Autumn Rhythm (Number 30)

Jackson Pollock, whose "drip" paintings continue to evoke strong reactions nearly forty years after the first one was completed, is surely the best known of the Abstract Expressionist painters. Along with his colleagues Willem de Kooning, Franz Kline, Adolph Gottlieb, and others, Pollock sought to express in his art the needs, desires, and impulses shared by all mankind. These artists rejected the subjects and techniques of traditional painting as insufficient to express these truths. In his early years as a painter, Pollock sought them in archaic myths of all cultures, evident in titles such as *Pasiphaë* (in the collection of The Metropolitan Museum), *Guardians of the Secret*, and *Totem Lesson*.

While he was seeking new subject matter, Pollock was also working toward a new style, one which would be as direct and fundamental as the content he wished to express. Thus, these early mythic works were painted with an aggressive, crude touch that was expressive of his deep impulses. By the late 1940s, Pollock rejected representation and specific subject matter altogether, concentrating on the process of painting itself. He believed that it was through the act of creating, of putting the marks onto canvas, that the artist could discover and express his most fundamental impulses—so fundamental that they would transcend his individual experience and be universally understood and felt.

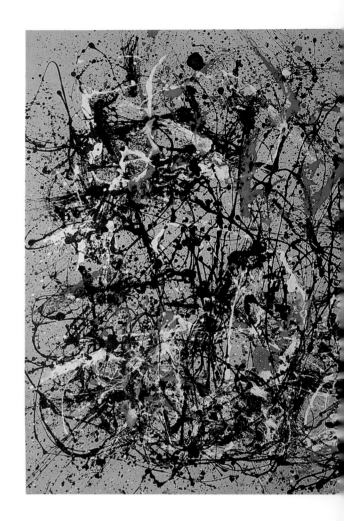

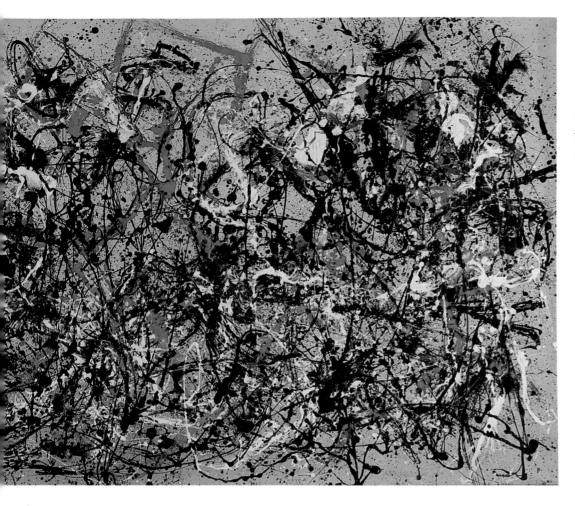

104 *Autumn Rhythm (Number 30)*, 1950
Jackson Pollock, 1912–56
Oil on canvas; 105 x 207 in.
(266.6 x 525.6 cm.)
George A. Hearn Fund, 1957 (57.92)
Below: detail

The famous drip paintings represent the ultimate rejection of the traditional means of art. By placing the canvas on the floor, where he could actually walk and crawl around it, and by dripping and pouring the paint onto the canvas, Pollock could involve his entire body, not just his hand and arm, in the creation of the work. Indeed, the viewer senses this total involvement, and the process of creation becomes the subject of the art.

The drip paintings were shocking when first exhibited, and remain so to many people, but today the extraordinary fluency and energy of the best of them is more widely appreciated. *Autumn Rhythm*, at once graceful in line and heroic in scale, is a superb example. The broad horizontal sweep of the painting is too great to take in at once, and the allover pattern covers the canvas with virtually equal emphasis throughout, denying us a single area on which to focus. Thus the painting requires our active involvement as eyes rapidly move over the canvas, unable to settle. The articulate cadences and delicacy of line of *Autumn Rhythm* belie the notion that Pollock's work was largely the result of accident: Only with consummate control, skill, and draftsmanship could an ecstatic, pulsating, dynamic work like this be so eloquent and coherent.

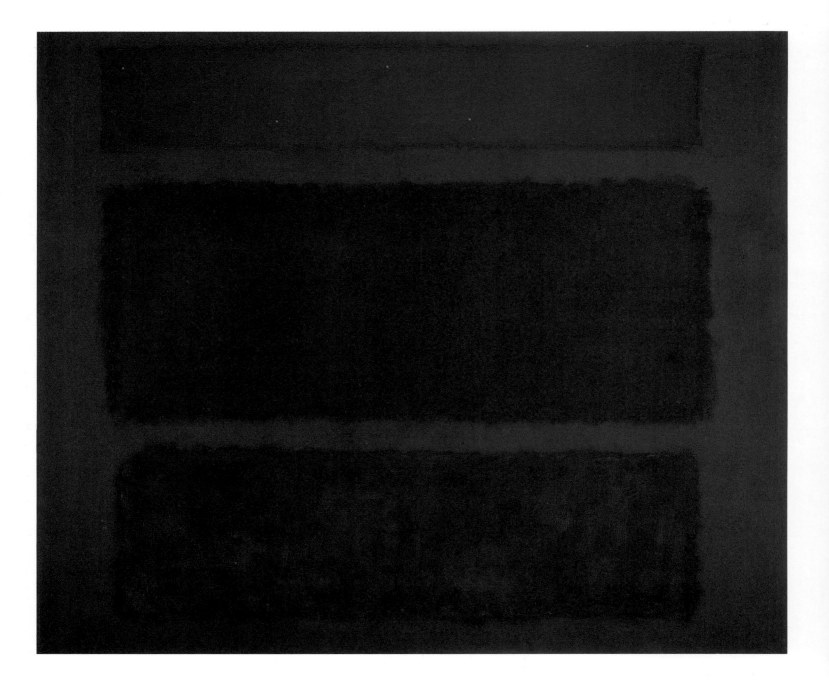

105 *Reds (Number 16)*, 1960
Mark Rothko, 1903–70
Oil on canvas; 102 x 119½ in.
(259.1 x 303.5 cm.)
Arthur Hoppock Hearn Fund,
George A. Hearn Fund, and
Hugo Kastor Fund, 1971
(1971.14)

MARK ROTHKO
Reds (Number 16)

By the late 1940s, Abstract Expressionism comprised two styles of painting. One, exemplified by Jackson Pollock and Willem de Kooning, is characterized by visible evidence of the process of picture making—expressive, assertive brushstrokes, and vibrant, shifting compositions. The other, seen here in the work of Mark Rothko, gives no evidence of the process of creation, but is marked by a sense of calm transcendence.

In *Reds (Number16)*, painted in 1961, we have a fine example of the luminous color and balanced composition that have given Rothko's work the quiet, contemplative character for which it is so well known. There are seemingly infinite nuances of color here, and the painting pulsates with hue and atmosphere. Yet the whole is perfectly balanced: The bright red rectangle at the top, for example, is the smallest of the three, so that its brightness does not overwhelm the rest of the painting. The colors, so close in value and intensity, are exquisitely adjusted, and no one of them calls itself to our attention. Rather, the entire painting envelops us in a single experience of color.

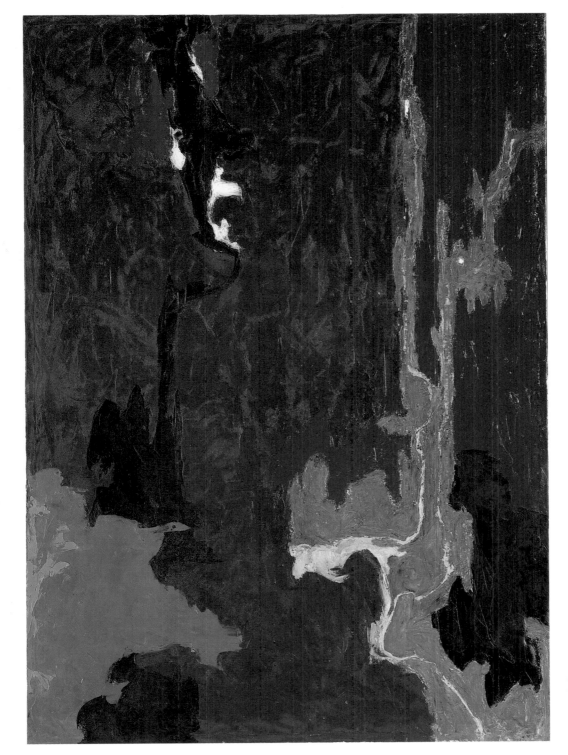

106 Untitled, 1946
Clyfford Still, 1904–80
Oil on canvas; 61¾ x 44½ in.
(156.8 x 113 cm.)
George A. Hearn Fund and
Arthur Hoppock Hearn Fund,
1977 (1977.174)

CLYFFORD STILL
Untitled

Although Clyfford Still spent a great deal of time in New York, his work came to maturity in San Francisco, where he helped popularize the new abstract art.

The work reproduced here is a dense, paint-encrusted canvas on which Still has applied his color with a palette knife in rough, energetic strokes. The interlocking areas of color are not defined by lines but by jagged, torn edges. Still has banished all vestiges of traditional composition from the painting, denying us entry into deep space and creating instead a work that is emphatically frontal. Everything about the painting contributes to this frontality: The planes of color are juxtaposed, rather than overlapped, to avoid the illusion of foreground and background; the composition fills the entire canvas, seeming to extend beyond its edges and thereby denying a sense of top or bottom, right or left; and each area of color is given equal emphasis—there is no single place on which to focus, and our eyes must restlessly scan the surface of the canvas. Finally, Still has chosen warm colors, very close in value, which seem to come forward on the picture plane.

BARNETT NEWMAN

The Station

In 1948, Barnett Newman painted a work that consisted of a deep red rectangular field bisected vertically by a narrow orange stripe. This format—a stripe (or stripes) dividing a unitary rectangle—was the one he would use through his career, creating a subtly varied body of work by adjusting the relationship of the stripe to the rectangle it divided.

In *The Station,* the narrow white stripe on the right seems to open the canvas, endowing it with a sense of space. The brushy black marks on either side of the stripe are offset by the deep, wide black stripe on the left, an area that feels like an abyss, deeper and heavier than the opening created by the white stripe on the right. By carefully balancing size, placement, and tone, Newman has created a strong and complex painting out of the simplest elements.

108 Ocean Park (Number 30), 1970
Richard Diebenkorn, b. 1922
Oil on canvas; 100 x 82 in.
(254 x 208.3 cm.) Purchase,
Bequest of Miss Adelaide Milton
de Groot (1876–1967),
by exchange, 1972 (1972.126)

107 The Station, 1963
Barnett Newman, 1905–70
Oil on canvas; 24 x 24¼ in.
(61.2 x 61.6 cm.)
Gift of Longview Foundation, Inc.,
in memory of Audrey Stern Hess,
1975 (1975.189.1)

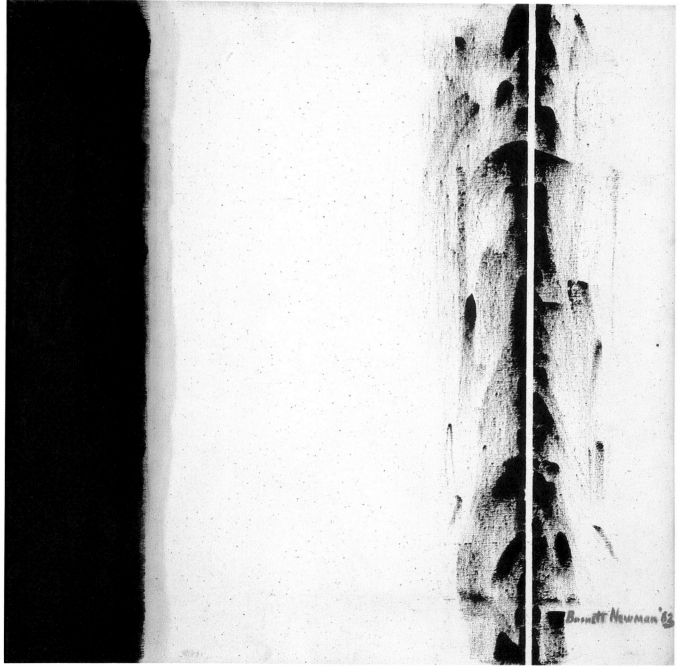

RICHARD DIEBENKORN
Ocean Park (Number 30)

Richard Diebenkorn came to maturity in the San Francisco Bay Area of California. Although he started out as an abstract painter, he soon turned to the figure, and was one of a group of prominent figurative painters centered in the San Francisco area. In 1967, Diebenkorn began a series of abstract works known as the Ocean Park series—a group of stunningly beautiful, sensuous, yet refined paintings, which show him to be among the most sensitive colorists of his generation.

Much as the space and light of New Mexico have inspired Georgia O'Keeffe, so the salt air and soft light of the Califor-

nia coast have inspired Diebenkorn in these works. *Ocean Park (Number 30)* was painted in 1970 and is a fine example of the series. So subtly has the artist modulated his exquisite, muted color that a soft, atmospheric light seems to emanate from the canvas. And the way in which the expansive color is given structure by the scaffolding of straight lines reminds us of the work of the great French painter Matisse. It is as if Diebenkorn has taken Matisse, whose paintings so often bordered on abstraction, one step further, crossing the line into abstract painting. But Diebenkorn has, like Matisse, maintained his ties to the natural world.

WILLEM DE KOONING
Attic

Willem de Kooning, together with Jackson Pollock, is one of the original and most important of the painters known as Abstract Expressionists. Born in Rotterdam, Holland, in 1904, de Kooning left school at sixteen and apprenticed himself to a firm of commercial artists and decorators. In 1926, he moved to New York, where his first job was as a house painter. Like his close friend Arshile Gorky (see Plate 103), with whom he shared a studio during the 1930s, de Kooning absorbed the work of the modern European masters before developing his highly individual style of painting.

Attic is the final canvas in a group of paintings executed during a period in which de Kooning eliminated color from his work (Pollock did the same at one time), perhaps to concentrate on composition and drawing, perhaps because commercial enamel paint was cheap and readily available. It is an active, extremely energetic work in which angular, thrusting forms collide with organic, curvilinear ones to yield a high-pitched, expressive picture. Whereas Pollock (see Plate 104) seems to have danced over his canvas, de Kooning seems to have jabbed and prodded his, laying on the paint in thick, active strokes. There are no flowing arabesque lines, gracefully floating over a shallow space, but rather, a dense, impacted canvas. De Kooning reworked this piece often, and in his eagerness to continue painting without a break, he used newspaper to absorb the moisture of the paint on the canvas before adding more. The imprint from the newspaper was allowed to remain on the canvas, resulting in an image that would become more common in the work of Robert Rauschenberg and Jasper Johns in the late 1950s and after.

Although in *Attic*, as in *Autumn Rhythm*, we can feel the gesture and excitement of the painter as he created his work, de Kooning's piece is marked by a stronger sense of structure, largely resulting from the central axis and the restriction to black and white. Yet although the use of black and white highlights structure and line and yields a sense of figure and ground, this painting is so dense that the two often seem to merge and exchange places. De Kooning's composition reaches right to, and apparently beyond, the edges of his canvas, increasing the sense of density in the painting and its assertive presence. Immediately following *Attic*, de Kooning reintroduced color into his work, already hinted at here in the touches of red and yellow.

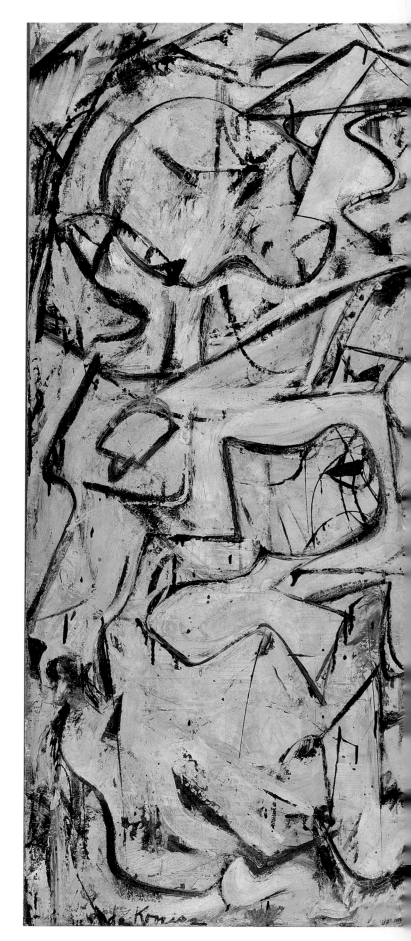

109 *Attic*, 1949
Willem de Kooning, b. 1904
Oil, enamel, and newspaper transfer
on canvas; 61⅞ x 81 in. (157.2 x 205.7 cm.)
Jointly owned by The Metropolitan Museum
of Art and Muriel Kallis Newman,
in honor of her son, Glenn David Steinberg,
The MURIEL KALLIS STEINBERG NEWMAN
Collection, 1982 (1982.16.3)

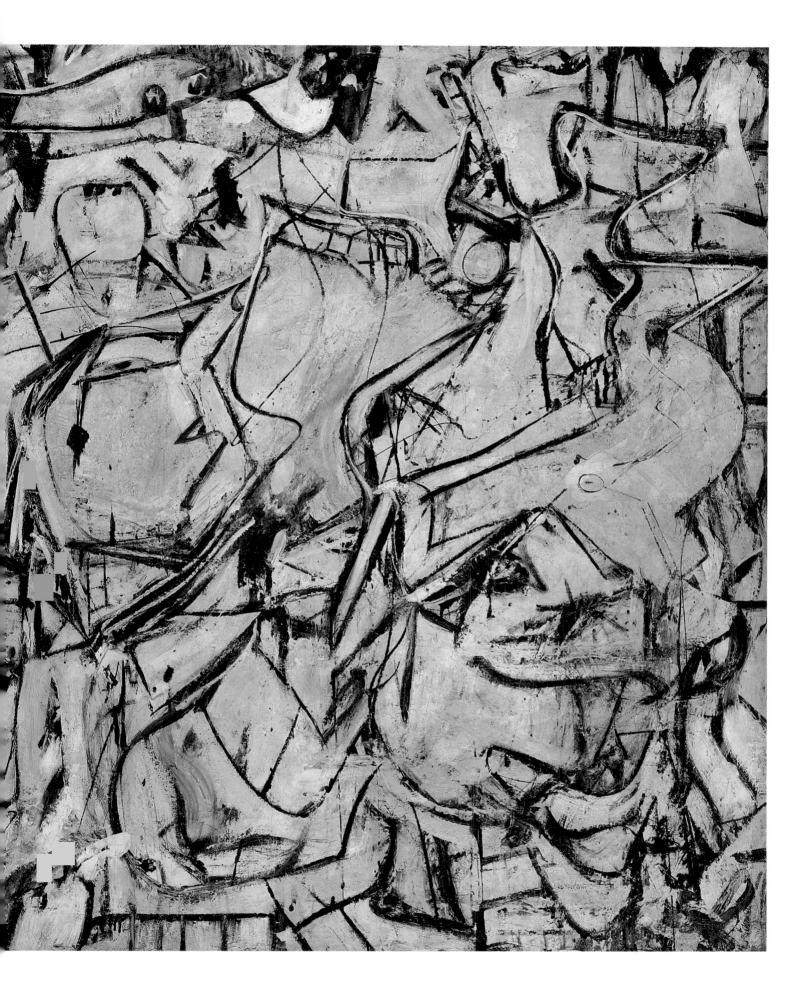

Kenneth Noland
Magic Box

Many artists of the generation following the Abstract Expressionists developed a set of concerns that differed widely from those of their predecessors. These younger painters focused not on the creative act, or the expression of universal truths through their art, but on the fundamental characteristics and irreducible formal elements of painting —on its color, size, and shape, and on its two-dimensional nature. These elements were seen not as a vehicle for personal expression, but as ends in themselves, and as the rightful subject of art. Kenneth Noland has explored these issues with a rigorous and sensitive intelligence.

In *Magic Box*, painted in 1959, we can see Noland distilling his art down to the formal components that would preoccupy him from then on. The geometric, brightly colored work comprises simple, concentric rectangles, rotated into a diamond shape, with a circle in the center. While the blue outer stripes, with their ragged edges and splatters, are still reminiscent of the free, gestural brushstroke of Abstract Expressionism, the rest of the composition is precise and regular in form. Moreover, the artist has restricted his palette to the three primary colors, which are equal in value and devoid of nuance or modulation: They are to be seen as color alone, and not as image, atmosphere, or space. Although *Magic Box* consists of only a few, very simple elements, the painting demands to be seen as a whole and cannot be broken down into component parts.

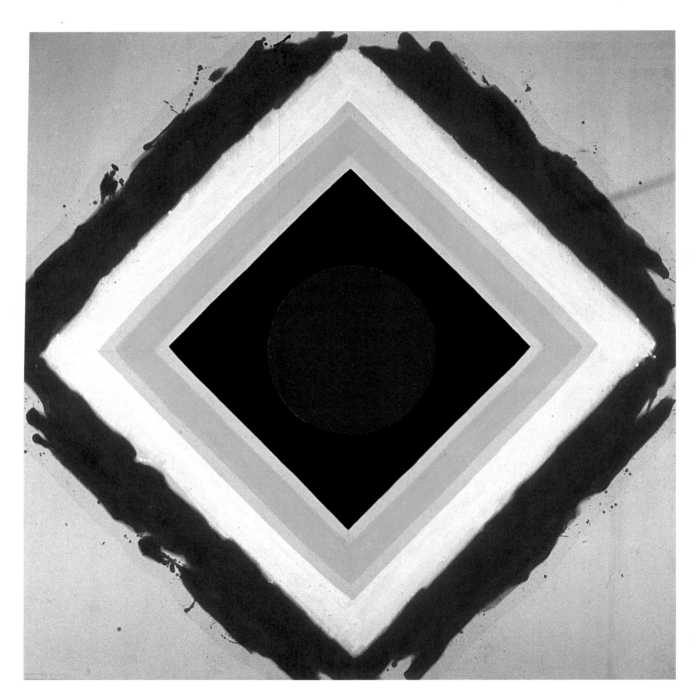

110 Magic Box, 1959
Kenneth Noland, b. 1924
Acrylic on canvas; 96 x 96 in.
(243.8 x 243.8 cm.) Purchase,
Anonymous Gift, 1977 (1977.8)

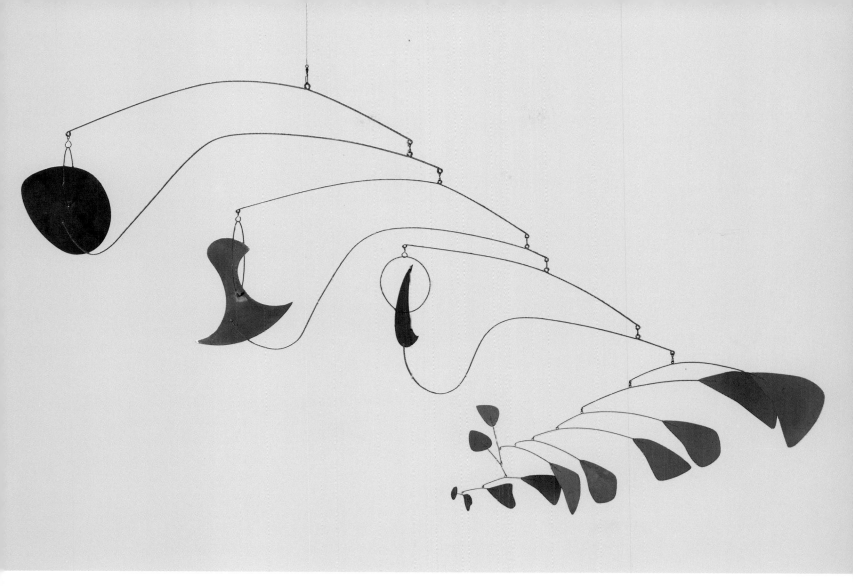

111 Red Gongs, 1950
Alexander Calder, 1898–1976
Hanging mobile: painted aluminum,
brass, steel rod and wire; overall size:
60 x 144 in. (152.4 x 365.8 cm.)
Fletcher Fund, 1955 (55.181.1a-f)

ALEXANDER CALDER
Red Gongs

Alexander Calder's first works were witty, sophisticated toys, the most famous of which is his delightful, many-figured *Circus* at New York's Whitney Museum of American Art. He began making moving sculpture—or mobiles, as his works were named by artist Marcel Duchamp—in 1932.

Red Gongs, completed in 1950, demonstrates how with a minimum of detail, Calder was able to create lyrical, rich works. As Klee and Matisse did in their painting, so Calder has here described volume with line alone. The curving, organic shapes described by the wire are rounded and appear fully three-dimensional. Moreover, this sense of volume is increased as the sculpture moves, describing literal volume in space. Even when static, the piece is marked by a sense of movement: The way in which each element increases in scale and breadth, from the cluster of small forms at one end to the large solitary ones at the other, forms a rising visual crescendo. To the movement of his composition, Calder adds the literal movement of the mobile.

OVERLEAF:

MORRIS LOUIS (Pages 148–149)
Alpha-Pi

Like Kenneth Noland, Morris Louis stained his canvases directly with pigment, rather than applying the paint with a brush. There is in his work no overlay of paint on paint, mark on mark; rather, the thinned pigment is so united with the surface that we can see beneath it the weave of the canvas.

Louis wanted to make purely optical works, in which color retains its identity as color only. In *Alpha-Pi*, the lines of color have been allowed to overlap only minimally, and each preserves its unique identity, stressing its role as color and denying any sense of atmosphere, image, or space. The center of the canvas remains blank, and the color is relegated to the edges. The composition is antitraditional and undermines our preconceived notions about painting, in which we expect to see the center of the canvas filled.

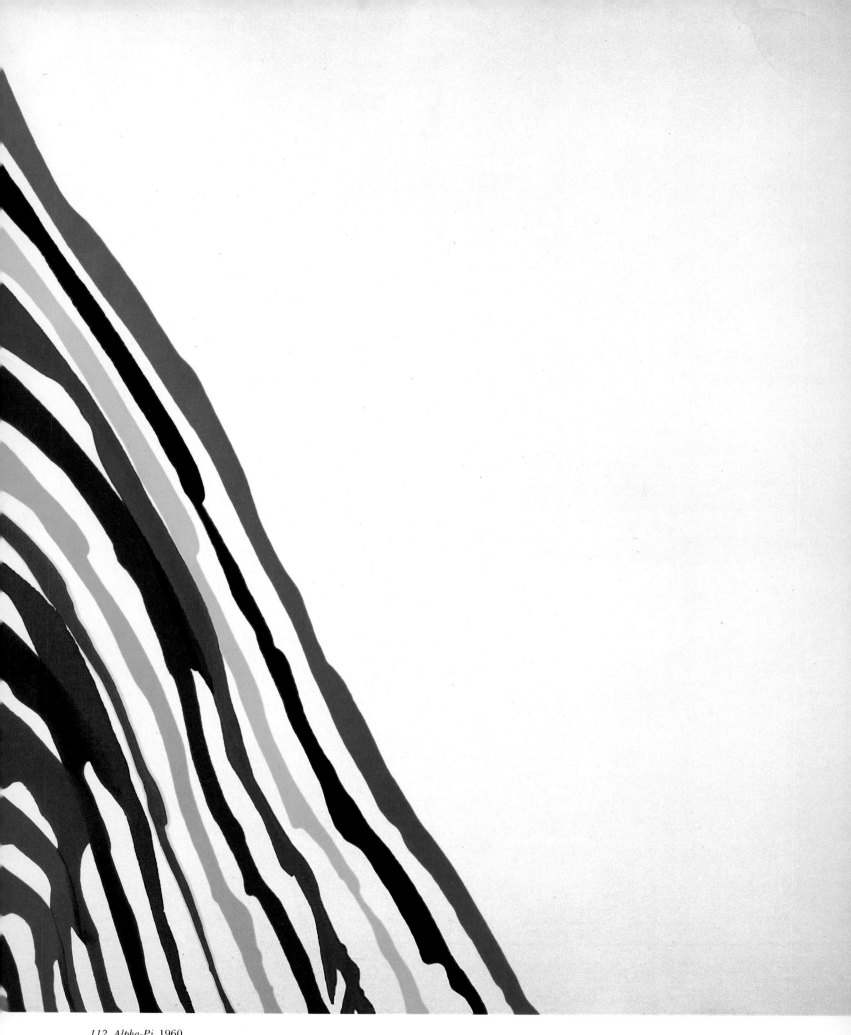

112 Alpha-Pi, 1960
Morris Louis, 1912–62
Acrylic on canvas; 102½ x 177 in.
(260.4 x 449.6 cm.)
Arthur Hoppock Hearn Fund,
1967 (67.232)

113 *Blue Red Green*, 1962–63
Ellsworth Kelly, b. 1923
Oil on canvas; 91 x 82 in.
(231.1 x 208.3 cm.)
Arthur Hoppock Hearn Fund,
1963 (63.73)

114 *Marrakech*, 1964
Frank Stella, b. 1936
Fluorescent alkyd on canvas;
77 x 77 in. (195.6 x 195.6 cm.)
Gift of Mr. and Mrs.
Robert C. Scull, 1971 (1971.5)

ELLSWORTH KELLY
Blue Red Green

Ellsworth Kelly was in Paris from 1948 to 1954, crucial years for the Abstract Expressionist movement in New York. Indeed, Kelly's art has greater affinity with that of Matisse and Arp, whose work he was able to see firsthand in France, than that of his Abstract Expressionist compatriots.

In *Blue Red Green*, two clean, unfussy shapes—a rectangle and an ellipse—and three bold colors interact to create a complex picture. Kelly uses no outlines, but rather—as in Matisse's brightly colored paper cutouts—color and shape are one. And here, the edges of one shape, the rectangle, are identified with the edges of the canvas, while the ellipse expands beyond the canvas's perimeters, forcing us to complete the shape in our mind's eye. Moreover, despite the clean, precise rendering of the ellipse, its form is irregular and seems to float and swell, activating the entire composition.

Kelly has juxtaposed his three colors in a highly skillful

and effective manner. He has used to good advantage the fact that congruent color opposites intensify each other and create a visual vibration at their intersection. The opposites of red and green here both add to the boldness of the work and divide the rectangle into two distinct units. Kelly has also exploited the tendency of warm colors to come forward on the picture plane and cool ones to recede. While the bright, unmodulated colors are in themselves unequivocally two dimensional, we can nevertheless read the red strip at the bottom as foreground and the cool green and blue as receding background. When viewed as foreground and background, the sources in nature for Kelly's forms are perhaps suggested: Blue and green are the colors of water and earth—perhaps lake and field, indicated not only by hue but by the swelling, fluid shape of the ellipse and the flatness of the green surrounding it.

FRANK STELLA
Marrakech

By the age of twenty-three, Frank Stella had created the radical paintings that stand out more than any others as pronouncements of the new, cool art that followed Abstract Expressionism. For Stella, a painting is before anything else an object, and an object that does not resonate with any meaning beyond its existence as a combination of colors and shapes on a two-dimensional surface. These early paintings were black canvases with thin gray stripes. The direction of these stripes, which constituted the entire composition, echoed the edges of the canvas. Thus, Stella's compositions were predetermined by the shape of the canvas rather than developed during the process of painting. The works are austere, sober, impersonal, and hermetic.

Marrakech is one of a series of paintings Stella executed in 1964–65, in which he added color as his primary composi-

tional element. The symmetry of the pinstripe paintings is continued here, but with a twist. Instead of following the edges of the canvas, the stripes in this work are perpendicular to them. Moreover, the way in which each colored stripe meets, at a right angle, not its mate but its opposite, activates the surface of the canvas. Yet despite the bright colors and active surface, the essential elements of the new painting announced by the pinstripes are all here: The pictorial elements—colored stripes—are kept to a minimum; there is no trace of the artist's hand; the composition, a symmetrical arrangement of stripes, is predetermined by the square format of the canvas; and the commercial fluorescent paint is flatly, evenly applied over the entire surface of the canvas, allowing no nuance or sense of atmosphere to detract from the work's existence as a self-sufficient object.

DAVID SMITH

Becca

David Smith was unquestionably one of the most influential and innovative American sculptors of this century. Born in Decatur, Indiana, in 1906, Smith was trained as a painter before turning to sculpture in the 1930s. His career as a sculptor, which may be divided into three phases, began with welded metal constructions into which he often incorporated industrial objects. Daring from the start, Smith was the first American either to make welded metal sculpture —practiced by the European sculptors Giacometti, Julio Gonzàlez, and Picasso—or to use modern industrial objects in his work, looking forward to sculpture of the late 1950s and early 60s. In his second phase, during the 1940s and 50s, Smith executed personal, landscape-inspired sculptures characterized by a delicate linear quality, reminiscent of drawing in metal and similar in feel to contemporary Abstract Expressionist painting. And in the final phase, begun at the end of the 1950s, the work is monumental in size, and its elements are reduced to overlapping geometric plates of highly polished steel. Just as the industrial objects of his early work prefigured later sculpture, so these reductive, geometric, massive pieces of the 60s may be said to prefigure the minimal "primary structures" of the later years of that decade.

Becca, executed in 1965 and named after one of the sculptor's two daughters, is a fine example of Smith's late work. Like almost all of his sculpture, this piece is two-dimensional in orientation, intended to be seen from the front. Although huge in scale and consisting of only a few, simple geometric elements, *Becca* is marked by grace and great energy. The composition is taut and controlled, yet open. The diagonal elements at the top of the piece give the work a joyous lift and buoyancy, and the scribbles—resembling brushstrokes—that cover the entire work are at once expressive and playful.

In *Becca*, we see that Smith was able to maintain the stamp of individual identity, despite his use of modern industrial materials and his reductive forms.

116 *Mona Lisa*, 1963
Andy Warhol, b. 1930
Silkscreen on canvas;
44 x 29 in. (111.8 x 73.7 cm.)
Gift of Henry Geldzahler,
1965 (65.273)

ROY LICHTENSTEIN
Stepping Out

To many people, Roy Lichtenstein's paintings based on comic strips are synonymous with Pop Art. Depictions of characters in tense, dramatic situations, the comic-strip paintings are meant to be ironic commentaries on modern man's plight, in which mass media—magazines, advertisements, television—shape even our emotions. Lichtenstein has also based paintings on masterpieces of art, perhaps commenting, as Andy Warhol did in his *Mona Lisa*, on the conversion of art into commodity.

Stepping Out, completed in 1978, is marked by Lichtenstein's customary restriction to the primary colors and to black and white, by his thick, black outlines, and by the absence of any shading except that provided by the dots imitating those used to print comic strips. Yet his work shows us that beneath a simplicity of means and commonplace subject matter lies a sophisticated art, founded on a great deal of knowledge and skill. Lichtenstein here depicts a man and woman, both quite dapper in dress, side by side. The male is based on a figure in *Three Musicians*, a 1944 painting by the French artist Fernand Léger. The female figure, with her dramatically reduced and displaced features, resembles the surrealistic women depicted by Picasso during the 1930s.

The composition of *Stepping Out* is complex and rather elaborate. The figures, while quite different in appearance and style of dress, are united through shape and color: The sweeping curve of the woman's hair is answered by the curve of her companion's lapel; the diagonal yellow of the end of her scarf is echoed in the yellow rectangle that covers the top of his face; the red benday dots cover half of both faces; and the black that serves as background for the man invades the area behind the woman.

ANDY WARHOL
Mona Lisa

When asked to say the first word that comes to mind upon hearing the name Andy Warhol, most people would probably say "Campbell's soup cans." In fact, it is by bearing in mind his repetitive images of that object that we may best understand this picture of the Mona Lisa, executed in 1963. Warhol has reproduced·what must be the world's most famous painting in such a way as to make it the equivalent of a mass-produced, commercial product—like the soup cans—which is, sadly, what Leonardo da Vinci's *Mona Lisa* has become. The painting has been reproduced so often—and so poorly—that most of us remember it as a printed image rather than as a unique, powerful work of art. Draining the image of all emotional impact, Warhol has repeated it four times in quick succession, as if it were stamped out mechanically. Appropriately, his method of reproduction—photo-silkscreen—is a mechanical, repeatable process.

117 *Stepping Out*, 1978
Roy Lichtenstein, b. 1923
Oil and magna on canvas;
86 x 70 in. (218.4 x 177.8 cm.)
Purchase, Lila Acheson Wallace
Gift, Arthur Hoppock Hearn Fund,
Arthur Lejwa Fund in honor of
Jean Arp; The Bernhill Fund,
Joseph H. Hazen Foundation, Inc.,
Samuel I. Newhouse Foundation, Inc.,
Walter Bareiss, Marie Bannon McHenry,
Louise Smith and Stephen C. Swid
Gifts, 1980 (1980.420)

118 Decoy, 1971
Jasper Johns, b. 1930
Lithograph from one stone, hand-
printed and 18 plates printed
on hand-fed, offset proofing
press on Rives BFK paper;
41⅜ x 29⅝ in. (105.1 x 75.2 cm.)
Gift of Dr. Joseph I. Singer, 1973
(1973.657)

OVERLEAF ·

JASPER JOHNS
Decoy

Jasper Johns is one of the major painters and printmakers
of this century. Born in Augusta, Georgia, in 1930, and raised
in South Carolina, Johns moved to New York in 1949. His
first mature works date from the middle of the 1950s. Johns's
well-known images of flags, targets, numerals, and other
prosaic objects—images which he continues to use to this
day—were seminal in the development of modern art, most
noticeably Pop Art, whose banal subject matter was predicted
in Johns's work. Johns is a master printmaker who for many
years has explored in prints of all types the issues raised in
his paintings. He completed the large colored lithograph
called *Decoy* in 1971.

"Accumulation" may be the best word to describe *Decoy.*
First, there is a literal accumulation of image, color, and
tone, since the work is the result of eighteen successive states.
Second, there is an accumulation of images, not only from
each of the successive states of this print, but also from Johns's
career as an artist. *Decoy* is filled with images from his ear-
lier work: The beer can is a frequent subject of his bronze
sculpture; the written names of colors have figured in his
art since 1959; the fragment of a leg at the top of the work
originates in a 1964 painting called *Watchman;* and the squares
at the bottom of the print contain objects, such as flags and
a coffee can containing paintbrushes, that appeared in much
of his earlier work.

Finally, as the color and images have been literally
accumulated layer upon layer, so are there layers of meaning
here. Note, for example, that color is an element of the
print not only as actual color but also as the words for each
color. Can the *words* "red," "yellow," and "violet" be read as
representations of red, yellow, and violet? Do the words mean
the same thing as the colors themselves? What happens to a
word when it is treated as an object in a work of art? Johns
is insisting here, as he does in all his other work, that we be
aware of the ambiguity and multiplicity of meaning in art,
and of the complexity of visual perception.

Johns refers to his activity as an artist in the mix of styles
in *Decoy.* He combines a painterly quality, seen in the large
areas resembling expressive brushwork, with the anonymous,
reproductive quality inherent in prints, evident in the letters.
He thus asserts his role as both painter and printmaker.

JAMES ROSENQUIST
House of Fire
(Pages 158–159)

James Rosenquist has painted some of the most intelligent,
complex works the Pop Art movement has produced. Born
in 1933 in Grand Falls, North Dakota, Rosenquist worked
as a billboard painter for several years after art school, an
experience reflected in the huge scale and bright colors of
his work.

House of Fire, completed in 1981, is executed in the artist's
characteristically cool, ultrarealistic style, in which no evidence
of the artist's brush is to be seen. Yet no matter how
realistically painted, the scene itself upsets all our notions
about the nature of objective reality. Rosenquist has placed
disparate, unrelated objects—a bag of groceries, a bucket
of molten steel, and lipsticks—into a single painting. And
he has done so in the most disquieting fashion: The bag of
groceries is overturned, yet remains full; the bucket of steel
descends through an open window; and the huge, aggressive
lipsticks dwarf the other objects and seem to rush into the
painting, invading the central panel like a battery of weapons
racing to the rescue. The bright, largely unmodulated colors
increase the dynamism and energy of the work. There is a
seemingly infinite number of shades of red here, especially
noticeable in the lipsticks: the fiery red-orange of the central
panel is contrasted by its color opposite in the blue of the
window; and the red of the left-hand panel is contrasted by
the green of the parsley—another juxtaposition of color
opposites that enlivens the picture. Unlike the rest of the
painting, the parsley is delicately, even sensuously painted.

Rosenquist's illogical assembly of objects, his abrupt and
irrational jumps in scale, and his bright, active colors make
this a striking, disquieting composition. Yet no matter how
ambiguous the subject, this picture is not without meaning.
The lipsticks, for example, are unquestionably phallic in
appearance: Perhaps they hint at the way women use
cosmetics to enhance their sexuality, and perhaps—in the
similarity of the lipsticks to guns—they recall our associations
of male sexuality with violence and aggression. But clearly,
House of Fire is not a narrative picture. Rather, it is one whose
objects, and the style in which they are painted, combine to
form a complex image of violence, sexuality, aggression,
industrialism, and consumerism—the overriding concerns
of intellectuals from the 1950s through the 70s.

119 *House of Fire*, 1981
James Rosenquist, b. 1933
Oil on canvas; 78 x 198 in.
(198.1 x 502.9 cm.) Purchase,
George A. Hearn Fund,
Arthur Hoppock Hearn Fund
and Lila Acheson Wallace Gift,
1982 (1982.90.la-c)

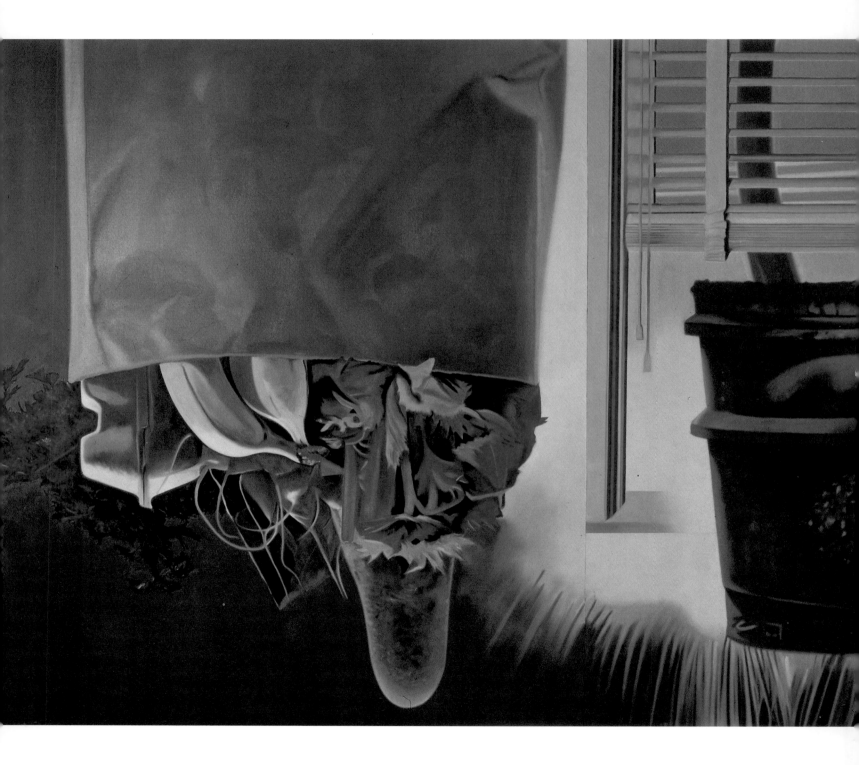

119 *House of Fire*, 1981
James Rosenquist, b. 1933
Oil on canvas; 78 x 198 in.
(198.1 x 502.9 cm.) Purchase,
George A. Hearn Fund,
Arthur Hoppock Hearn Fund
and Lila Acheson Wallace Gift,
1982 (1982.90.la-c)

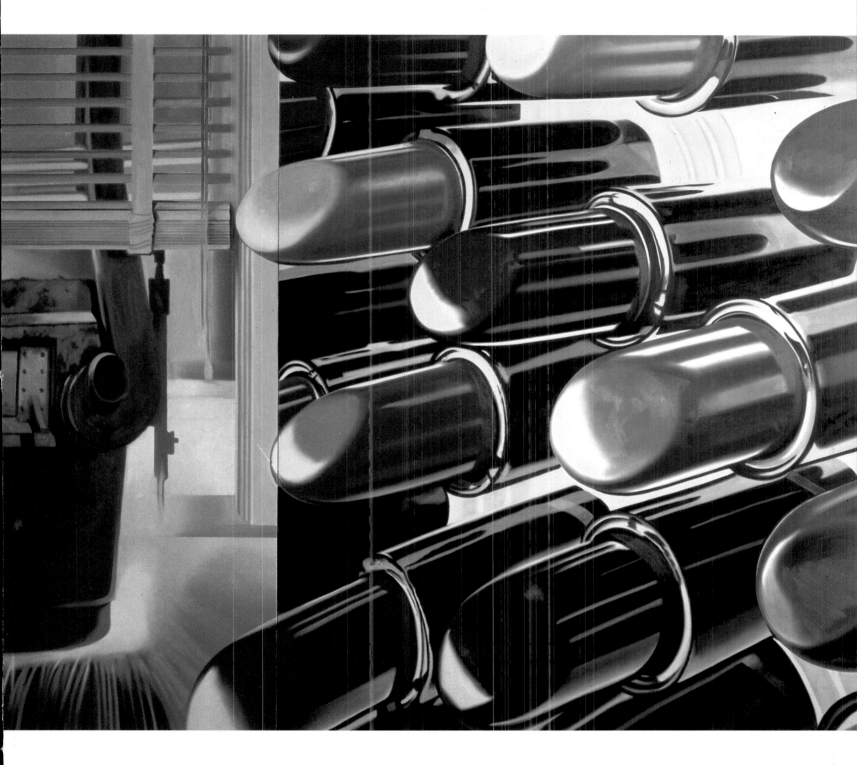

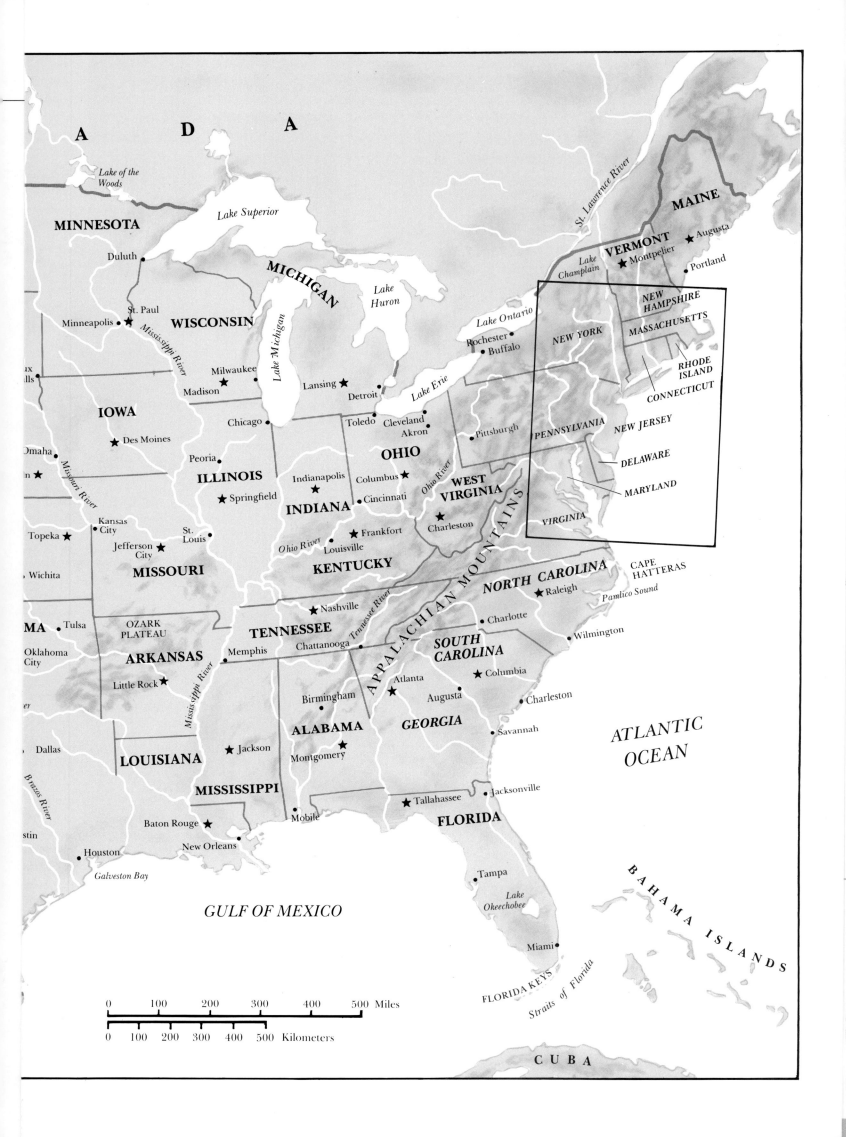

ADA

Lake of the Woods

MINNESOTA

Duluth

Lake Superior

MICHIGAN

Lake Huron

St. Paul
Minneapolis ★

WISCONSIN

Mississippi River

Lake Michigan

Milwaukee ★
Madison ★

Lansing ★

Detroit ●

Lake Ontario

Rochester ●
Buffalo ●

St. Lawrence River

MAINE

★ Augusta

VERMONT
★ Montpelier

Lake Champlain

Portland ●

NEW HAMPSHIRE

NEW YORK

MASSACHUSETTS

RHODE ISLAND

CONNECTICUT

Sioux Falls

IOWA

Des Moines ★

Omaha

Peoria ●

ILLINOIS

Chicago ●

Toledo ●

Lake Erie

Cleveland ●
Akron ●

Pittsburgh ●

PENNSYLVANIA

NEW JERSEY

DELAWARE

MARYLAND

OHIO

Indianapolis ●

Columbus ★

Springfield ★

INDIANA

Cincinnati ●

Ohio River

WEST VIRGINIA

Charleston ●

VIRGINIA

Missouri River

Kansas City

St. Louis ●

Topeka ★

Jefferson City ★

MISSOURI

Ohio River

Louisville ●

Frankfort ★

KENTUCKY

Wichita

MA

Tulsa ●

OZARK PLATEAU

Nashville ★

TENNESSEE

Tennessee River

APPALACHIAN MOUNTAINS

NORTH CAROLINA

★ Raleigh

Charlotte ●

CAPE HATTERAS

Pamlico Sound

Oklahoma City

ARKANSAS

Memphis ●

Chattanooga ●

Wilmington ●

Little Rock ★

Mississippi River

Birmingham ●

Atlanta ★

SOUTH CAROLINA

★ Columbia

Augusta ●

Charleston ●

Dallas

LOUISIANA

Jackson ★

ALABAMA

Montgomery ★

GEORGIA

Savannah ●

Brazos River

MISSISSIPPI

Tallahassee ★

Jacksonville ●

ATLANTIC OCEAN

Baton Rouge ★

Mobile ●

FLORIDA

B A H A M A I S L A N D S

Austin

Houston ●

New Orleans ●

Galveston Bay

GULF OF MEXICO

Tampa ●

Lake Okeechobee

Miami ●

| 0 | 100 | 200 | 300 | 400 | 500 Miles |

| 0 | 100 | 200 | 300 | 400 | 500 Kilometers |

FLORIDA KEYS

Straits of Florida

C U B A

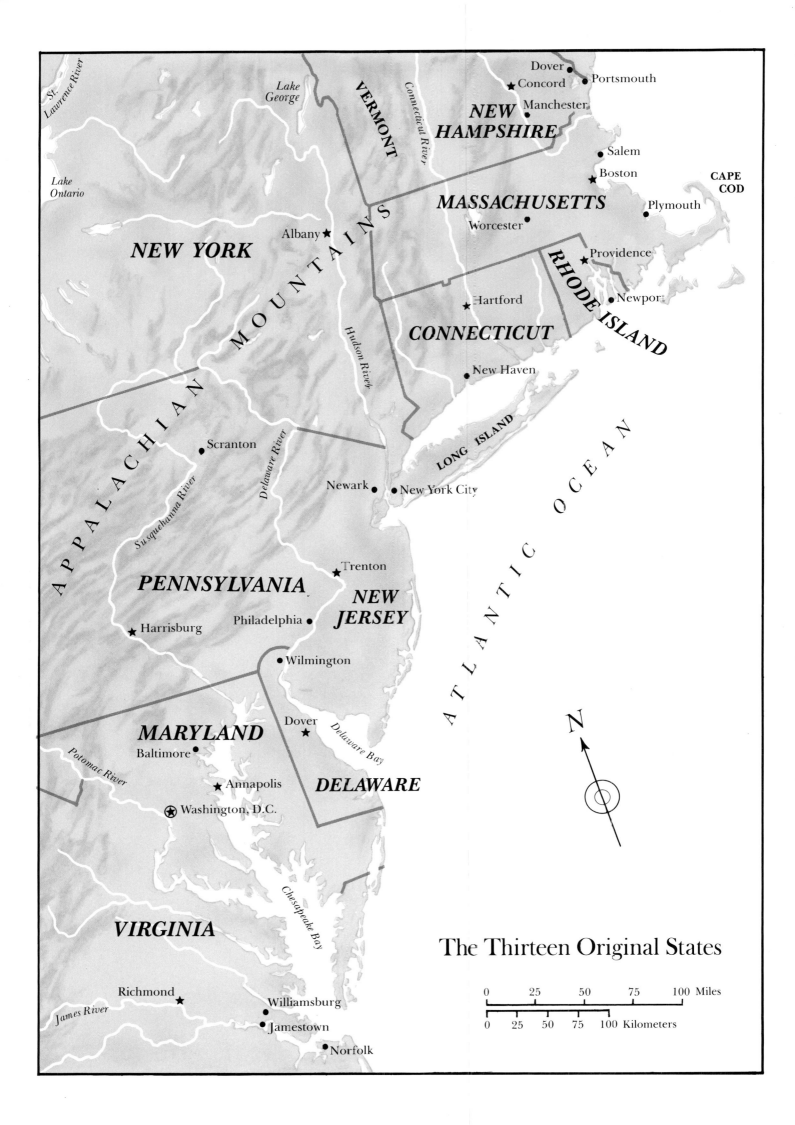

St. Lawrence River

Lake George

VERMONT

Connecticut River

Dover
★ Concord ● Portsmouth

NEW HAMPSHIRE

● Manchester

● Salem

Lake Ontario

MASSACHUSETTS

Worcester ●

★ Boston

CAPE COD

Plymouth ●

NEW YORK

Albany ★

● Providence ★

RHODE ISLAND

Hartford ★

● Newport

CONNECTICUT

APPALACHIAN MOUNTAINS

New Haven ●

Hudson River

Scranton ●

LONG ISLAND

Susquehanna River

Delaware River

Newark ● ● New York City

A T L A N T I C O C E A N

Trenton ★

PENNSYLVANIA

NEW JERSEY

★ Harrisburg

Philadelphia ●

● Wilmington

N

MARYLAND

Dover ★

Delaware Bay

Potomac River

Baltimore ●

★ Annapolis

DELAWARE

⊛ Washington, D.C.

Chesapeake Bay

VIRGINIA

The Thirteen Original States

Richmond ★

Williamsburg ●

James River

● Jamestown

● Norfolk

| 0 | 25 | 50 | 75 | 100 Miles |

| 0 | 25 | 50 | 75 | 100 Kilometers |

1900 Pop. 76 million
1903 Wright brothers' airplane flight
1905 Alfred Stieglitz opens gallery "291" in New York
1908 Henry Ford introduces Model T car
1909 Frank Lloyd Wright's Robie House, Chicago, Illinois

u GEORGIA O'KEEFFE
(American)
Black Iris, III

1912 New Mexico and Arizona become 47th and 48th states
1913 Armory Show in New York City
1917 U.S. enters World War I
1921 Congress severely restricts immigration
1922 T.S. Eliot's "The Wasteland"
1924 George Gershwin's *Rhapsody in Blue*
1927 Charles Lindbergh's transatlantic flight
1927 Early sound film *The Jazz Singer* released
1928 Charles Demuth's *I Saw the Figure 5 in Gold*
1929 Stock market crash leads to Great Depression
1929 Ernest Hemingway's *A Farewell to Arms;* William Faulkner's *The Sound and the Fury*
1930 Grant Wood's *American Gothic* exhibited
1932 Franklin Roosevelt elected president; launches New Deal
1941 U.S. enters World War II
1942–43 Piet Mondrian's *Broadway Boogie-Woogie*
1943 Thomas Hart Benton's *July Hay*
1943 Jackson Pollock's *Pasiphaë*
1945 Roosevelt dies; succeeded by Harry S. Truman

v MARSDEN HARTLEY
(American)
Portrait of a German Officer

1900 Sigmund Freud's *Interpretation of Dreams*
1901 In England, Queen Victoria dies; succeeded by Edward VII
1901 Thomas Mann's *Buddenbrooks*
1901 Pop. (in millions): Russia, 146; Germany, 56; England and Ireland, 41; France, 39; Italy, 32
1901 Guglielmo Marconi sends first transatlantic telegram
1903 George Bernard Shaw's *Man and Superman*
1904 Giacomo Puccini's *Madame Butterfly*
1905 Sinn Fein organized in Dublin
1905 Henri Matisse and others exhibit fauvist paintings
1905 Albert Einstein's special theory of relativity
1907 Pablo Picasso's *Demoiselles d'Avignon*
1910 Wassily Kandinsky's *Composition No. 2*
1910 Igor Stravinsky's *Firebird*
1912 Marcel Duchamp's *Nude Descending a Staircase*
1913 Marcel Proust's *Swann's Way*
1914 World War I begins
1915 Franz Kafka's *Metamorphosis*
1917 Russian Revolution
1917 Journal *De Stijl* appears
1918 World War I ends
1919 Walter Gropius establishes Bauhaus in Weimar, Germany
1922 Benito Mussolini forms Fascist government in Italy
1922 James Joyce's *Ulysses*
1924 André Breton's *Surrealist Manifesto*
1927 Virginia Woolf's *To the Lighthouse*
1933 Hitler appointed Chancellor of Germany
1935 Nuremberg Laws deprive German Jews of civil rights
1936 Spanish Civil War begins
1939 World War II begins
1942 Albert Camus's *The Stranger*
1944 Allied invasion of France ("D-Day")
1944 Jean-Paul Sartre's *No Exit*
1945 End of World War II in Europe
1949 Ireland (Eire) declares itself a republic
1949 George Orwell's *1984*

w PABLO PICASSO
(Spanish)
Gertrude Stein

x BALTHUS
(French)
The Mountain

1901 Pop. (in millions): China, 350; India, 294; Japan, 45
1902 British victorious in Boer War
−05 Russo-Japanese War
1905 Sun Yat-sen organizes Chinese revolutionary alliance
1910 British establish Union of South Africa
1912 Edwin Lutyens designs New Delhi, India
1922 Mohandas Gandhi imprisoned for civil disobedience in India
1926 Nationalists overthrow Manchu dynasty in China
1929 National Revolutionary Party organized in Mexico
1932 Japanese troops invade China and seize Manchuria
1934 Mao Tse-tung leads Chinese Red Army on Long March
1935 Italy invades Ethiopia
1937 Japanese attack China
1942 Chiang Kai-shek president of Chinese National Republic
1945 World War II ends
1947 British India divided into independent India and Pakistan
1947 Dead Sea Scrolls discovered
1948 State of Israel proclaimed
1948 South African Alan Paton's *Cry, the Beloved Country*
1949 People's Republic of China proclaimed

y MASK
(New Hebrides)

1850 California admitted to the Union
1850 Nathaniel Hawthorne's *Scarlet Letter*
1850 Pop. 23 million, including 3 million slaves
1851 Herman Melville's *Moby Dick*
1852 Harriet Beecher Stowe's *Uncle Tom's Cabin*
1854 Henry Thoreau's *Walden*
1855 Walt Whitman's *Leaves of Grass*

 1860 Abraham Lincoln elected president
 1861 Telegraph wires connect New York and San Francisco
 1861 Civil War begins
 1865 Confederate Army surrenders, Lincoln assassinated
 1869 Transcontinental railway completed

 1870 Pop. 40 million
 1870 The Metropolitan Museum of Art founded in New York
 1871 Thomas Eakins's *Max Schmitt in a Single Scull*
 1874 Louis Comfort Tiffany opens glass factory
 1877 Alexander Graham Bell patents telephone
 1879 Thomas Alva Edison invents incandescent light

 1881 Henry James's *Portrait of a Lady*
 1883 Brooklyn Bridge completed
 1884 Mark Twain's *Huckleberry Finn*
 1886 Indian wars in Southwest end with Apache surrender
 1888 George Eastman perfects Kodak hand camera
 1898 Spanish-American War begins

o WINSLOW HOMER
(American)
Prisoners from the Front

p JOHN SINGER SARGENT
(American)
Madame X

1851 Giuseppe Verdi's *Rigoletto*
852–70 French Second Empire under Napoleon III
854–56 Crimean War
1857 Gustave Flaubert's *Madame Bovary*
1857 Charles Baudelaire's *Fleurs du Mal*
1859 Charles Darwin's *Origin of Species*

 1861 Pop. (in millions): Russia, 76; England, 23; Ireland, 6; Italy, 25
 1861 Czar Alexander II emancipates Russian serfs
 1861 Ivan Turgenev's *Fathers and Sons*
 1862 Victor Hugo's *Les Misérables*
 1863 Edouard Manet's *Déjeuner sur L'Herbe* exhibited
1865–69 Leo Tolstoy's *War and Peace*

 1870 Papal States annexed. Rome becomes capital of united Italy
 1870–71 Franco-Prussian War
 1871 Paris Commune
 1871 William I proclaimed emperor of Germany
 1871–72 George Eliot's *Middlemarch*
 1872 Friedrich Nietzsche's *Birth of Tragedy*
 1874 First Impressionist exhibition, in Paris
 1876 Richard Wagner's *Ring des Nibelungen* first performed
 1877 Johannes Brahms's *Symphony in D Major*
 1878 Pyotr Tchaikovsky's *Violin Concerto in D*
 1879 Henrik Ibsen's *A Doll's House*
 1879–80 Fyodor Dostoyevsky's *The Brothers Karamazov*

 1880 Auguste Rodin's *The Thinker*
 1880 Emile Zola's *Nana*
 1888 William II ("the Kaiser") becomes German emperor

 1890 Paul Cézanne's *Card Players*
 1891 Oscar Wilde's *Picture of Dorian Gray*
 1891 Claude Monet exhibits series of fifteen *Haystacks*
 1891 Trans-Siberian Railroad begun
 1895 First collection of poems by William Butler Yeats
 1895 Lev Ivanov and Marius Petipa choreograph *Swan Lake*
 1895 Sergey Rachmaninoff's *First Symphony*
 1897 Henri Rousseau's *Sleeping Gypsy*
 1899 Maurice Ravel's *Pavane for a Dead Princess*
 1899 Anton Chekhov's *Uncle Vanya*

q EDOUARD MANET
(French)
Woman with a Parrot

r VINCENT VAN GOGH
(Dutch)
Madame Ginoux

1851 Chinese pop. 430 million
1854 Admiral Perry negotiates treaty to open Japan to western trade
1857 Sepoy rebellion in India

 1863 Austrian Archduke Maximilian proclaimed emperor of Mexico
 1864 Englishman Samuel Baker discovers source of Nile in central Africa
 1867 Shogunate abolished in Japan; Meiji dynasty restored; capital moved from Kyoto to Tokyo
 1869 Suez canal completed

 1871 Feudalism abolished in Japan; pop. 33 million
 1875 Kuang Hsu becomes Chinese emperor
 1877 Porfirio Díaz elected president of Mexico
 1879 British take control of Khyber Pass

 1881 India's pop. 253 million
 1885 Indian National Congress founded
 1889–90 Japanese emperor grants constitution; first general election held
 1894–95 First Sino-Japanese war
 1898 Boxer rebellion in China begins
 1899 War in South Africa between British and Boers

s YOGI COVERLET
(Japanese)

t MAYURI
(Indian)

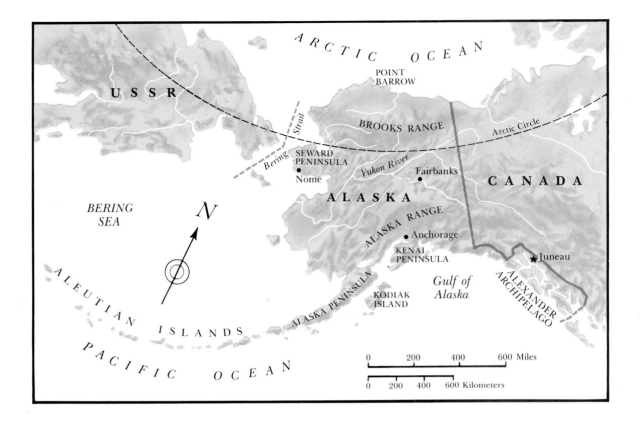

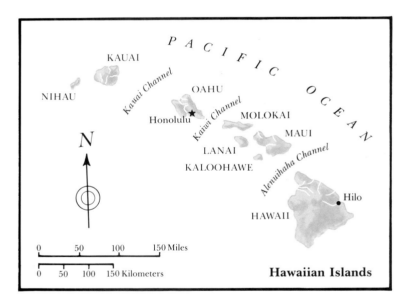

Hawaiian Islands

CREDITS

a Samuel D. Lee Fund, 1938 (38.63); *b* Gift of Irwin Untermyer, 1968 (68.141.81); *c* Munsey Fund, 1934 (34.138); *d* Louisa Eldridge McBurney Gift, 1953 (53.7.2); *e* Rogers Fund, 1907 (07.160); *f* Gift of Edgar William and Bernice Chrysler Garbisch, 1963 (63.201.1); *g* The Lesley and Emma Sheafer Collection, Bequest of Emma A. Sheafer, 1973 (1974.356.121); *h* Bequest of William K. Vanderbilt, 1920 (20.155.1); *i* Gift of Lewis Einstein, 1954 (54.14.2); *j* Bequest of Adele S. Colgate, 1962 (63.550.56); *k* Gift of Mrs. Russell Sage and various other donors, by exchange, 1969 (69.203); *l* Robert Lehman Collection, 1975 (1975.1.186); *m* Gift of the Samuel H. Kress Foundation, 1958 (58.75.89ab); *n* Rogers Fund, 1922 (JP 1367); *o* Mrs. Rachel Lenox Porter, 1922 (22.207); *p* Purchase, Arthur Hoppock Hearn Fund, 1916 (16.53); *q* Gift of Erwin Davis, 1889 (89.21.3); *r* Bequest of Sam A. Lewisohn, 1951 (51.112.3); *s* Seymour Fund, 1966 (66.239.3); *t* The Crosby Brown Collection of Musical Instruments, 1889 (89.4.3516); *u* Alfred Stieglitz Collection, 1969 (69.278.1); *v* Alfred Stieglitz Collection, 1949 (49.70.42); *w* Bequest of Gertrude Stein, 1946 (47.106); *x* Purchase, Gifts of Mr. and Mrs. Nate B. Spingold and Nathan Cummings, Rogers Fund and the Alfred N. Punnett Endowment Fund, by exchange, and Harris Brisbane Dick Fund, 1982 (1982.530); *y* The Michael C. Rockefeller Memorial Collection, Bequest of Nelson A. Rockefeller, 1979 (1979.206.1697)

THE METROPOLITAN MUSEUM OF ART NEW YORK · THE M
ITAN MUSEUM OF ART NEW YORK · THE METROPOLITAN M
F ART NEW YORK · THE METROPOLITAN MUSEUM OF ART
K · THE METROPOLITAN MUSEUM OF ART NEW YORK · THE
OLITAN MUSEUM OF ART NEW YORK · THE METROPOLITAN
M OF ART NEW YORK · THE METROPOLITAN MUSEUM OF A
ORK · THE METROPOLITAN MUSEUM OF ART NEW YORK · T
OPOLITAN MUSEUM OF ART NEW YORK · THE METROPOLI
UM OF ART NEW YORK · THE METROPOLITAN OF ART NEW
HE METROPOLITAN MUSEUM OF ART NEW YORK · THE ME
TAN MUSEUM OF ART NEW YORK · THE METROPOLITAN M
F ART NEW YORK · THE METROPOLITAN MUSEUM OF ART
K · THE METROPOLITAN MUSEUM OF ART NEW YORK · THE
OLITAN MUSEUM OF ART NEW YORK · THE METROPOLITA
M OF ART NEW YORK · THE METROPOLITAN MUSEUM OF A
ORK · THE METROPOLITAN MUSEUM OF ART NEW YORK · T
OPOLITAN MUSEUM OF ART NEW YORK · THE METROPOLI